Creating a Fre

G000108212

Creating a Freelance Career covers everything anyone needs to know about becoming a freelance writer, graphic designer, copy editor, artist, musician, or any other creative occupation. It includes chapters on how to get started with your career and where to look for work, how to write pitch or query letters, how to work with contract employers, and how to build and sustain your business. Lingo necessary for successfully navigating the freelance world is defined throughout. Author Jill L. Ferguson, an experienced freelance professional and educator, guides you through finding success in the gig economy, discussing how to pursue freelancing with an entrepreneurial spirit. *Creating a Freelance Career* includes examples of what to do, and what not to do, when pursuing freelance projects, and includes perspectives from additional real-life professionals who have found success in their fields.

Jill L. Ferguson is the former chief of staff of the Western Association of Schools and Colleges, Senior Commission; the former department chair of General Education, assessment coordinator, and a professor at the San Francisco Conservatory of Music; and a senior lecturer in the School of Business and Management at Notre Dame de Namur University. Jill has been a freelancer writer since she was first published at age 12. She is an award-winning writer, an artist, a business and higher education consultant, and a serial entrepreneur. She is the author of eight books and has written for the *Washington Post*, *Huffington Post*, *Sierra Club Magazine*, and more than 200 other magazines, newspapers, and websites.

Creating a Freelance Career

Jill L. Ferguson

Routledge
Taylor & Francis Group

NEW YORK AND LONDON

First published 2019
by Routledge
711 Third Avenue, New York, NY 10017

and by Routledge
2 Park Square, Milton Park, Abingdon, Oxon, OX14 4RN

Routledge is an imprint of the Taylor & Francis Group, an informa business

© 2019 Taylor & Francis

Library of Congress Cataloging in Publication Data
Names: Ferguson, Jill L., author.
Title: Creating a freelance career / Jill L. Ferguson.
Description: New York, NY : Routledge, 2019. | Includes bibliographical
 references.
Identifiers: LCCN 2018016175| ISBN 9781138605770 (hardback) | ISBN
 9781138605787 (pbk.)
Subjects: LCSH: Arts—Vocational guidance. | Self-employed.
Classification: LCC NX163 .F47 2019 | DDC 700.23—dc23
LC record available at https://lccn.loc.gov/2018016175

ISBN: 978-1-138-60577-0 (hbk)
ISBN: 978-1-138-60578-7 (pbk)
ISBN: 978-0-429-46796-7 (ebk)

Typeset in Optima
by Swales & Willis Ltd, Exeter, Devon, UK

People who want to forge their own paths,
follow their passions, and focus on
creating lives they love,
this book is for you.

Contents

Acknowledgments

Creating a Freelance Career is based on the circuitous and broad career trajectory I have been on since I published my first piece of writing as a pre-teenager. But the breadth and depth of this book would not have been possible without the vast and fabulous network and help of friends, colleagues, and very generous strangers who opened their lives to me and to you, dear readers, so we could all grow and learn from each other.

In particular, I'm grateful to (in alphabetical order) Sahba Aminikia, Scilla Andreen, Becca Bair, Emily Brantley, Danielle Brooks, Kristie Burns, Emily A. Danchuk, Kristen Gill, Abby Glassenberg, Matthew Holmes-Linder, Jane Hughes, Marjory Kaptanoglu, Kate Peters, Alison Rose, Madeline Sayet, Rick Schank, Tarlan Seyedfarshi, Dan Silberman, Lorna Stell, Aaren Strand, Mimi Tsang, Dan Vassiliou, Armando Veve, Stephen Warley, and Ali Wunderman for being willing to be interviewed and quoted in this book. Your words of wisdom and collective experience are invaluable.

A special thanks to my friend Beatriz Maldonado for being the first reader of most of this book. She and my husband, Rick Heckt, the second reader, caught the typos and asked me important questions that helped clarify some of the language and ideas. Rick, I couldn't have done this without your support. Thank you. I love you. And thank you also to our dog Nacho. He's a great office companion and an insistent physical trainer. He ensured I took breaks from sitting and typing to go on numerous walks per day.

Thank you to Kristina Ryan at Routledge who got me involved with her company and passed an idea I had along to editor Ross Wagenhofer. He and Nicole Salazar have been a wonderful editorial team. I'm grateful for their oversight of this project.

Lastly, no parts of my career, my research, my life, or my writing would have been possible if it weren't for my parents. They took me on my first trip when I was still an infant and helped create a drive in me to see the world and to be able to work from anywhere. They also taught me to read way before I was the age to enter school. Thank you, Dennis and Leah Ferguson, for all of the books over the years and for the encouragement, and for all of the forgiveness when I didn't hear a word you said because I was reading or writing.

Contributors (in Order of Appearance)

Lorna Stell
Emily Brantley
Armando Veve
Madeline Sayet
Kate Peters
Matthew Holmes-Linder
Scilla Andreen
Emily A. Danchuck, Esq.
Mimi Tsang
Becca Bair
Rick Schank
Stephen Warley
Sahba Aminikia
Daniel Silberman
Jane Hughes
Kristen Gill
Kristie Burns
Alison Rose
Kristie Burns
Ali Wunderman
Abby Glassenberg
Tarlan Seyedfarshi
Danielle Brooks
Dan Vassiliou
Marjory Kaptanoglu

What It Means to Freelance (or Jumping in with Your Eyes Wide Open)

This chapter explores the definitions of freelance and entrepreneurship, the reasons people freelance or choose to participate in a gig occupation, the benefits and drawbacks to launching a freelance or entrepreneurial career, as well as where to look for work.

Often, upon meeting someone new, we ask, "What do you do?" We may ask this as a way to start a conversation, to help us subconsciously or consciously categorize people, or because we are genuinely interested. But more and more, we are moving into a collective work history and culture where that question becomes harder and harder to answer.

Many people in traditional, professional occupations (doctors, lawyers, dentists, etc.) have paying side occupations. Take Chris Reed, a Los Angeles-based lawyer, for example. Reed is also a photographer and an author ("Chris Reed," 2018). Or Dr. Ting-Wey Yen, a dentist, oil painter, sculptor, and photographer ("Yen Dream Art," 2018). Or even someone like Oprah, who started her career as a radio newsperson, moved on to television and has added actor, producer, director, philanthropist, entrepreneur, and many other titles after her name ("Oprah Winfrey," 2018).

Whether it's because we don't want one occupation to define us, or because we have many interests we want to pursue, or because we feel we need to cobble together many jobs to help us make ends meet, Americans are increasingly turning hobbies into paid opportunities and taking advantage of the many side hustles available today. Television commercials extol the virtue of making extra money for travel and for dating by having a side gig, business publications, such as *Business Insider* encourage readers

to turn their hobbies into high-paying supplemental income (Gillett, 2017) and financial websites, like *The Balance*, encourage people to "earn a little extra money on the side, without compromising your current schedule" by recommending apps you can use to start a side hustle (Lockert, 2018).

In fact, in 2016, 53 million Americans categorized themselves as freelancers (defined as "individuals who had engaged in supplemental, temporary, or project- or contract-based work in the past 12 months") (McCready, 2016). And 30 percent of those people were freelancing in addition to their "regular" jobs, according to the report "Freelancing in America: A National Survey of the New Workforce" (2017). We are living in a time of a robust gig economy, where people are supplementing their income, trying to control every aspect of their careers by working for themselves and/or trying to nurture their creative sides by following their passions.

Those 53 million Americans include: independent contractors (40 percent of independent workforce) 21.1 million; moonlighters (27 percent) 14.3 million; diversified workers (18 percent) 9.3 million; temporary workers (10 percent) 5.5 million; freelance business owners (5 percent) 2.8 million, according to "Freelancing in America" (p. 3). And the thing is, whether these freelancers went to college or not, the majority of them were not trained in how to freelance or run their own freelance businesses. Most have had to learn by trial and error, and have succeeded—if they have—by hard work, networking and maybe some luck.

Take Anderson Cooper, for example, who worked briefly as a fact checker upon university graduation, before taking off on his own as a freelance news correspondent for three years and making a name for himself before signing a contract to work for ABC (Cooper, 2006). Or Cameron Crowe, who started publishing music reviews in San Diego at the age of 13, before going on to freelance at *Rolling Stone*, at the age of 15, before writing novels and making movies (Bozza, 2000). Or Donald Glover, creator, writer, occasional director and star of "Atlanta" who started his career as a sketch comic, standup comedian, DJ, and then was a writer on "30 Rock" (Friend, 2018). Or even NBA basketball star Kobe Bryant who wrote the script for a short animated film called "Dear Basketball" and won an Oscar in early 2018 (ESPN, 2018).

In the age of student/artist/on-campus employee, parent/project manager/Lyft driver, comic/DJ/writer, what does freelancer or self-employed or entrepreneur really mean?

What Does It Mean To Freelance?

According to the *Merriam-Webster*, the first known use of the word "freelance" was in 1819, and it referred to mercenary soldiers especially in the Middle Ages ("Freelance," 2018). But the way the word currently is used isn't that different (except for the solider part). Freelance is defined as "(1) a person who acts independently without being affiliated with or authorized by an organization or (2) a person who pursues a profession without a long-term commitment to any one employer" ("Freelance," 2018).

When working as a freelancer, one can work for different companies at different times or different companies at the same time. One can do the same or similar work for all of the places or different types of work depending on what is needed. For example, if you're a skilled graphic designer and artist, you could be a freelancer working on a branding project for Company A, designing their logo, their website and all of their marketing materials, while in the space of the same day or workweek, working on your own graphic novel that is under contract to a big worldwide publisher, and doing layout on a small catalog of merchandise for a jewelry designer client, too.

Essential to being a freelancer is that your work is done under contract, where you are either paid per hour, per piece (page, word, or widget, for example), or per project, and the contract has a start and an end time (or a deadline). And though you are contracted to the company for the work, you are self-employed (meaning you have different tax status recognition and different paperwork, such as you fill out a W-9 instead of a W-4 and receive a 1099 for the year's work instead of a W-2, but more on that in Chapter 4).

But that isn't to say you cannot be a freelancer and an employee, too.

What Is a Diversified Worker?

If you are a part-time or full-time employee somewhere and you receive a regular paycheck and you have a side gig doing anything that makes you money, you are called a "diversified worker." Business media *Bloomberg* reports that

the biggest category of freelancer is now . . . diversified workers, defined as: "People with multiple sources of income from a mix of traditional employers and freelance work. For example, someone who works part-time at a start-up, manages an Airbnb, and does freelance coding."

(Fox, 2017)

Diversified workers come from every industry and their side gigs or multiple sources of income may come from a range of industries, too. Diversified workers can come from every economic strata of life. Think athletes who own restaurants or have their names on shoes or clothing lines or appear in advertising. Or consider the woman I met in 2007, when I was on a book tour for *Sometimes Art Can't Save You*. The part-time salesperson at the Borders bookstore where I was speaking and signing books was also a filmmaker, who was on her way to the Cannes Film Festival to show one of her films.

Which begs the question, what's the difference between a freelancer, a diversified worker, and an entrepreneur? And in today's economy, a person may be one, two, or all three.

What Is an Entrepreneur?

The *Merriam-Webster* defines an entrepreneur as "one who organizes, manages, and assumes the risks of a business or enterprise." ("Entrepreneur," 2018). Based on that definition, anyone who claims self-employment could be considered an entrepreneur. But let's delve a little deeper. *Entrepreneur*, the magazine, says that to be an entrepreneur, you can't just build a brand or a platform or a following (things that have little to no risk). Being an entrepreneur has to be part of the equation: Entrepreneur + Capital = Products + Customers = Business (Tobak, 2015). So entrepreneurship takes an investment of money and time, involves the creation of a product and finding customers and that's how one creates a business. Tobak uses the examples of the founders of SnapChat and Whole Foods, and writes, "If you want to be a successful entrepreneur, don't start out wanting to be one. Start out with a customer problem and a product that solves it. Get capital. Make the product, market the product, win customers."

Take the example of SmartNews (www.smartnews.com) whose mission is "delivering the world's quality information to the people who need it" ("About," 2018), but that came about by trying to answer an engineering problem: "How do you deliver the world's most important information to the people who need it automatically, in real-time? How do you determine what makes a quality story or what people want to read?" ("Careers," 2018).

When you want to go beyond having a side hustle and turn that or something else into more of a career, you have to ask yourself what do people need and what can I provide? (Even answering that question in a side hustle can help set you apart from others in the same industry who are doing similar things. For example, Uber drivers who offer bottled water, mints or candy, iPad usage, or other things to enjoy on the ride.) Approaching your freelance gig with an entrepreneurial mindset (what product am I offering and who are my customers and what do they need or want?) will make your freelance gig more successful.

Reasons People Freelance or Participate in the Gig Economy

People freelance, work as contractors, participate in a gig economy, or start their own businesses for a number of reasons. *Quartz* reports the "splintering of traditional jobs into freelance work and temporary work" as one of the reasons" (Wang, 2018). *Bloomberg* reports that stagnant wages in traditional jobs may push people into freelance work because they can't get by on a single paycheck, or because upstarts like "Airbnb to Upwork make it easier for people to earn on the side" (Fox, 2017).

One of the things that has shifted over recent years, according to the survey and "Freelancing in America" report is that "63 percent of free-lancers (up from 53 percent in 2014) said they are freelancing by choice, not out of necessity" (Fox, 2017).

People may start a freelance gig on the side because they want to pursue or transition into another type of work, because they want to launch a business but want the security that comes with a regular paycheck while they start out, or simply because they like the work or the people. (One of my graduate school professors said how much he loved a cab-driving gig he had because he got to meet fascinating people.)

Photographer Lorna Stell, in Case Study 1.1, is an example of someone who works for a start-up but has her own company as she transitions into being financially independent from her day job:

Case Study 1.1 Lorna Stell

When I finally graduated from school in Boston, Massachusetts, I knew I was in a tricky situation: I was young and relatively inexperienced in my field as an artist and photographer, and had decided to make an urban area with a high cost of living my new home after moving from Virginia. Having been an art major and trying out different types of creative work in my college years, I knew without a doubt that being a photographer was the only career path I wanted, and it was the only type of work that really excited me to my core for the long term. This intuitive knowing was something I knew I would be crazy to ignore, but I also knew that if I was going to make my new life in Boston work, I had to do whatever it took to support myself financially.

As a college student, I found that the easiest type of work for me to get was in retail and customer service. As an introvert and someone still learning to juggle chronic health issues at the time, the thought of dealing with the stress and scheduling of other jobs like bartending or working in food service made me cringe. Picking up customer service and retail work quickly became the way that I could start to earn a living while meeting interesting people, but it also left me just enough white space in my schedule that I could do my own creative work or look for photography opportunities. There were also times when I would pick up one-time gigs or juggle multiple part-time jobs.

In my journey towards reaching my financial goals, I found that there is almost always somewhere new to look for your next opportunity, whether that's a day job or creative job. For me, many of those came from Craigslist, social media, and direct connections with friends and teachers. My first job working for another photographer

(the type of work I searched for while not on a retail shift) came from a conversation I had with an acquaintance I had reconnected with. My friend had a friend who was a wedding photographer. Although when I reached out to that photographer, she told me that she had all the help she needed already, but she had another wedding photographer friend who could use an administrative assistant. Once this photographer and I got to meet in her home office, I was hired on the spot.

In working for that photographer, I saw what the day-to-day behind the scenes work looked like, what tools she used to run her business, what challenges she faced, what special things she would do for her clients, and even what business expenses needed to be managed. These were all the things that were never taught to me in school, and things I knew I needed to learn if I was to become a photographer myself. By this point, I had learned that staff photographers were dying out, and to be honest, I really wanted that freedom of being able to do only the work I wanted to do, for people I really loved working with, on my own schedule. This was exactly what this wedding photographer was able to do, so I learned a lot from being able to work right next to her and see her business in action. That being said, I continued to work retail shifts while working for her, as she wasn't in a position to provide me with more than 15 hours per week.

Up to this point in my creative development, I was actually not interested in wedding photography at all, and portrait or fashion photography was where I thought I might make my career. However, after working alongside the wedding photographer, I was very inspired by her work and also began to see new kinds of visual inspiration everywhere. I realized that the traditional style of wedding and portrait photography that I had always seen and thought was so boring, with heavy posing, lighting, and camera-aware faces, was not a style I liked at all. But the most important lesson I learned as a photographer was there is a market for whatever your personal and aesthetic style is. Once I discovered that, it felt like the whole world opened up.

After working for that wedding photographer, I landed my next long-term job working nearly full-time as the studio manager for a portrait photographer. He was phasing his business out of wedding photography, but still had a few left on the calendar that I had the opportunity to second shoot for. At those weddings, I was able to get more experience seeing the flow of a wedding day, what moments are most important to capture, and preparing for technically difficult situations. On weekdays, I garnered experience with print products, sales, and client relationships as I took each client from start to finish in our portrait session workflow. Through all of this work, I learned just how many hats a "solopreneur" has to wear within their business, and I learned where some of my business weaknesses were.

About a year and a half later, the portrait photographer decided to close his studio. I didn't have much transition time and knew I needed other work fast. By this point in my journey I had been freelancing on and off, but hadn't committed to starting my own business. I had been afraid of failing publicly and not getting booked for work, and I was also afraid of what I didn't know about how to run a sustainable business. However, I figured out that "the right time to start my business" would never come—I needed to just jump in and do it! So, I created my website, updated my portfolio, and told people I was open for business. The floodgates didn't open overnight though, so I still looked for a day job.

I became a part-time administrative assistant in the headquarters of a sports retail chain, which was an amazing opportunity because I worked right next to their full-time graphic designers, who were constantly creating marketing pieces and working with commercial photography. After a short time, the company paid me a higher rate to do in-house product photography alongside my other work. While I had very little experience with this, the company was mostly concerned with being able to generate content quickly and inexpensively, so in this way I was essentially being paid to learn on the job. While this position lasted, it was instrumental in building my own business, as I am now able to offer product photography to local small businesses.

When that company was liquidated, I was again in the position of needing a new job fast while I grew my business on the side. This time though, I had more constraints. I had moved further away from the city due to the cost of living, and my husband and I were sharing a car. Public transportation was available but very limited. I also needed flexibility with scheduling so I could shoot weddings on weekends, and portrait sessions and product photography during the week. This means I needed an opportunity that would ideally allow me to work from home and set my own hours. Amazingly, I found a Boston startup was hiring for a customer service associate and they allowed me to do exactly that. It turned out that they were a small team scattered through all different states, and all members of the team worked whenever they were able. Because they are in the baby product industry, they were very understanding of needing flexibility with scheduling and meeting in person.

I still work for this company today and it's been a fantastic experience. The startup culture is an amazing fit for me, and they actually love to see team members active in pursuing their own opportunities on the side, whether that is a formal business or not. When I interviewed with the founders, I was unsure how they would feel about me having my own business, but they were clear that as long as I stayed on top of my work for them and was responsive to the team, they were happy to have me pursue other work on the side. Not all the skills I've developed at this position are transferable to my business as it is a different industry and different business model (they sell products online while I offer a personalized service in person), but I've learned about the importance of balancing upholding policy with making sure customers are happy. Since I focus on customer service, those skills are always important in my business as well since I work one-on-one with all my clients.

Currently the way my business functions is I shoot my own client's weddings, shoot as an associate for another company, or shoot as a contractor directly for another photographer on weekends, and during the week I will shoot family sessions, engagement sessions, or product and portrait photography for small business owners.

Because I work from home, it's easy for me to quickly shift gears between my day job and my business, with zero commute time. I have a home office, so all of my business work (desktop computer, paperwork, equipment, print products, etc.) stay in that room (for the tax deduction and for mental separation), and I work in my common area for my day job. I try to time block whenever I can, and do four solid hours at a time for my day job so I'm not mentally switching back and forth all day long. Since the company doesn't have a preference for what specific hours I work, I can always change my schedule day-to-day if one of my clients needs to schedule a call at an unusual time, or even if I need to run business-related or personal errands.

As I began building my business, I found that while there are dozens of factors that contribute to having a sustainable business, and while there are literally hundreds of other photographers in my area that I could see as my competitors, the one thing we cannot compete with each other on is who we are. So for that reason, I make my business as personal as possible. I do not refer to my business as "we" or write about myself in the third person because I am the owner and only employee. I write all of my own web and social media copy, and my goal is always to write in such a way that I bring in my own personality. I try to get my clients off of e-mail upfront and have as much face time with them as I can. If potential clients can grow to know, like, and trust you, then that is a huge barrier that's broken down before booking. This is especially true in the wedding world, where the wedding photographer is often the one vendor that spends the most one-on-one time with the couple before and during the wedding day.

That being said, it has also been important for me to hone my aesthetic style and figure out who my "dream clients" are as I work to create a niche for myself in an industry that is saturated with other photographers. Along the way I have learned that if you appeal to everyone, you appeal to no one, which means that finding my target market is a constant process, and the target market can also change over time. I'm always trying to further discover what clients are

the best fit for me and vice versa when it comes to demographics, personality, style, and values.

As for my future, my "big dream goal" is to get to the point where my business is my full-time job. This still feels like a big goal since marketing has always been my weak point, so keeping the flow of inquiries and client bookings coming in can be a challenge, especially while I handle all tasks that need to be done in my business. While having a day job has helped a lot in terms of taking financial stress off my family in the short term, it also means that I have less time to do the work I'm really passionate about, and I have less control over where my money comes from. The wisdom of previous generations always seemed to say that having a steady full-time job was the best way to support yourself, and I've found that this is no longer true: Not only can it be challenging to find employment in the first place, companies can go under or be sold, sometimes with very little notice (or none at all) to employees. This is why my ultimate goal is to depend on day jobs less and less, so that I can work for myself and continue to do the work I love for the clients I love.

Lorna Stell
Photographer
Facebook: www.facebook.com/lornastellphoto
Instagram: @lornastell

Benefits and Drawbacks to Working for Yourself

Working for yourself as a contractor for others, either part- or full-time, can be a mixed experience, just like when you work for an employer. Some days you may not feel like working or doing a particular project. Other days the sunshine may call to you. And yet other days, you may feel so inspired that you don't want to stop working after a full eight or more hours.

Some of the benefits of being self-employed are:

You are your own boss. Yes, you have a contract with others to do work for them by a certain deadline and that contract probably dictates many of the terms of your work (deadline, length, who owns the work once it is done, etc.—more on this in Chapter 3). But for the most part, you get to be your boss and tell yourself what to do and when. And you are in charge of determining how much money you will make and when you want to give yourself a raise, take a sick or vacation day, and what kinds of benefits you will provide yourself.

You get to set your own hours. That means if you are a night owl, you can work from 9 p.m. until 5 a.m. instead of its opposite. Or if you want to take a surf, samba, and/or Szechuan cooking class in the middle of the day, you can schedule your Skype meetings, writing, recording, painting, driving, whatever around it. You can also not work the same hours every day nor the same days every week. And since you aren't clocking in anywhere, you can choose to work weekends or holidays or early mornings or any other time when the mood strikes and you are feeling productive or you have an imminent deadline.

You determine what kind of work you do. We've all had to do things we haven't wanted to, such as take a specific class to fulfill a graduation requirement, eat a certain food to appease a parent or grandparent, or done a task at work that we've hated, such as cleaning out the ice cream cooler, a bathroom, or a fitting room. When you work for yourself, you can determine which tasks you tackle and which you can outsource. For example, if playing music and recording is your passion, focus on that, and find an assistant to help carry the equipment or help with your social media or whatever task you find onerous. Or if you're a wordsmith and you want to land a client who needs design, too, partner with a graphic designer and work together on the project.

You can choose with whom you want to work or collaborate. Ever had a job where you didn't like a boss or a co-worker? When we work for others, sometimes we are stuck with those people. But if you're self-employed, you don't have to deal with workplace drama. You can choose with whom you collaborate and for whom you do work.

And if, at any point, you decide something isn't working for you for any reason, you can choose not to work with that person or organization again after the terms of your contract have been fulfilled.

You have the freedom to work from many different places. Computers, smart phones, tablets, and Internet connectivity have given us the ability to work at any time, from any place, doing many different kinds of things, with people all over the globe. From the West Coast of the United States, I have worked for a digital marketer in London, been editor-in-chief of a magazine and book publisher based in Copenhagen, and worked with writers and editors on six continents. I have written books and edited articles at 36,000 feet while flying through the night. We have the ability to work from hotels, beaches, jungles, and on public transportation anywhere in the world. And some of our smart freelance colleagues have been deciding where they want to go and then finding the work to take them there.

Your pay scale can be higher. When a company hires you as an employee, they determine how much you cost them (often referred to as your package, which consists of salary, benefits—health insurance, paid time off, disability insurance, dental and vision insurance, life insurance, retirement plan, and possibly a flexible spending account—plus the taxes the company pays on your behalf). When you work for yourself you are in charge of all of these things, and because of that, you can charge a higher hourly rate than you would get as an employee to cover those things. And this still costs the company hiring you less than it would if you worked for them as an employee, which is why you'll read in case studies in Chapters 4 and 5 about people getting laid off and then hired as contractors for a higher rate at the same companies that laid them off.

You get more tax deductions. When you are a contractor, a freelancer or a business owner, you can deduct things from your taxes as business expenses that you couldn't when you receive a steady paycheck for a company. For example, if you drive to a meeting, you can deduct mileage, parking, and associated costs as a business expense when you are self-employed. You can also deduct computer and phone expenses and office supplies if you use them in your business. And

meals with clients, business-related travel expenses, and possibly even a percentage of your utilities and living expenses if you have a designated space for a home office or studio may be deductible, too. (Consult a tax professional for a complete list of deductions.)

You may save money on expenses (such as clothing, gas, parking, etc.). If you work from a home office, you may not need to get dressed up every day or to wear a uniform like you would as someone's employee. You may save on gas and parking expenses and car maintenance if your commute consists of walking from your bedroom to your office space or studio.

In Case Study 1.2, artist Emily Brantley talks about some of the benefits and drawbacks she's discovered in working for herself.

Case Study 1.2 Emily Brantley

Becoming a freelance artist came with a learning curve. I knew how to get good grades and I knew how to please an employer, but neither experience prepared me for the mountain of responsibility involved in running my own business.

In the educational world, there is a system in place: Play by the rules, work hard, fulfill requirements—and you're golden. The workplace is similar: Get your prescribed work done, be a tolerable human being, and please the boss. In the freelance world, however, you quickly realize that school left you sorely unprepared. The only structure, the only goals are those you create for yourself. If you don't know how to create these, failure is guaranteed.

When I graduated from college, I was unsure of what I wanted to do, career-wise. I accepted a temporary job at my church where I performed administrative tasks, ran the website, wrote and edited copy, planned weddings and funerals . . . all of which somehow turned into five years of my life. At the end of these five years, I surveyed my life and knew I wanted more. Sitting behind a desk doing menial tasks day after day was for me a spirit-killer.

I wanted to do something I loved. I wanted flexibility. I wanted to get out from behind the desk and find a lifestyle that wasn't so sedentary. I had studied art in school and enjoyed painting. So, with all of the courage and naiveté of youth, I left the security of my job to become an artist, certain the world would embrace me. I humbly admit that it was MUCH harder than I had anticipated. My young and optimistic self was startled to find that the world did not immediately embrace me. I painted and I sold some pieces, but quickly realized being a professional artist wasn't just about being a good painter. I needed to be a good businesswoman. I needed to learn marketing, finance, customer service, and web design. I struggled to promote myself and grow my business because of a lack of knowledge and skills.

During the lean months, I periodically picked up jobs copywriting and event planning. I even worked full-time for a year as an art buyer and TV show host. Yet, I always returned to painting and working for myself where I was empowered to make my own choices. I set the hours. I chose the work and the people with whom I work. That was the lifestyle I wanted. I had the passion and the work ethic; I just needed to figure out how to make my work lucrative.

Freedom is a seductive concept. But achieving freedom, while also making an income adequate to support myself in pricey Los Angeles, proved difficult. For the first time, I had no authority telling me what to do. No syllabus for the "pathway to success." No rulebook. No guarantee that if I worked hard and did my homework, I'd earn a paycheck.

It became apparent that I had to self-educate. I devoured books like *The E-Myth Revisited: Why Most Small Businesses Don't Work and What to Do About It* by Michael E. Gerber and *The Four-Hour Work Week* by Timothy Ferriss. I reached out to successful artists and asked them questions about how they started their careers and how they stayed above the dreaded "starving artist" poverty line. I approached gallery owners and asked questions about how their businesses were run and why their artists were successful. I joined

local art groups, attended networking events, and made friends with other artists on similar career trajectories.

Through my research, reading, interviews, and plenty of trial and error, I began to develop a proper business plan. I set goals and markers for achievement. Taking a hard look at myself, I determined the business skills that needed development—sometimes a LOT of development. I used to ignore the tasks I did not enjoy or at which I felt unskilled, causing myself more grief and frustration down the line. I learned to practice discipline. I realized that working nonstop was not healthy for me, and that I needed occasional getaways to reset my drive to work hard. Slowly but surely, my stubbornly creative mind allowed systems and habits to develop. With these good practices, my business began to bloom and grow.

Running your own business and being your own boss is not for everyone. You have to want it more than security, more than comfort, more than paid vacation. Self-motivation, discipline, and good time-management are essential, as is an openness to constant change and growth. Failures can be turned into learning opportunities, and you have to see these as positive experiences, not allowing discouragement to halt your progress. You have to distinguish between risks that are worth taking and risks that are not. One of the most important things I learned was to surround myself with my cheerleaders—the people who encourage me, help me, and give me honest critique and feedback. I am so grateful for the friends and family who have walked alongside me in this journey. I couldn't have made it this far without their strength behind me.

It is encouraging to step back and look at my journey of self-education and see how far I've come. After working as a professional artist for a few years now, I'm proud of my achievements. Still the new kid on the block in the art world, I have plenty more to learn. I'm constantly adapting my business practices as well as learning new artistic techniques. It's exciting and terrifying to work independently, with the full responsibility of my financial well-being

resting solidly on my own shoulders. But I know that I can grow and change, and I know that the adventure is worth it.

Emily Brantley
Artist
www.emilybrantleyart.com
Facebook: www.facebook.com/SummersPearl
Instagram: @summers_pearl

While working for yourself or being a freelancer offers some degree of freedom and flexibility, it also can present some challenges that may make some people wonder if it is truly for them. Some of the drawbacks to being self-employed are:

You have to have a number of business skills (or money to outsource them). In order to successfully run your own business, you have to some idea of basic bookkeeping and accounting to be able to invoice clients. You also need some idea of how to negotiate contracts and payments and rights. And you need basic marketing, public relations, and sales skills. You may also need to know a bit about web design, social media management and messaging and branding, plus a number of other things that go into the day-to-day operations of a business.

No one else sets your schedule or tells you where to be when. As you read in Emily Brantley's case study, suddenly not having a set schedule can be jarring after sixteen or more years being told where to be and when. Wanting to succeed at self-employment makes one become a self-starter, a person who sets goals and figures out a schedule and works hard to maintain it. If you don't, it becomes too easy to get distracted by other things and not do the work.

Your business succeeds or fails almost solely based on you. When you work for yourself you are in charge of creating all of your income and managing all of your own expenses. You have no one to blame but yourself really if things don't go well. This can be overwhelming or paralyzing to realize that it is up to you and only you. For some people, this becomes their driving force, their "I'll show you . . ." (like you'll read in Danielle Brooks' case study in Chapter 7). For others, self-employment may feel like a crushing weight, until their business is firmly in the black.

You have less security. When we work for ourselves it is up to us to make sure we save for a rainy day and for retirement and sick days and vacation. Our employment is only as strong as the length of each contract, so we must keep in mind our present while planning our next gig to make our business more secure and our income streams steadier.

You have fewer free benefits. When you are self-employed, no one pays you for vacation time; offsets your health, dental, and/or vision insurance; or funds your retirement plan. It is up to you to seek ways to accomplish these things and then to fund them.

You're in charge of filing all of your own tax paperwork and paying your taxes. With self-employment comes self-employment tax, which includes Social Security and Medicare taxes. "Self-employment taxes are assessed on a percentage of your net earnings," according to Intuit's "A Tax Guide for Solopreneurs" (2017).

You can feel socially isolated. If you work from home and/or work for yourself in an occupation that can be done solo (writing, editing, fine or applied arts, composing, design, coding, online sales and marketing, etc.) you probably spend the majority of your time by yourself, maybe interrupted by walking the dog, a phone call, or an electronic meeting. Not having face-to-face contact with others while you work can feel very isolating. This is why work-share spaces and work-in-a-coffee-shop culture is thriving. *Forbes* estimates that by 2020, 26,000 shared office spaces may host 3.8 million people so that people don't have to work in isolation and can use the spaces to network (Alton, 2017).

You can get distracted easily if you work from home. When you don't have a boss breathing over you or anyone to manage (or micromanage) your time, stopping to pet the dog, do the laundry, cook, play an online game or visit Facebook, or stare at the squirrel out the window becomes easier. Not stopping work to play Words with Friends every time "your turn" chimes takes discipline. Some freelancers or solopreneurs set aside specific time each day to check e-mail, return phone calls, or give themselves a break. Others negotiate with themselves. (One colleague made herself write five more pages and then allowed herself 30 minutes of Bubble Witch.) If you know what distracts you, find a system that works so you can get your work done and still have time to play or be distracted.

If, in your mind, the benefits of working for yourself, clearly outweigh the drawbacks, then move on to the next section.

Where to Look for Work

Work can be found anywhere and everywhere and can be found when we least expect it. Shortly after college, I was freelancing (called "being a stringer" in newspaper lingo) for my city's newspaper, I was working as a part-time nanny, and I owned a small business (I bought into a franchise that made personalized children's books and products). One day the woman who was teaching me watercolor painting called. A client of hers, a district court judge, wanted a St. Patrick's Day card made to send to her constituents. The judge had seen something I had written, said she thought I had a way with words, and asked my teacher if she could get me to collaborate with her. Would I write greeting card copy for a singing leprechaun that my teacher would draw and paint? Of course I said yes and quoted a price, and that became the first card I ever helped create.

The Internet makes getting in touch with potential clients and companies much easier than the phone and snail work of decades past. Contacts can be found on LinkedIn Pulse, on regular job sites like Indeed.com and Monster.com, on multi-purpose classified places such as Craigslist.com, on gig-economy sites such as UpWork.com or Guru.com, or on industry-specific spaces such as Behance.com. Or you can study your favorite companies—the ones you'd love to do work for and for which you think you're a great fit—and contact them (more about how to do this in Chapter 2).

That's how illustrator Armando Veve got his start at *The New York Times*, as he explains in Case Study 1.3.

Case Study 1.3 Armando Veve

I studied illustration at the Rhode Island School of Design (RISD) and moved to Philadelphia shortly after graduating in 2011. I worked several odd jobs in order to sustain my art practice, which consisted of making drawings for myself, and occasionally showing in artist-run spaces in Philadelphia and New York. My "day job" left me emotionally drained, which made it difficult to feel motivated to make art. And even in the creative positions I held, I was merely

the hands behind someone else's vision. I had a lot to say, but I was not given the space to express myself. I decided to begin seeking freelance work, which would give me more creative control over my projects.

At RISD, I took an editorial illustration course that gave me the fundamental skills to approach art directors for work in newspapers and magazines. I started by cold e-mailing art directors at *The New York Times* Op-Ed. I also went to Barnes & Nobles and flipped through every magazine that caught my eye. If they seemed like a good fit, I would go to the masthead and copy their art director's name. If contact information was not available, I would then go online and try to find their information. I reached out to several art directors at *The New York Times* and was fortunate enough to receive a commission several months later. That first published work led to a second, and it snowballed from there. Now, I've accumulated hundreds of art directors' e-mails and I contact them with published work updates up to three times a year. I use Google spreadsheets to organize all of this information.

I fell in love with the editorial process. The topics/themes presented to me gave me something to bounce off, fueling endless possibilities for imagery. I loved the problem-solving aspects of making editorial illustrations. I have been working as a freelance illustrator for six years now, and my favorite part has been the unpredictability of the journey. Every week I have no idea what is going to be thrown my way. The work has now evolved into other markets including advertising and book publishing. I'm also developing work for galleries again. It is still a dream of mine to write and illustrate my own picture book.

I have been fortunate to receive recognition for my work by organizations including American Illustration, Communication Arts and the Society of Illustrators in New York. Most recently I was named in the Forbes 30 under 30 list and named an ADC Young Gun by the One Club for Creativity. The awards have helped legitimatize my work in the eyes of clients, but accolades are not enough to sustain a career. They are not what will get me to the studio every day.

I still face the same challenges I did when I started. Overcoming these obstacles inspires me to push myself out of my comfort zone and be ambitious with my work.

It's important to feel a bit uncertain with the process. The day I figure everything out is probably the day I move on to something else. Success is not a place destination.

Along the way, I have learned some very important lessons, including:

- Be kind. Remember that all client interaction is human–human interaction. Your behavior and language has consequences.
- Try not to sweat the small stuff; it's important to keep the bigger picture in mind.
- Be open-minded. You will be thrown curveballs and it's important to catch them with a smile and willingness to make the necessary changes.
- Be yourself. You are being hired for the work you do. It is important to keep your clients needs in mind, but finding a way to meet these needs in your own way is the key to developing a unique product that stands out in a saturated market.
- Clear communication is key to a successful collaboration. Take your time to articulate your points clearly. If you disagree with a specific idea, voice your opinion.
- And of course, do not miss a deadline.

I have also learned that if you can think of anything else that you would rather be doing, do that. Freelancing is not for the faint of heart. There is the notion that freelancing comes with the flexibility to choose your own hours and projects. Yes this is true, but it also comes with longer hours and much more responsibility since you are taking on multiple roles (unless you hire assistants, but this is unlikely when you are starting). In the beginning, there will be times you will have to take on work that is not desirable. Try to learn with every new project, and even if it did not turn out exactly as intended, you can at least take that knowledge to the

next project. I find freelancing to be an incredibly exciting and stimulating path.

Keep in mind that this is a long journey. It's important to think about the big picture. I am happy that I had two years between graduation and my first assignment because I was able to experiment and develop my work independent of the expectations of a client. I am considering taking another break soon to reflect on several years of work and to make room for more experimentation. It's important to find ways to reinvent yourself to keep the work alive.

I have also learned the importance of trying to maintain a regular schedule. Knowing that there is a beginning and end to each day pushes me to use my time more wisely. This has allowed me to enjoy other activities outside of my studio, which give me energy and fuel for the studio the following day. I have been more productive by working less.

Good luck on your journey!

Armando Veve
Illustrator
www.armandoveve.com
Instagram: @armandoveve

Chapter Summary

Chapter 1 explored what being a freelancer or a contractor means and how it can differ or be similar to being an entrepreneur. Some people freelance as a way to make money in addition to their full-time employment; others freelance as way to launch a new business or as their main source of income because they love to be their own bosses, set their own hours, and work on a variety of projects at the same time. Successful freelancing takes determination and grit, discipline, a drive to do the work, and a bit of business know-how. And lastly, freelance work can be found online, through your networks or can be made for yourself with a bit of ingenuity.

Exercises

1. Find examples of three people who started as freelancers and share part of their stories with a class discussion.
2. Research possible freelance opportunities in your industry. List five types of freelance gigs you could do.
3. Research companies that hire freelancers and pick three. What do they use freelancers for? What kind of information can you find out online about freelancing for those particular companies?
4. Interview someone you know who has a side hustle. Talk to them about what they love and hate about their freelance gig and what they've learned, then write it up as a case study.
5. Create a personal list of pros and cons regarding starting your own freelance or entrepreneurial career.

References

"About." Smart News. Last modified 2018. http://about.smartnews.com/en/careers.

Alton, Larry. "Why More Millennials Are Flocking to Shared Office Spaces." *Forbes*. Last modified May 9, 2017. www.forbes.com/sites/larryalton/2017/05/09/why-more-millennials-are-flocking-to-shared-office-spaces/#4722902b69e8.

Bozza, Anthony. "A Boy's Life (in Sex, Drugs and Rock & Roll)." *RollingStone*. Last modified October 12, 2000. www.rollingstone.com/movies/features/a-boys-life-in-sex-drugs-and-rock-roll-20001012.

"Careers." Smart News. Last modified 2018. http://about.smartnews.com/en/careers.

"Chris Reed." Artrepreneur. Last modified March 3, 2018. https://atp.orangenius.com/author/chrisreed/.

Cooper, Anderson. *Dispatches from the Edge: A Memoir of War, Disasters, and Survival*. New York: Harper, 2006.

"Entrepreneur." *Merriam-Webster*. Last modified February 25, 2018. www.merriam-webster.com/dictionary/entrepreneur.

ESPN News Services. "Kobe Bryant's 'Dear Basketball' Wins Oscar for Animated Short." ESPN. Last modified March 3, 2018. www.espn.com/nba/story/_/id/22648342/kobe-bryant-dear-basketball-wins-oscar-best-animated-short.

Fox, Justin. "The Rise of the Not-Just-Freelancing Freelancer." *Bloomberg*. Last modified October 17, 2017. www.bloomberg.com/view/articles/2017-10-17/the-rise-of-the-not-just-freelancing-freelancer.

"Freelance." *Merriam-Webster*. Last modified March 1, 2018. www.merriam-webster.com/dictionary/freelance.

"Freelancing in America: A National Survey for the New Workforce." Freelancers Union and Elance-oDesk. 2017. https://fu-web-storage-prod.s3.amazonaws.com/content/filer_public/c2/06/c2065a8a-7f00-46db-915a-2122965df7d9/fu_freelancinginamericareport_v3-rgb.pdf.

Friend, Tad. "Donald Glover Can't Save You." *The New Yorker*. March 5, 2018.

Gillett, Rachel. "18 Hobbies You Can Turn into a High-Paying Side Gig." *Business Insider*. Last modified July 26, 2017. www.businessinsider.com/hobbies-high-paying-side-job-2017-7.

Intuit. "A Tax Guide for Solopreneurs: Self-Employed Tax Tips." Last modified 2017. https://turbotax.intuit.com/tax-tips/self-employment-taxes/a-tax-guide-for-solopreneurs-self-employed-tax-tips-/L6N77a4mr.

Lockert, Melanie. "7 Apps You Can Use to Start a Side Hustle." *The Balance*. Last modified February 23, 2018. www.thebalance.com/apps-to-start-side-hustle-4134658.

McCready, Ryan. "How Much Do Freelance Writers Actually Make?" Venngage. Last modified June 10, 2016. https://venngage.com/blog/how-much-do-writers-make.

"Oprah Winfrey." IMDB.com. Last modified March 2, 2018. www.imdb.com/name/nm0001856/bio.

Tobak, Steve. "The True Meaning of Entrepreneur." *Entrepreneur*. Last modified April 3, 2015.

Wang, Amy X. "The Number of Americans Working for Themselves Could Triple by 2020." *Quartz*. Last modified February 21, 2018. https://work.qz.com/1211533/the-number-of-americans-working-for-themselves-could-triple-by-2020.

"Yen Dream Art." Beach Heights Dentistry. Last modified March 2, 2018. www.beachheightsdentistry.com/yen-dream-art.

2 Making Contact and Getting Work

This chapter delves into the details of places to make connections, how to pitch potential contract employers, how to write a solid pitch or query and cover letter and how to follow up after those initial contacts. Examples of initial contact and follow-up e-mails and letters will be included—both good and bad (but too common) with the bad examples dissected so readers understand what not to do. The chapter also explores how to handle rejection and how to learn from each potential client/employer/customer.

As said at the end of the last chapter, connections to potential work are everywhere, from websites, apps, and social media to random in-person encounters, to official networking parties and organizations. For example, during the last three decades, I have gotten writing, editing, consulting, and marketing work from people I've met at conferences, on planes, and at parties; from strangers who have posted for freelancers on Upwork, LinkedIn, Writing for Education, and many other places; from private industry-related Facebook groups to which I belong; and from word-of-mouth through friends, colleagues, and clients. The key is to always be open to opportunities and to connections and to present yourself professionally. Now let's discuss where connections can be made and how in more detail.

Where to Make Connections

Sometimes figuring out who to talk to, how to approach them, and what we specifically want out of the encounter is confusing or unclear.

In *Alice's Adventures in Wonderland* (Carroll, 1865/2003), Alice asks the Cheshire Cat which way she ought to go. The cat tells her that the direction depends where she wants to go. When Alice responds that she doesn't care where, the cat then says it doesn't matter which way she goes.

That's how we act sometimes. We may think, I'd really like to work on movies, but then become stymied about how to make that happen. Or we may think, I'd love to get my music out into the world, and we might put it up online somewhere, but we might not know how to get it into the hands and ears of record labels, music producers, managers, and/or publishers.

In order to make beneficial and career-moving-forward connections, we have to be clearer than Alice. We first have to know who we are and what we have to offer, and then we need to care where we go and pay attention to and follow the path that will take us there.

For music people, this will mean going to open mic nights, writer's nights, and any industry event you can. For writers and editors, this will mean going to conferences and workshops (especially ones containing a variety of levels of editors and publishers), joining organizations like the American Society of Journalists and Authors, and doing a lot of pitching (more on this later). For artists, this means going to shows and galleries to meet others in your community and networking, while creating a distinctive brand for yourself by knowing who you are and being yourself. (See Paul Klein's (2013) "How to Succeed As an Artist" lecture at www.you tube.com/watch?v=UcTYhaA72iY for more on this.) If you're a designer that means going to industry events, joining professional organizations and social media groups. And if you're an entrepreneur, that means joining professional organizations, possibly geared to your gender or your location. For example, when I moved from San Francisco to Seattle, I knew I needed to start networking with other business owners. So I joined Women's Business Owners and Illuminating Women, two organizations that brought women business owners in any industry together for networking. These two groups also planned events, such as happy hour mixers and lunches with speakers from other business groups around the city. Both groups were instrumental in helping me find clients and speakers for events I was sponsoring, and for introducing me to people who later became my friends.

Making connections is important because, as Abdullahi Muhammed (2016) writes in *Forbes*, "To have the best shot at having a stable

income, you want to constantly be marketing your services and signing on new clients."

In Case Study 2.1, director and writer Madeline Sayet explains how she has created work to keep her circle of colleagues together and how almost every job she gets is through networking and word of mouth referrals.

Case Study 2.1 Madeline Sayet

I was obsessed with storytelling and training to be a dancer and actor when I was a child. Opportunities and schooling exist for children to learn to act, but forays and education about other parts of the profession, such as directing or producing, don't really exist so I didn't know what was possible. I got my first paid gigs as an actor in my teen years. I had a job as a professional puppeteer, did some regional theater, and was a part of health videos.

When I was in seventh grade, I developed a plan to go to Tisch School of the Arts at New York University, because I already knew I wanted to create art and tell stories. But when I finally got to Tisch, I found negativity in the rehearsal room, learned the value put on attractiveness, and met people who were there to become famous, and this made me confused about what it meant to be me. I am Mohegan and my mother is our nation's medicine woman, so I always believed in story medicine—that stories have tangible effects in our world. I'm interested in exploring ancient stories and ideas through perspectives that have been left out. I believe the stories we pass down shape our future.

I graduated from Tisch a year early and then pursued a Master of Arts at Gallatin School of Individualized Study at NYU. While there, I co-founded Mad and Merry Theatre Company and started directing as a way for me to keep my group of friends together. We did a Mohegan version of *The Tempest* and that show got asked to travel and then led to other shows so that we ended up producing two or three shows per year. Starting a theatre company gave us the experience and the mistakes we needed to make us grow. We had to learn things about insurance we needed to have venue booking and all

of the other things that go into producing theatre. This experience renewed my love for the rehearsal room, but also made me realize I didn't need to be on stage.

Each directing job I've done has led to other jobs. Early on, I would collaborate in unpaid work and that usually led to paid work with the same people. My career has been built through relationships. People e-mail me to work with me, and because my yesses lead to new projects, sometimes I have a hard time saying no (though I have to when I get multiple requests for the same time frame). I feel like a lot of luck has been involved in my career.

At the age of 24, I was asked to direct an opera, an indigenous version of *The Magic Flute*. I explained to them (repeatedly) that I didn't read music and they kept saying that it would be okay. I wasn't sure. There's a big difference going into a project full of hope and going into a project with fear of failure. That fear overshadows everything and makes it very stressful. I had so much to learn every day, a crash course from day one. You know how in order to build muscle you tear it down? And you need rest periods in between. Well, I spent the entire time tearing down muscles daily. It was painful and the whole time I was feeling like I was failing, even though I had great collaborators and the show turned out great and we got great reviews in *The New York Times*. But by the end of it, I swore I'd never direct an opera again.

But of course, when the offer came again, within the same year, I found myself saying yes, and that yes led me to one of the two gigs I consider my biggest successes to date. The second opera I directed was *The Coronation of Poppea* for the Lyric Theatre at University of Illinois, Champaign-Urbana. That show reminded me how limitless the potential of collaboration could be and how a show could be built without any negative inputs. It re-opened the optimism I felt as to what theatre was capable of, of how stories could be told.

The second show I directed that also tapped into that optimism was *As You Like It* for Delaware Shakespeare. We did it in the Ten Thousand Things model of theatre-in-the-round, traveling from

place to place. We brought theatre to as many kinds of venues as possible, where theatre didn't usually go and the audience members were incredibly generous collaborators in every venue. This show reminded me that the best work comes out of connection with other human beings. Both shows were places I wished I could hang out in forever.

Freelancing can be challenging since you are learning to work with new people on every project and you have to learn the rules of the organizations with which you work. But friends are the greatest allies in creative professions, even though someone once said in acting school, "Look to your right and to your left. These people are your biggest competitors." My best friend from acting school is now a casting director, and I'm a director. We all like working with our friends, as they understand who we are and how we work, and they get our shorthand, which can make projects go smoother and faster.

Creative industries are undergoing change, especially the theatre and film worlds. It's important to remember that you don't have to be good at collaborating with everyone. Some people won't like you and you won't like them, and that's okay. People have different values. You don't have to be friends with everyone you collaborate with, either. Effective working arrangements and successful products can be created with people you don't like. But never change to fit into other people's bubbles. I have found that by staying true to my values, and telling my stories, and saying yes to each opportunity, that is what keeps me working and leads me to my next project.

Madeline Sayet
Director, writer, actor
MIT Media Lab Director's Fellow
2018 Forbes 30 Under 30 in Hollywood and Entertainment
www.madelinesayet.com
Twitter: @MadelineSayet
Facebook: www.facebook.com/madeline.sayet
Instagram: @madsay
LinkedIn: www.linkedin.com/in/madeline-sayet-3782b835

Since odds are you will need to expand your network beyond your friends and those with whom you went to school, we will now talk about how to present yourself to people you don't know.

How to Pitch Potential Contract Employers

Contacting people with whom you want to work is called pitching (or sometimes in writing it is called querying). Pitching potential employers or people with whom you want to work can be done a number of ways. The most common is to phone or e-mail the person. As Cliff Goldmacher (2010) writes on the Broadcast Music Inc. (BMI) website, "Make this first contact short and to the point."

General guidelines for any type of pitching in any industry are to always remain professional and courteous and to always double-check what you're writing to make sure it is typo and error free. Or as Goldmacher (2010) says to remember, "No one in the industry owes you anything." Also, patience is definitely a virtue when pitching and waiting for responses as it can take some time for people to read what you sent, and to consult their colleagues if they need to before they issue a response. Other important general guidelines for pitching are to sound confident, but not arrogant. (Meaning if you're a songwriter, you never write things like "This song will be a big hit or go platinum" or "It's better than the crap on Sirius XM today." Arrogant comments scream that you're an amateur and probably one with an attitude who doesn't understand the industry.) Pitching is all about establishing and starting relationships.

Pitches generally can be broken down into four categories: the cold pitch, the casual pitch, the relational pitch, and the hot pitch.

The Cold Pitch

A cold pitch is the most common type of pitching and it is when you try to get a company or a publisher or editor to hire you when they don't know you and have never worked with you before. You have no prior relationship with the company or its employees and you really have no idea if they even need whatever services you offer, meaning if it's a publishing

company, there's no information on their website that they are soliciting work from writers nor they do provide specific contact information on who to e-mail if you were interested in doing so.

Writer Megan Krause (2017) likens cold pitching to the methodology behind account-based marketing, where sales reps tend to identify what companies they want with a particular market and then they develop "a tailored, personalized campaign to try to land those accounts."

Jake Sirianni cold-pitched Jimmy Fallon for an internship in a creative, tailored, personalized campaign (Washington State University, 2017). Sirianni, a Washington State University student, created a parody of "Alphabet Aerobics" (originally done on October 28, 2014 on "The Tonight Show" by Daniel Radcliffe) as a part of his application. The video went viral and landed Sirianni his coveted internship. You can watch Sirianni's 2017 pitch on YouTube at www.youtube.com/watch?v=LLpYv70jF_s.

Food Stylist Gabriel Cabrera also believes that a cold pitch works best when you show people your abilities. He told Kevin Vaughn at *Artrepreneur* (2018):

> Even if you are very well known and have a strong established brand as a food stylist or photographer, it is difficult for companies to imagine what you can do for them. It is difficult for them to visualize how your style can be integrated into their brand. Instead, I thought about the clients that I wanted to work with; I would go out and buy their products and create a series of photos with their products in different scenarios, but always thinking of something that would work for the brand as a campaign. I'd publish the photos on the blog and across all my social media and tag the company. I'd always follow up with an e-mail to let them know and tell them that they could share if they wanted. Some companies would regram the photos, and a few companies followed up asking me to develop something for them.

A few of the key ingredients to successful cold pitching includes thoroughly understanding your audience and being able to speak to their needs, establishing credibility by showcasing or linking to your best work and talking about any awards you've won or testimonials from previous

clients (including those on LinkedIn), and grabbing their attention (with a compelling subject line, if you're connecting via e-mail or through social media if you're connecting that way).

The Casual Pitch

The casual pitch, like cold pitching, happens when you don't know the people at the company and they don't know you, but the company is open to submissions and to working with contractors. If it's a publishing company, this may mean writers' guidelines are on their website, along with contact information regarding where to send your pitch. Or maybe you went to a conference or a trade show and picked up a flyer from a company stating they were looking for collaborators, cross-promoters, or influencers. I just edited this type of document for a client of mine and the flyer contained very specific information about the companies and people they wanted to collaborate with, what the collaboration would look like, and how they wanted to be contacted.

If you run across a company you'd love to work with and it looks like they are open to hearing from you, be sure to follow exactly their submission guidelines or preferred ways of being contacted. And you may want to mention the guidelines, flyer, LinkedIn post, or whatever you saw as a point of reference so they know you'd done your homework.

Relational Pitching

Relational pitching is all about who you know. While the pitch may be slightly cold, meaning you are sending the e-mail or making the call to someone you don't personally know, you may know someone at the company and that someone said you can use their name as an "in." Or if you are a writer and you want to pitch a story idea and you know or have access to the experts or the famous people about whom you're writing, you want to say that.

Relational pitching can give you an inside track into an organization or a publication, but you never want to relationally pitch unless the person you are mentioning has given you permission to use their name and/or you are certain you have access to people about whom you are pitching. Meaning ask permission FIRST.

The Hot Pitch

The hot pitch is when you are pitching to an active (timely) solicitation that often has a deadline for the pitches. For example, the company may have put out a request for proposals, the editor may have sent out a call for articles on a specific topic, or a professional organization or group to which you belong may be asking for screenplays or songs or art on a particular theme. Competition can be intense during a hot pitch, so in your pitch you need an awesome idea with a unique angle and to convince people why you are THE best person for the job.

Krause (2017) says in a hot pitch you should "(1) convey your expertise and (2) explain the angle you plan to take with one or two specific points."

Though those are the four main categories pitches can fall into, one pitch may fall into more than one category. For example, you may receive a tip from someone you know that his company is actively seeking someone or something in your line of work. Your pitch would then be a hot pitch that could use a relational angle if he's given you permission to use his name.

When Kate Peters developed a blog on using one's voice effectively, the contact she got from the tech company employee to help an executive was a solid lead, but she still had to pitch her services to the executive himself and be hired for the job. Read about Kate's transition from performer and voice teacher to coach of executives in Case Study 2.2.

Case Study 2.2 Kate Peters

I am very proud of the fact that I made my living exclusively as a musician for more than 25 years. I started when I was in high school, teaching folk guitar at the YWCA and singing at weddings. Through college, I often sang at special events, had church soloist positions for every service at the campus religious center, and began teaching in my own studio. Music was my passion and it became my career. Performing was my focus and I was often on stage, but with a Master of Music degree in applied voice, teaching voice became my bread and butter.

When I became a single mother, however, I felt the importance of expanding my income. The girls needed things and although I was good at shopping the thrift stores, making clothes for them, and even growing some of our food, I wanted more for them and for me. I remember visiting some artist friends in Laguna one night in 1994, and seeing how they lived. They were older than me, and had no children, but they lived the bohemian life with chipped cups in the bathroom holding their toothbrushes, and clothes from Salvation Army counters on their shoulders. That was fine for them, but not for my children. There would be college to attend, and braces to wear, and God knows what else, and I wanted them to have everything they needed and wanted in life. That night, I swore I would find a way to create the life I wanted for me and for them, and I began to look around to see what else I could do to increase my income.

A month or so later, one of my students, who was a tenor in a large barbershop group by night and an engineer by day, asked me if I would help him with a presentation he was going to give. I said, "sure," because I rarely say, "no," when it comes to applying my skills to something new. I'm curious and, most likely, full of myself. As it turned out, giving a presentation was a lot like giving a performance, and that was important to learn because even though I didn't do much about it right away, in the back of my mind was the knowledge that I could apply my hard-earned and expensively-trained skills in music to teaching business leaders to be more effective communicators.

I began reading books on leadership and image. It all sounded a lot like acting and stage presence to me. I began to write newsletters about these things for my students. Then I began writing a blog. At first the blog had a random focus. Blogging was just a new technology platform that I found seductive. I mean, I could write whatever I wanted to and people might read it without me having to find a publisher. Wow! How fun! I experimented with writing daily, weekly, monthly, and bi-monthly and my topics changed just as often. However, I found that I needed a focus even if no one was ever going to read my posts. Thus, in 2006, I landed on a new

platform called WordPress, and named my blog "Kate's Voice" with the tag line, "a blog about voices: using them, hearing them, and freeing them."

Blogging was fun. I thought I had something to say, but I primarily used the blog to experiment with new technology. After blogging for about three years, I became aware that I had analytics on my blog, looked at them, and discovered that I was getting lots of hits from another blog called Six-Minutes.com. When I followed the links, they took me to a page called Public Speaking Blogs: The Definitive List. Exploring further, I found my blog at number 70! That was an unexpected consequence of putting my ideas out there.

Social media is primarily a big conversation. It is based on relationships, and by being on that list, I was formally invited to the party. People on the list reached out to each other, wrote posts for each other, and tweeted about each other. As soon as I saw my name there I wanted to know more. I reached out to the others and began writing posts for them. I also gave many virtual pats on the back through Twitter or LinkedIn; the idea was to write a post in which you mentioned and linked to another blog, then to give them a "shout out" on Twitter, thereby increasing their traffic as well as your own.

A year later, in March 2010, I got an e-mail from someone on the list. The note said, "I am the communications manager for a senior vice president (SVP) at a large tech company. I can't understand him. Can you help?" My blog was speaking a language others understood and had helped me establish credibility in the business world, something that would have taken much more energy and dollars without social media. I went to meet the executive and got the job. That first job with the SVP led to a whole new consulting career where I work with many high-tech executives on their communication skills at some of the biggest tech companies in the world.

As a blogger, I am a participant in the "free" economy. I give away tips and techniques on my blog; if you want more services, I charge for them. Free is an important part of the social media world, even though today, sites like Twitter are becoming less of a

conversation and more of a marketing platform. But in many ways, "free" is as old as the hills. Free is about giving your potential customers a taste of what you have so they want more. It is also about building relationships, which is probably the most important marketing anyone can do.

Today, I find clients in several different ways. I have grown my company to include other consultants so I have to do more business development than I used to do. In one company, we are a preferred vendor in the area of communication for a group of leadership development managers. Once a year, I pitch our services to them so that they know how to refer their executives to us. It's like having my own business development team and my job with them is to keep in touch with them during a client engagement with one of their execs and to continue to remind them we are there by having quarterly check-ins. Usually that's a phone call, but sometimes it's lunch or a glass of wine after work.

Another way I find clients is by keeping track of where our former clients are and by keeping in touch with them and letting them know what we are up to. I have a "relationship map" that I update regularly with contact info on everyone we've coached. It's not really a map; it is an Excel spreadsheet that helps me find the treasure I seek. If I don't have current contact info because they have moved to a new job and haven't let me know, I reach out on a social network such as LinkedIn, or I text them. I consider texting a more personal and sometimes intrusive way of contacting people, so I only use that if they've give me permission to text them, or if every other method has failed.

Finally, the most important way that I find new clients is by adding value to the current or former clients over and over again. I add value by sending out a weekly newsletter that is short but has actionable tips for vocal health and better communication. Everyone who works with us gets the newsletter, and I add people regularly who I meet or who contact me, whether or not they work with us. I add value by being on the look out for articles, videos, and books that I feel would be interesting to our clients, often reinforcing what we

are working on. When I find something, I send it in e-mail or by snail mail with a personal note, and I encourage my other coaches to do the same thing.

I add value by being willing to give some of our services in exchange for referrals. I recently coached a former client on a talk. In exchange, she introduced me to some people. I had to do the selling, but it was a warm call, not a cold one and it paid off. Since I am a believer in more long-term engagements rather than short term, giving away a few coaching sessions isn't the same as giving away our core business. That I rarely do. Finally, I occasionally give away short coaching sessions on my blog. Once I offered 30 minutes of time to the first five people who contacted me through my blog's contact form. When I add value to existing relationships, whether current clients or not, I deepen the bond with people who believe in what we do. When I add value to former clients, it reminds them that we are still around.

Kate Peters
Singer, teacher, consultant, vocal coach, author
www.katepeters.com
Twitter: @K8peters
Facebook: www.facebook.com/katesvoice
Instagram: @K8peters31
LinkedIn: http://linkedin.com/in/k8peters

Now let's move on the mechanics of the pitch, especially if the initial contact is in a written or an electronic format.

Writing Pitches or Query Letters

Pitches or query letters are ways to gain interest from publishers and potential contract employers. The purpose of the pitch or query is to grab the reader's interest, explain your idea, explain why you are qualified for what you are proposing, and then to ask for something (usually if you can send them additional materials or schedule a phone call or meeting).

And while it is tempting to find a pitch e-mail template online and then send out a mass e-mail blast, this is not an efficient or effective use of your time in getting new business. People respond best to you when they feel like they have a relationship with you, so think of pitching or querying as a way to initiate a relationship, one where you help someone else fulfill a need that they may or may not know they have.

Before you can send that e-mail or make that first contact, you need to do some research. You need to know your audience. What business are they in? What is their mission? What do they value? What are their needs? Much of this information can be found on company websites, under the "About Us" section or an area similarly titled.

Next, figure out who you need to approach. Is the decision maker the head of marketing department, a senior manager, the department head, the hiring manager, a particular editor? Once you think you've narrowed down the person to pitch to, use Google or LinkedIn or Twitter or Email Hunter to find the person's e-mail address. And if you can't find it for some reason, try to find any e-mail address for that company so you understand the format. Is it last name_first name@company.com or first name.lastname@company.com or some variation?

Also look for that person's social media contacts. James Johnson (2018), content manager at SERPed, recommends making contact with the person three times before sending the e-mail, such as following them on Twitter, connecting with them on LinkedIn, and commenting on their blog.

Write a compelling subject line, if you are sending an e-mail, and you can do so by being direct and specific. Muhammed (2016) recommends wording like "A [benefit] for [prospect's company]" or "Ideas for [a topic they care about]." Others recommend creating a sense of urgency or curiosity along with showing relevance, either by asking a question or making an intriguing statement. For example, a couple of years ago, I pitched the editor of InsideOutMedia's iexplore.com, an online adventure travel publication, with the subject line: 7 Bucket List Trips for Billionaires. I guessed it would make the editor curious and implied I was familiar with their publication and its readers.

In the content part of your message, address recipient by name, grab the person with the first sentence (open-ended questions work well for this),

and get straight to the point. Letting the person know immediately why you are getting in touch shows that you respect them and their time.

Speak to the person's needs and provide value in the sentences or paragraph or two that follows, and then explain your benefits (meaning what you or your product can do for them). As Johnson (2018) says, this is where many people fail in their pitches as they talk too much about their features when what people really care about is how you can help and why they may need your help. And you should never explain why something is good or say that if the company or person doesn't act on your idea that they are missing out.

Second to last, provide proof that you are the right person to tackle this job or topic by mentioning credentials or experience. And lastly, thank the person for his or her time and consideration and say you look forward to their reply.

So let's take a look at what this looks like, using an example of a cold pitch I sent to *Sierra Club Magazine*. The subject line of the e-mail was: Is Bear-Watching on the Katmai Peninsula Healthy for Humans and Bears? And I attached one bear photo that I personally took to my pitch.

Credit: © Jill L. Ferguson

Hi Katie,

Twice now, with two different outfits (including Chris and Ken Day who were part of the Bears 2001 IMAX movie), I have flown on a prop plane from Homer, Alaska, to the Katmai National Park to go bear watching. I have awesome photos and loved being so close to grizzlies. The last time I went was two years ago when I took my father as his seventieth birthday present. He is an avid outdoorsman who instilled this love in me.

But going on these trips made me question if bear watching benefits or is detrimental to the grizzlies. I have talked to scientists (such as grizzly experts Lana M. Ciarniello and Chris Servheen), animal behavior specialists (such as Dr. Barrie Gilbert), and the bear adventure operators themselves. Dr. Gilbert told me that bear viewing in Katmai National Park is beneficial to moms and cubs as it helps keep male grizzlies from committing infanticide as they act differently when people are present (and I've personally watched a mom put two cubs on her back and swim towards our group of humans to get away from an aggressive male. Dr. Ciarniello recently presented her research at the International Bear Conference in Anchorage stating that bear viewing has a few positive effects but it also has negative affects on habitat, reproduction, life span, and survival of individual grizzlies.

I'm the author of seven books www.amazon.com/Jill-L.-Ferguson/e/B002BM48YE, a healthy lifestyle blogger for *Huffington Post* www.huffingtonpost.com/author/jill-667, and a travel writer for *Travel by Lightfoot* www.lightfoottravel.com/destination/australasia/new-zealand/wonderful-world-of-wearable-art/, iExplore.com www.iexplore.com/experiences/the-luxe/bucket-list-trips-for-billionaires, *Together Guide Travel* http://together.guide/elope-south-pacific/, and others. I've been writing for newspapers and magazines since I was 12, so I've written more than 1,000 published articles in over 200 media outlets.

I would love to write a balanced article for Sierra Club about bear watching in Katmai National Park (especially since this year is the National Park Service's centennial) as I think people should be informed about the consequences before they decide whether or not to bear watch.

Thank you for your time and consideration. I look forward to your reply.

Sincerely,
Jill L. Ferguson
Artist, author, entrepreneur
Founder of Women's Wellness Weekends
www.jillferguson.com

www.womenswellnessweekends.com
Twitter: @JLFerg
650.999.9999

This pitch netted me a contract to write the article for *Sierra Club Magazine* and launched a relationship with the editor and the publication. My e-mail showed I understood who Sierra Club was and what was important to them (understanding our impact on the planet and being a good steward of our environment). Plus the e-mail explained that I had relationships or access to experts, and prior experience writing and publishing. I pitched the Sierra Club editor more than a half a dozen times during one year and received four contracts for articles.

The following is a pitch I wrote many years ago for a children's picture book that did not yield positive results. It was sent via snail mail as that was the publishing house's requirement. Read through this example and then we will discuss what could have been done differently and that may have yielded different results.

Fiction book query letter format (if sending via snail mail):

Jill L. Ferguson
111 SOME DRIVE
SAN CARLOS, CA 94070
650.999.9999
jill@jillferguson.com
January 4, 2001

Marisa Miller, Assistant Editor
Morrow Junior Books
William Morrow & Co.
1350 Avenue of the Americas
New York, NY 10019

Dear Ms. Miller,

During the last decade, preschoolers and young children have finally had Arthurian tales written for their age group. Young children can now read (or listen to) picture books about King Arthur and his Knights of the Round Table. But few books have been

written about Queen Guinevere as a young girl, especially in books for preschoolers and other young beginning readers.

I have written a children's book for young readers titled *Guinevere: Queen of the Round Table* that I would like to send to you for your review. Guinevere is a strong female character in Arthurian tradition, during a time when women were oftentimes seen as property of the males in their lives. My book starts with her at age 12 and ends with her marriage to Arthur, only a few years later. *Guinevere: Queen of the Round Table* is based loosely upon prior Arthurian tales, including those of Sir Thomas Malory, Chretien de Troyes, and T.H. White.

Over 400 of my articles have appeared in print in publications such as *The Christian Science Monitor*, *Woman's Day*, *Pittsburgh Post-Gazette*, *Seattle Post-Intelligencer*, *School Violence Prevention Report*, and *Family Times*.

Thank you for your time and consideration. I look forward to your reply.

Sincerely,
Jill L. Ferguson

In this pitch, the opening paragraph, though it shows a familiarity with the subject matter and the marketplace (including potential competitors), is not very grabbing or strong. Plus, it takes four sentences before it gets to the point of the letter. Second, and maybe even more importantly, the pitch has no language that shows familiarity with Morrow Junior Books, their list of published books or their needs. Nowhere does the letter state or imply the value my story could add to the company or the benefits.

Now let's look at a non-writing example. Let's say you want to pitch a song to someone from a record label or a publishing house that you met at an open mic night or a networking event last night. You exchanged some friendly words and business cards and feel like the person would be okay with you getting in touch.

Maybe you're not comfortable calling and you want to e-mail. The best way to do so is write in the subject line: I enjoyed talking to you last night about X.

The content of the e-mail would then go something like this:

Hey Mike,

I'm glad we met last night at X. I enjoyed talking with you about the Lakers and the Chargers (though I still can't believe they are here instead of San Diego). I was

wondering if you are accepting CDs, and if I could submit one song to you for your feedback.

Please let me know what your preferred format for the song is.

Thank you for your time. I look forward to your reply.

Sincerely,
Chad Smith
562.999.9999

As Hugh Hession (2011) reports on *Making It In Music*, the industry is built on relationships, not inquiries, so frame your pitch in sincerity and ask for feedback as that's "the best way to start building relationships." And just like if you were pitching an article, a book idea, a photography exhibit, or a collaborative partnership, it is always better to pitch one very specific thing at a time.

Let's look at one more example, and dissect its pros and cons before we move on. This is an actual cold pitch e-mail (except I changed the person's name for privacy reasons) that my Women's Wellness Weekends company received on September 13, 2016 and again on September 19, 2016, both times with the subject line: Ethical SEO Help for WomensWellnessWeekends.com. The italic text at the bottom of the e-mail was red in the original and the boldface words were bold in the original.

Hello womenswellnessweekends.com Team,

Hope you are doing well.

I thought you might like to know some reasons why you are not getting enough hits/visitors and conversion for womenswellnessweekends.com.

My name is **Nate Allen** and I am the digital marketing expert of a leading software provider company. As per my analysis, your website womenswellnessweekends.com is not performing well in the Google, Yahoo, and Bing organic searches.

Also your traffic flow is poor from last couple of months due to some of the reasons. You might know about recent Google Panda 4.2, Penguin, Pigeon, and Paydate etc. update.

Google has completely dropped all authorship functionality from the search results and webmaster tools. So be careful on it and take the help of a Digital marketing company to fix it.

Some of the aspects given below:

- Due to poor and unauthorized link sites.
- Relevant keyword phrases are not visible on first page listing.
- Due to HTML validation errors and warnings present in website.
- Website content quality is not high standard.
- Website is having on-page and on-site issues.

Area of improvement:

- We will give you 1st page ranking on Google, Yahoo, and Bing.
- Improve your organic traffic and sales.
- Secure your website from Google penguin updates.
- Increase your conversion rate.
- Target your local market to increase business.

Our digital marketing offerings:

- Website development and mobile application development.
- Search engine optimization.
- Pay per click.
- Reputation management.
- Social media optimization and many more.

Note: We guarantee on the improvement in your keyword ranking, link popularity, and targeted traffic within 3–4 months itself, if we fail to achieve our targets, then 100 percent money back.

We will be optimizing your website in the major search engines like: Google, Yahoo, and Bing, which results in improvements in keyword ranking, traffic, link popularity, goal conversion, and ROI in the first month of our work.

Thanks and Regards,
Nate Allen (Web Analyst)

--

Caution: *This is our marketing strategy that we are using the Yahoo mail. If you want to receive a detailed plan of action, please feel free to reply* **Yes**. *I will get back to you with details from our official e-mail id.*

In analyzing this e-mail pitch, you probably notice a few things right off the bat. The subject line may catch someone's attention because, if the recipient knows what SEO stands for, she might think, how is SEO (search engine optimization) ethical or not ethical? But if the recipient doesn't know anything about SEO or the acronym, the subject line is meaningless.

Next, Nate Allen did not take the time to address the e-mail to the recipient, even though he sent it to "jill@womenswellnessweekends.com." Then his writing "hope you are doing well" to someone he's never met (nor even personally addressed in the opening) seems a bit flippant and insincere.

The fact that he identifies himself but does not specify what company he is with is a red flag.

The bulleted point lists could be a pro or a con depending on how detailed and relevant they are. In this case, because no specific examples were given regarding the womenswellnessweekends.com website, we can assume that it is a cut and paste list he may use in every cold pitch solicitation, as are the areas of improvement and the guarantee. Lists like these are strengthened when you can show understanding of the company to whom you are pitching, answer their needs, and then cite examples of previous work for satisfied customers.

The Caution at the end would have been much better deleted and changed to words such as "I'll call you next week to discuss . . ." and then name specifically what recipient-relevant benefit you are pitching before your salutation.

How to Follow Up

Odds are favorable toward you having to follow up after your pitch, either via e-mail or with a phone call. Pitches clutter the inboxes of executives in many industries, so your pitch could get overlooked or read and then forgotten.

A follow up e-mail or card after meeting someone can be sent within 24 hours of meeting them, and you should certainly send a follow-up thank you message if you've been hired for a project and it has been completed. In this age of everything electronic, I'm a big fan of sending a snail mail thank you, since it helps you stand out from the pack. Purple Couch

owner Rick Schank, whose case study is in Chapter 4, also mentions that this is the way he does business, except he goes one step further than I do and he designs his own cards.

If you are following up on a meeting request or have gotten no response to a proposal or job offer, one to two weeks is usually the acceptable follow-up time. A follow up can happen be via e-mail or phone call, but before you write the words or push the buttons on your phone, understand your objective for a follow-up.

Do you want to request a meeting, say thank you, need information such as a response or update, or just want to catch up with the person? Open your communication with that objective as the context. For example, if we use the previous example, if Chad wants a meeting with Mike, he would write to Mike or call him on the phone after two weeks and say:

Hey, Mike. We met two weeks ago at X and I would love to grab and drink and get your feedback on my song "Pain." Are you available on Thursday at 4 p.m.?

I look forward to seeing you.

Thank you,
Chad Smith
562.999.9999

Other follow up e-mails ask questions like, "Is there anything I can send you to make your decision easier?" Or begin with "This e-mail is a follow up to the one I sent a few weeks ago about . . ." The purpose of these follow up e-mails is to jog the person's memory.

And once you've made connections with people, following up with them once every three months or so is useful, as Armando Veve mentioned in his case study. A quarterly check-in, it lets clients and potential clients or customers or collaborators know what you're doing and helps establish contact so you can find out about their needs, too.

Writing Meaningful Cover Letters

Once you get a positive response from a potential client or customer or collaborator, you may need to send them more information, such as

your music, an article, samples of your work, a portfolio, etc. Make sure everything you send has your name and contact information on it in case pieces get separated from each other. Or in the case of music, make sure contact metadata is embedded in your recording.

Then write a meaningful cover letter to send with whatever you are including. Cover letters that are meaningful contain information about who requested the material and when (which can also be in the subject line of the e-mail if everything is being e-mailed), any necessary additional information, a listing of what has been attached, and then a positive closing remark.

For example, if Cheri Graham, graphic designer, met someone at an American Institute of Graphic Arts chapter meeting who asked to see her portfolio, she might write this, a combination of cover letter and casual pitch:

E-mail subject line: Requested Materials: Cheri Graham's Portfolio

Dear Teresa,

Your presentation on "Greatest Achievements by Women Graphic Designers" was so inspiring last night. Thank you for teaching me more about the Women Lead Initiative.

As promised, here's a link to my portfolio on Behance. I've been a designer for seven years and my niche has been creating websites and marketing campaigns for non-profits. I'd love to talk to you more about Dogville, since I noticed your LinkedIn profile says you are Board President. With a couple of small changes, I think we could make Dogville's website more engaging.

Thank you for your time. I look forward to your reply.

Sincerely,
Cheri
555.000.0000

(And in this case, I don't think it is necessary to say the last name again since it is in the subject line, and not including the last name in the signature makes it more friendly and casual.)

Where many people miss the mark with cover letters is to not make them value-added. Use the cover letter to once again show your

professionalism, your interest, and how you can help the person fulfill a need he or she has.

How to Handle Rejection

Regardless of how well your pitches are written or made, the reality is that you will still face rejection, at least occasionally. Sometimes that rejection will come in the form of no answer at all. Sometimes it will be an actual "no." Sometimes it will be a "yes" that turns into a "no" or that just doesn't end up working out. Or as Hession (2011) says, ""Expect to get snubbed."

Psychologist Amy Morin, author of *13 Things Mentally Strong People Don't Do: Take Back Your Power, Embrace Change, Face Your Fears, and Train Your Brain for Happiness and Success*, said that emotionally strong people overcome rejection by acknowledging their emotions, view rejection as evidence they are pushing their limits, treat themselves with compassion, refuse to let the rejection define them, and learn from rejection. Let's take a few moments to look at these one at a time. Emotionally strong people overcome rejection by acknowledging their emotions. Too often when something happens to us that we don't like or agree with, we try to brush it off and pretend it doesn't matter. We do this because we may buy into a societal belief that showing emotion is a sign of weakness or because we don't think it is cool to show what we may think are negative emotions in the workplace. But even if we don't feel like we're in a place physically where we can acknowledge our emotions, we can tell ourselves, yes, I feel this emotion but can't give into it right now. And then set a date with ourselves to give into the emotion later. Processing, as opposed to stuffing, emotions is the only true way to work through them, and this is part of Morin's third point about treating yourself with compassion. Along with not calling yourself names or beating yourself up over this one missed opportunity.

Morin said that emotionally strong people view rejection as evidence that they are pushing their limits. Almost everything we try for the first time we do not do well. Think about it. The first time you swung a bat or wrote in cursive or rode a bicycle, you probably didn't create something fluid and beautiful or succeed. Rejection and failure mean we are learning

and growing. And each time we try again and practice, we get better and better and receive fewer rejections or missed pitches or scraped knees.

Fourth, Morin said emotionally strong people don't let rejection define them. They treat rejection as a "this wasn't the right thing right now," understanding that the answer "no" is situational, not personal. Just because someone doesn't want to work with you right now doesn't mean the door is shut for the future or that the rejection is of you as a human being. Your idea could be rejected because it wasn't what the company or person needed, they don't have the funds to do it, they don't have the time or energy to devote to it, they don't recognize its value, or for any number of reasons . . . most of which have nothing to do with you.

And lastly, every time someone says yes or no to us about anything, we can choose to use it as a learning experience. While rejection by silence may not be helpful as a learning experience, if we get a rejection response from someone, we can politely ask the person for five minutes to explain what we could have been done differently or what would have been more effective.

In Case Study 2.3, Musician Matthew Holmes-Linder explains how he handles rejection.

Case Study 2.3 Matthew Holmes-Linder

My career being "freelance" is a means to an end. I wanted to become a guitarist and musician, and it turns out that the only classical guitarists who are considered employees and receive salaries tend to be full-time faculty/full professors at conservatories and universities. In fact, it's definitely a goal of mine to get there one day, because, while I love my work, I really hate the "freelance" aspects of it—trying to book gigs, promoting myself/my business, lack of structure, and insecurity—and I definitely crave the type of stability that "real jobs" provide. I'm willing to acknowledge a bit of "grass is always greener" mentality here, and that I might take for granted the freedom afforded me by my career, but still—I love to play, write, and teach guitar and music, and I really hate selling people things.

I've tried to create the most stability I can out of being a free-lancer. I help run Mobius Performing Arts, Inc. a 501(c)3 nonprofit surrounding my group, Mobius Trio, and that provides almost all of my performance work. In fact, we have management (Ariel Artists), so we even have help with a lot of the freelance aspects of our work that all three of us find challenging, namely selling ourselves and booking concerts.

I also largely do my teaching work at the California Conservatory of Music, which, while technically a contract position (my thoughts about all music schools being independent contractor vs. employee work are ample and somewhat disgruntled), provides a great deal of stability. I do also teach from my home studio, where technically I am in charge of things like promotion and advertising, but I don't do any of that stuff; I rely solely on word of mouth.

As a result, I rarely actively seek to "find work," which is as I like it. I really hate asking people for money or trying to sell myself or my art as a product.

I hate the word "networking." It's an extremely gross word that equates things I view positively—meeting new, interesting people, exchanging interesting ideas, beginning new collaborations—with things that I find very gross, like trying to climb some weird prestige ladder ("oh man—[hot new composer] will be at this concert. Let's go meet him so we can try to commission a new piece!") or making money. I actually think I'm very good at "networking," because I'm extroverted, a good conversationalist, and I really love meeting new creative partners. I just can't define it as "networking" to myself, or else I will rebel and just stay at home alone. In other words, I think networking has to come from a really good, pure place, otherwise it's just a type of cynical schmoozing that (a) I see right through when I observe it in others (and quickly excuse myself from talking to them), and (b) hate doing myself.

As a white male from a socially (but less so financially) privileged background, I think I've probably faced rejection of a different type than others might have, and I've probably faced less of it. I was lucky enough to start playing guitar early, and I was lucky enough to

be good at it quickly; combine that with the fact that I grew up in the suburbs of NYC, with access to (arguably) the most significant guitar community in the world, and I was able to do things like "know important people" and "study with well-connected teachers" right off the bat, with no special effort on my part.

None of this is to say I haven't worked hard doing a thing that I love or been rejected from various things throughout my career; it's just to say that I consider myself really lucky. As I'll reiterate below, music is not a true meritocracy; since taste in music and playing is subjective, who you know and how much they like you often matters more than if you can technically play better than somebody else. There are myriad examples, and I am sure you, readers, can think of plenty from your own specific creative field. I was lucky enough to know lots of people from a young age, and lucky enough that they like me and my playing.

But when I have had to deal with rejection, my best self deals with it by remembering that art is subjective, so a given person or institution rejecting me and/or my work is more of a reflection of a difference of taste than of any objective deficiency in my or my work's quality. Like, that's a true statement. But I don't always feel that way, and I think my own personal emotional state when I receive the news matters as much as anything else in how much a given rejection upsets me. For instance, I got rejected from my safety school when applying for Master's programs. At the time, my life was turned upside down: my dad had cancer, I had just traveled to another continent to visit my girlfriend at the time and been dumped, and I was living at my family home, working at Starbucks for the health insurance. So, I've never really gotten over being rejected by this stupid safety school. I mean, I was accepted to all of my reach schools, and I really didn't like the teacher at this school. But still, the fact of that rejection has stayed with me; my Impostor Syndrome (a great friend of nearly every performer) likes to trot it out occasionally as proof that this one guy was the only one who ever figured out that I'm a fraud, and everyone else has just been fooled.

But, in terms of how I deal with it, I just remind myself of the absolute truth that (a) taste in art is subjective, (b) as a person who has judged competitions, I know that rankings and rejections are impersonal, and (c) that little Impostor Syndrome voice is going to grab onto every imperfection and do the same thing with it, so the things it grabs must not really be significant in themselves.

My advice to others who want to work in freelance or entrepreneurial careers is:

1. If you are in a creative field: work with friends. Make friends with the people you work with. Creative work is really personal, and the positive energy that comes from real friendship will carry you through the hard work required to actually make anything. Plus, hanging out is fun, and what if work was more like hanging out?

2. Reflect at length about your attitudes on failure and rejection (see above). If you can't take failure, it's going to be rough, because all creative work involves failing a lot. Failure is how we learn. All of the preceding statements have been turned into clichés by the smarmy, privileged rhetoric surrounding the tech business, but that doesn't make them any less true. Try to do new things all the time, so you can fail a lot. Practice associating failure with learning.

 Rejection is similar. Sometimes being rejected has literally no bearing on whether that thing has any sort of intrinsic brilliance or quality. A Good Thing is just as likely to be rejected as a Bad Thing by any given person or organizations. Humans aren't really great at seeing Good Things that are new. Rejections are badges of honor that you are doing something new and different.

3. Figure out how you work best. When your career doesn't give you any structure, you build your own. And not everyone thrives in the same types of framework. I used to think I had to be

"organized" in the specific ways I was taught. (I grew up diagnosed with ADD and had tons of "organizational" help and tutoring.) Turns out, none of those ways actually worked well for me. I thought I was just bad, because I couldn't fit into the structures I was told to create. Turns out, those just weren't the right structures for my brain. Rather than rigidly scheduling every aspect of my life into the large empty blocks on my schedule, I need to work in a more dynamic, intuitive way. Give me a three-hour block and a checklist of things to do, and I will tear up that checklist, doing really great creative work. If anyone else tries to follow what I am doing, how I am doing it, and why I am doing things in the order I am doing, they'll be confused, but I get stuff done.

This isn't to say I think "structure" is B.S. I think it's absolutely integral, but there are times to be highly structured and times to be highly intuitive. Learn to recognize which framework helps you with which work and you'll be more likely to succeed.

<div align="right">

Matthew Holmes-Linder

Guitarist, teacher, founder of Mobius Performing Arts

www.mobiustrio.org

Facebook: www.facebook.com/mobiustrio

Instagram: @mobiusmatt

YouTube: www.youtube.com/watch?v=oFDc28Pd-TE

YouTube: www.youtube.com/user/mholmeslinde

</div>

If you're unfamiliar with the Imposter Syndrome about which Matt speaks, it is the feeling that we are pretending we are experts or great in something while our inner critic screams in our brains that we are not, that we are failures or just faking it.

In the next chapter, we'll explore a bit more about structure, specifically deadlines, professionalism, the ins and outs of contracts, and how best to communicate or negotiate with contracted employers.

Chapter Summary

Connections and opportunities for work are everywhere and anywhere, from a wealth of online job and gig websites to possibilities with every person we meet. Sometimes we are our biggest obstacles because we neglect to look for opportunities in every encounter. Pitching potential collaborators and companies involves understanding who the people or companies are, catching their attention, explaining the benefits of what you do and how it meets their needs. After pitching or meeting people, following up is an essential part of the process. Inherent in the pitching process and in establishing a freelance (or any kind of career, really) is a certain amount of rejection, from which we can choose to learn from and not take too personally.

Exercises

1. Draft a cold-call contact e-mail.
2. Write a cover letter that adds value to your submission.
3. Draft a pitch e-mail to someone you've met or connected with on professional social media such as LinkedIn.
4. Create a query letter to propose an article you'd like to write for a magazine, newspaper, or website.
5. The following is a cover letter for a magazine article submission. Discuss its strengths and weaknesses and rewrite it to make it more professional and formatted for an e-mail letter.

<div align="center">

Jim Boehme
555 W. Seventh Street
Cincinnati, OH 45226
513.555.9999
jimboehme@email.com
January 5, 2018

</div>

Emily Brewstick
Food for Me!
329 Detroit Avenue
Chicago, IL 60618

Dear Em,

Enclosed is "Alien Shaped Foods for Fun" for the May issue.

Photos should have arrived from the National Flying Saucer Association and USDA. If you don't receive them by the end of the week, please let me know and I'll call to check on them.

I'll be away on business tomorrow until 10 and most likely off e-mail, but I may be available via phone or text.

Here are the contact numbers for the sources:

Martin Miller, agronomist with the U.S. Department of Agriculture, 716.555.4322

Peter J. Person, professor of extraterrestrial studies at Iowa State University, 515.555.1224

Larry Broccolini, executive director of the National Vegetable Association, 716.555.3400

Shinya Yokimoto, a biochemist at the USDA's Agricultural Research Service 510.555.7060

Thanks again for the assignment. I look forward to working with you again soon.

Sincerely,
Jim Boehme

References

Carroll, Lewis. *Alice's Adventures in Wonderland*. New York: Little Simon, 2003. Original edition published 1865.

Goldmacher, Cliff. "The DIY Guide to Submitting Your Songs to Anyone in the Music Industry." Broadcast Music Inc. (BMI). Last modified March 15, 2010. www.bmi.com/news/entry/the_diy_guide_to_submitting_your_songs_to_any one_in_the_music_industry.

Hession, Hugh. "7 Insights to Effectively Pitch Yourself to the Music Industry." *Making It In Music*. Last modified September 6, 2011. www.makingitinmusic. net/marketing/7-insights-to-effectively-pitch-yourself-to-the-music-industry. html.

Johnson, James. "How to Pitch for New Clients (And Actually Get Responses)." SERPed. Accessed March 6, 2016. www.serped.com/pitch-new-clients/1749.

Klein, Paul. "How to Succeed as an Artist." Klein Artist Works Lecture. Last modified March 12, 2013. www.youtube.com/watch?v=UcTYhaA72iY.

Krause, Megan. "The Freelance Writer's Guide to Pitching." *Clear Voice*. Last modified June 20, 2017. www.clearvoice.om/blog/freelance-pitching.

Morin, Amy. *13 Things Mentally Strong People Don't Do: Take Back Your Power, Embrace Change, Face Your Fears and Train Your Brain for Happiness and Success*. New York: William Morrow, 2014.

Muhammed, Abdullahi. "5 Steps to Cold Pitch Prospective Clients as a Freelancer." *Forbes*. Last modified August 18, 2016. www.forbes.com/abdullahimuhammed/2016/08/18/5-steps-freelancers-can-use-to-craft-a-cold-pitch-for-a-client/#41f3a1ba2413.

Siranni, Jake. "The Tonight Show Internship Rap." YouTube. Last modified March 20, 2017. www.youtube.com/watch?v=LLpYv70jF_s.

Vaughn, Kevin. "Food Stylist Gabriel Carera on Building Your Personal Brand." *Artrepreneur*. Last modified January 18, 2018. https://atp.orangenius.com/food-stylist/.

Washington State University. "Viral Video Lands Student Tonight Show Internship." Last modified March 23, 2017. https://news.wsu.edu/2017/03/23/viral-video-lands-student-tonight-show-internship.

3

What to Expect from Your Contract Employer (and What They Should Expect from You)

This chapter covers contracts in simple, easy to understand language, including length of engagement, deadlines, who owns rights to your work, non-compete clauses, personal service contracts, sponsorship or trade for promotion, terms of payment and other commonly asked questions about contracts in a freelance career. Chapter 3 will also discuss what parts of the contract may be negotiable and how to negotiate. The chapter will also cover things like integrity, professionalism, how to best communicate with your contract employer, and how to handle disputes or renegotiate if the work you've been hired to do changes.

In choosing a freelance or entrepreneurial career, you are choosing to work on contract, meaning you will sign an agreement with the person or company hiring you to do work and you and they will be expected to uphold the terms of the contract for its specified duration. Ideally, the contract exists to protect the company's and the contractor's interests. If the contract is broken or breached (meaning its terms have not been met), consequences may ensue, including possible fines, re-payment of money already paid, lawsuits, and damage to your reputation.

Let's look at two famous examples, involving the actress Kim Basinger and actor Woody Harrelson. Back in 1993, weeks before shooting began actress Kim Basinger backed out of the film *Boxing Helena*, which the production company Main Line Pictures said she agreed to star in (Fox, 1993). Though Basinger had never signed a physical contract, Main Line Pictures claimed they had shook hands to signify agreement to a verbal contract, and during the trial, they projected a letter with 13 points in a preliminary agreement (Fox, 1993).

The Los Angeles Times reported that this was the second time in one year a star was sued for backing out of a film.

> MGM slapped Woody Harrelson and producer Sherry Lansing with a lawsuit for $5 million for breach of contract when Harrelson jumped out of *Benny and Joon* and took a part in Lansing's *Indecent Proposal* . . . The Harrelson case was settled out of court for less than $500,000.
>
> (Fox, 1993)

In the case of Harrelson, the contract had been written and signed.

In Basinger's case, the jury decided she had breached her contract even though she had not signed anything and that she should pay $8.1 million in damages. The following year, the ruling was overturned on appeal (Reeves, 1994).

Contracts 101

"The goal of any written contract is to express the parties' full understanding of their deal," according to Jeswald Salacuse, author of *The Global Negotiator: Making, Meaning, and Mending Deals Around the World in the Twenty-First Century* (2003). But the fact is, not all contractual agreements are written. Oral contracts, though sometimes harder to defend and provide evidence of their terms, have been declared valid and binding in courts of law, as seen in the first Basinger judgment.

Contracts exist to provide individuals and businesses with a legal document stating the expectations of both parties, how resources will be safeguarded (or who owns or has rights to what is created), and how conflicts or negative situations will be resolved According to the U.S. Small Business Administration, to be legally valid, a contract must generally contain two elements:

> (1) All parties must agree about an offer made by one party and accepted by the other and (2) Something of value must be exchanged for something else of value. This can include goods, cash, services, or a pledge to exchange these items.
>
> (Beesley, 2016)

But many contracts contain more sections than two. So let's explore the basic elements of business contracts.

Parties. Who are the people involved in the contract. This section spells out the names, titles and company name, if appropriate and sometimes the addresses, too.

Terms. A complete description of the product that will be provided or created and/or the services that will be provided in as much detail as possible, such as quantity and attributes of any products or services. Price is included here as well as length and scope of the project, if a service is being provided. A start date and a completion date also must be included in the terms.

Delivery. How will the goods or services be delivered? Who is in charge of providing insurance, covering the cost of shipping or transportation, and who has the liability at each stage for the delivery of goods is also covered in this section of the contract. If the contract is for services, then this section often has how will the client know/recognize/understand that each stage of the project has been complete.

Compensation. This is the money part that shows the total cost for the goods and/or services and explains any retainers or deposits that may be required and it may contain a payment schedule at milestones throughout a service or project.

Legal consequences. This is the section of the contract that explains what happens when things are not delivered or the agreement is not fulfilled. It also spells out what happens if the client or buyer fails to make payments. Sometimes in this section is also information about what happens if company or client fails to provide information needed in a timely manner causing the project to stall or timelines to be missed, and how much time the party providing the work has to correct the situation before the contract is terminated.

Amendments. This section may explain how the parties can change the agreement (usually must be in writing).

Signatures. The signature area includes room for signed names, printed names, titles, and the date. Addresses of where to send notices of change to the contract are also included in this area.

Other sections of a contract could include language on who owns the intellectual property or the rights for what is created, for how long of a time period, and what product distribution will look like and who

is responsible for securing and financing that. A section may also be included on marketing expectations for the work (for example, if you are an artist signing a contract with a gallery, you may be required to do a certain number of appearances and media interviews and to post on your own blog or social media or the gallery's). And if you work in an industry where royalties may be paid based on sales, the contract will contain percentage breakdowns on types of sales and a payment schedule for when bookkeeping will be done and you will be paid.

But before we delve too far into intellectual property and copyrights, two hot topics because of so much online infringement, let's read Case Study 3.1, Scilla Andreen's story of starting her own production company and IndieFlix after finding movie industry contracts to be unfavorable to filmmakers.

Case Study 3.1 Scilla Andreen

If I had to choose the highlights of my career, I don't think I could choose just one. That would be like asking who my favorite child is. I have so many highlights in my career and they're all equally important to me. Every time I make a movie it seems to be better and do more and have greater impact than the last one. With each project I learn so much that I feel like I know nothing. I am meeting people and expanding my circle of personal and professional friends in ways I could never have imagined. I say "yes" to things that scare me, and suddenly I'm in rooms with people I never thought I could meet. I've been nominated for an Emmy and had a film I helped produce, called *Empowerment Project*, featured in the store window of the Nordstrom flagship store in my home town of Seattle. I've given a keynote speech that I can't remember giving that got a standing ovation. I worked with Toshiro Mifune, one of the most famous international actors ever to walk the planet, and I became friends with him. I had the great privilege of being the costume designer on *The Wonder Years* for seven years and worked with some of the most talented people in Hollywood from actors to writers to directors and crew.

I learned early on to surround myself with people I thought were smarter than me. They would share their expertise and experience with me. I used to take everything everyone said to heart and try to implement it. I later learned that it's only best to take on that which truly resonates with you regardless of how smart the source.

I got into the film business in an unexpected way. I studied political science at New York University, but I fell in love with a director nine years my senior so I quit school and started making commercials as a stylist. I fell in love with the business and the money was so good; I never looked back.

In with every job I've done, I've learned. My producing partner Carlo Scandiuzzi and I got multiple distribution offers on our feature film, *Outpatient*. While those three offers had a healthy advance, the fine print in the contracts didn't look like the film would make any money. Having worked in television as a costume designer while I produced my first feature film, I had a lot of friends at the studios. I met with each of them and learned that filmmakers don't make money. It just felt wrong to me that this was how our industry worked. I was naïve, idealistic, passionate, and frustrated. So I decided to do something about it, hence IndieFlix came to be.

I mostly network because I really do enjoy meeting interesting people. I learn from their stories, and sometimes I meet people who lead me to other people that turn into great partnerships. As much as people think I'm an extrovert, I'm actually quite shy and uncomfortable in crowds. I've learned from making my last movie, *Angst*, that I have social anxiety. So it's really important for me to put myself out there and meet people. I find it helpful to join credible organizations such as Women in Film, The Northwest Film Forum, TheFilmSchool, and Film Festivals. I attend film and interactive/technology panels. I learn as much as I can. I hand my card to everyone, but more importantly I get their cards. I e-mail people the same night I meet them just so that they have my e-mail address in their address book. I do things that scare me because I know that's healthy. It's called exposure therapy (ha ha). For example, I joined the Women's CEO poker group, which was extremely intimidating,

but I learned to play poker and I met some incredible women. But I also went a little overboard and started saying "yes" to a lot of women's networking groups and I started to drown in them. So I pulled back and only participate in groups and organizations where I really connect with the people and the mission.

My advice to others who want to have entrepreneurial careers is to surround yourself with smart people you trust and who have your back, and to never give up your power. When I was fundraising for IndieFlix, before I would walk into a room and pitch, I would give up my power. For some reason I thought since the venture capitalists and investors had money they knew more than I did. They didn't.

When you're looking at a contract or a business relationship, it's important to ask a lot of questions and ask them over and over until you understand the answer. If you don't understand the answer, then don't do that deal.

I'm grateful because I finally found my sweet spot with IndieFlix. I like making social impact films. I believe film is the most powerful medium on the planet, and I want to make the world a better place by using film to open up conversations about everything from bullying, to empowerment, to growing up in the digital age, to anxiety, mental health, money, and social media, or the impact of technology on the brain. My company's non-profit arm, the IndieFlix Foundation, supports the stories and the corporation helps to distribute them. As for me, my personal goal is to direct, produce, and write stories that unite us.

Scilla Andreen
CEO and co-founder of IndieFlix Group, Inc.
Founder, IndieFlix Foundation
Producer, director, costume designer
www.indieflix.com
www.indieflixfoundation.com
Twitter: @IndieFlixCEO
Facebook: www.facebook.com/indieflix
Instagram: @indieflixceo
LinkedIn: www.linkedin.com/in/scillaandreen

Scilla Andreen directs, produces, and writes stories that unite us, and in essence, that is what a contract does too: unites us with the companies that hire us or license designs from us. Attorney Jeff Gluck (2016) writes:

> Perhaps the cornerstone of any collaborative agreement, especially when art or graphic design is involved, is the retention of the underlying intellectual property. Meaning, who owns the design? Who owns the rights to use the images? Who owns the underlying copyrights? If the endeavor is considered a traditional work-for-hire, when a brand "commissions" an artist or designer to create product, the brand would likely intend to own the rights in and to the end result. However, the collaborating artist (or designer) may not always be clear on this, and should carefully read the contract language to look for any provision announcing intellectual property ownership rights and the triggering keywords "work-for-hire."

Intellectual property refers to things the mind creates, such as inventions, literary and artistic works, and the symbols, names, and images used in business. The three ways to protect intellectual property from theft are copyrights, patents, and trademarks.

Copyrights, Watermarks, and Other Essential Things

According to the U.S. Copyright Office, a copyright is a

> form of intellectual property law, protects original works of authorship including literary, dramatic, musical, and artistic works, such as poetry, novels, movies, songs, computer software, and architecture. Copyright does not protect facts, ideas, systems, or methods of operation, although it may protect the way these things are expressed.
>
> ("Copyright in General," 2018)

Copyrights differ from patents and trademarks in that copyrights "protect original works of authorship" while patents protect inventions and

discoveries and trademarks protect words, phrases, symbols, and designs that identify "the source of goods or services of one party and distinguishing them from those of others" ("Copyright in General," 2018).

Creating copyrights for works—by filing with the U.S. Copyright Office or having a lawyer do so for you—helps protect it from being used and disseminated by others (though you are tasked with policing copyright infringers yourself). Traditionally works that have been copyrighted have the copyright symbol © with the date and the copyright holder's name somewhere on the work. Or, for photos, illustrations, and digital images the copyright may look like a watermark.

A watermark is a design or word or figure pressed into the paper or super-imposed in a "behind-the-scenes way." In Microsoft Word, the watermark button can be found under the "layout" tab, allowing the user to insert a picture or words, like *Confidential*, *Draft*, or *Do Not Copy* in gray scale or color, diagonal on the page.

The purpose of using a watermark is to cut down on image theft and copyright infringement. But creative professionals have mixed feelings about how effective watermarks are in preventing theft and how they affect the aesthetics and experience of someone looking at online images. For example, the Surface Design Association says that a watermark that includes your name and date is the only way to drive traffic to your blogs and websites, and if you don't include those things, "your talent becomes anonymous. You're giving your artwork away!" (*Surface Design News*, 2014).

And *Surface Design News* (2014) calls it "imperative to watermark your images BEFORE sharing them with the global Internet audience—or submitting them to museums, galleries, and competitions that publish, print or otherwise disseminate them." But illustrator Thomas James (2018) writes on *ArtBistro* that copyright notice laid over artwork, "degrades the experience an art director or other potential client has when viewing your work."

While copyrights are necessary if you do not want what you've created to be part of the creative commons (meaning open to and usable by everyone), the size, style, and placement of watermarks and other copyright symbols is up to the creator's discretion. In regards to contracts, when you create a product for a client, the agreement you both sign needs to clearly spell out who will own the intellectual property. And because this can be contentious or easily misunderstood in all of the legalese, attorneys like

Jeff Gluck and Emily A. Danchuk, have devoted their practices to helping creative individuals protect their designs and their businesses and make smart collaborative choices. Danchuk's advice is in Case Study 3.2.

Case Study 3.2 Emily A. Dunchuk

After law school, I needed to find a job in New York City so I applied for a job at a boutique intellectual property law firm, not really knowing much about that area of the law. Very quickly I saw a need for small business owners and creative people to better understand contracts. People were signing things that seemed one-sided or without understanding the terms and the language.

I have seen some freelance and creative people being presented with or signing some horrible contracts or agreements, such as an agreement that stated boilerplate "licensing agreement" language, but it later stated that the "licensee" actually owned the work outright and could use the work as long as they wanted. Other contracts are very "take it or leave it." The "take it or leave it" contracts that many retailers give designers from whom they are licensing designs are most offensive, but these contracts are the most practical for the retailer. The purpose of having an attorney look over the contract isn't necessarily to change things, since the terms of these agreements from, say, Target or Anthropologie (two companies I've seen plenty of contracts from) can't be changed, but rather to note any red flags so the designer can make an informed signing decision.

Because I've advised so many creative people on their contracts, I started Copyright Collaborative, LLC, an organization that advises artisans on all things intellectual property.

Specifically, when presented with a contract, freelancers should watch out for:

- terms or language they don't understand;
- payment terms and conditions (and what conditions have to be met before the employer owns the work);
- terms that seem very one-sided (they usually are);

- insurance requirements;
- liability requirements (especially for infringement and product defects).

I think that the most important thing to remember is just don't get in over your head. If you don't understand either the agreement you're signing, or the situation that you're diving into, take a pause and try to get some advice on what both will entail. A contract isn't something to treat casually; you can bet that the employer/contractor is going to enforce terms against you. They're looking out for their best interest, and while you may have a friendly relationship with them, they're in business to make money, not friends.

In any business, especially in a small business where you may be your own employee, you have to wear many hats. One of the most important (and uncomfortable) hats you can wear is business management and administration, which may not be your strong skill set, so some areas may need to be outsourced. I am a strong believer in the idea that you have to spend money to make money. If you're not willing to do that, you may want to reconsider the faith you have in your business. As a small business owner, I don't recommend spending money on "luxury" items, but you have to suss out what's important (QuickBooks, a good bookkeeper, a good website developer, good legal advice, etc.) and understand that you get what you pay for. You should think of it as an investment in yourself.

Shop around for good services, including lawyers. Just because a law firm is big and well known does not mean that they are the lawyers for you. Usually, you'll find a much better fit with a smaller firm or solo practitioner who has the client's best interest at heart. Small business owners should, in my opinion, stick with small business owners.

And lastly, follow these two best practices: First, make sure the company acknowledges via e-mail that sending designs to them is "to explore a commercial agreement" so they can't infringe on your designs. And second, file copyrights for your designs to fully protect them.

Emily A. Danchuk, Esq.
Attorney and founder of Copyright Collaborative
www.emilyesquire.com
www.copyrightcollaborative.com
Facebook: www.facebook.com/CopyrightCollaborative

So let's take a look at a few sample contracts, the first of which is a contract I received from a publishing company when they hired me to write an 800-word article in early 2017. (The company's name and identifying features have been changed to protect their privacy.)

XXX COMPANY, INC.
CREATIVE SERVICES AGREEMENT

This Creative Services Agreement ("Agreement") is made and entered into as of 1st day of January, 2017 (the "**Effective Date**") by and between XXX **COMPANY, INC.** ("**XXX**"), whose address is XXX Some Street, Suite 888, Toronto, ON, XXX XXX, and **[NAME]**, an individual acting as an independent contractor, whose address is _____ _____ ("**Contractor**").

XXX and Contractor agree as follows:

1. **Work**.

 1.1 Contractor shall provide the services and produce the deliverables (collectively, the "**Work**") as detailed in Attachment 1 hereto. A description of any additional Work (if any) and terms associated therewith shall be evidenced by an additional Attachment (consecutively numbered, i.e., Attachment 1, 2, 3, etc.) and shall be subject to the terms set forth herein. Contractor is not obligated to perform any Work hereunder and XXX has not contracted for any Work unless and until an Attachment that references this Agreement is executed by both parties.

 1.2 In the event that XXX desires to make changes to the Work specifications and/or delivery schedule during the term of this Agreement, XXX

shall so notify Contractor, and both parties shall agree in writing (acting reasonably) on necessary adjustments, if any, to the other terms of this Agreement required to accommodate such changes.

2. **Assignment of the Work**. Contractor hereby acknowledges that XXX will be the sole owner of the Work and hereby assigns to XXX, all right, title and interest in and to the Work, including all copyrights, patents, trade secrets, and all other proprietary or intellectual property rights therein. Contractor shall execute and deliver such instruments and take such other action as may be required and requested by XXX to carry out the assignment made pursuant to this section. Contractor waives on a perpetual, irrevocable, and worldwide basis all moral rights in the Work and agrees to obtain such a waiver in writing from all persons involved in the development or creation of the Work.

3. **Payment**.

 3.1　As complete and final payment for the Work and all rights granted herein, XXX shall pay Contractor as indicated in the applicable Attachment.

 3.2　All payments due hereunder are conditional on XXX's written acceptance of the Work and XXX's receipt of a written invoice for all amounts due under this Agreement, the payment terms of which shall be not less than net thirty (30) days. Contractor shall bear sole responsibility for all expenses incurred in connection with the production of the Work, unless otherwise agreed in writing by XXX.

4. **Warranties**. Contractor agrees and warrants that:

 4.1　Contractor's performance of the Work pursuant to this Agreement will not violate any agreement or obligation between Contractor and a third party, or applicable law;

 4.2　The Work will either be originally created by Contractor or Contractor will obtain all necessary rights to the Work so that the Work may be assigned in its entirety to XXX under Section 2 above;

 4.3　The Work will not infringe any copyright, patent, trade secret, trademark or other legal right held by any third party;

 4.4　The Work is factually accurate as submitted, that the Work does not contain any information, instruction or formula that might be injurious to anyone's physical well-being, and that the Work does not, and its use by XXX as permitted in this Agreement will not, defame or infringe or violate any

rights (including but not limited to privacy rights and publicity rights) of any person, product, service, company or other third party; and

4.5 All services provided by Contractor in connection with the Work will be performed in a professional manner and shall be of a high grade, nature, and quality, and performed on a timely basis (including that the deliverables in an applicable Attachment will be duly completed, and delivered to XXX, by the delivery dates specified in the Attachment).

Contractor is specifically advised that XXX promotes a diverse work environment. Contractor understands that XXX will not tolerate remarks, gestures, or behaviors by Contractor that are discriminatory toward or offensive to individuals on the basis of gender, race, colour, national origin, sexual orientation, age, religion, or disability.

5. **Indemnity**. Contractor shall indemnify, defend, and hold XXX and its officers, customers, contractors, agents, representatives, directors, and employees harmless from any and all actions, causes of action, claims, demands, costs, liabilities, expenses, and damages (including legal fees) arising out of, or in connection with (i) any allegation or claim that the Work infringes any copyright, patent, trade secret, trade-mark, or other legal right of any third party, or (ii) any other allegation or claim that, if true, would constitute a breach of Contractor's warranties set forth in Section 4 above.

6. **Confidentiality**. Contractor agrees that at all times during the term of this Agreement, Contractor will hold in strictest confidence, and will not use or disclose to any third party, any confidential information of XXX. The term **"confidential information of XXX"** shall mean all non-public information that XXX designates as being confidential, or which, under the circumstances of disclosure ought to be treated as confidential. "Confidential information of XXX" includes, without limitation, the terms and conditions of this Agreement, the Work, information relating to released or unreleased XXX software or hardware products, marketing or promotion of any XXX product, business policies or practices of XXX, customers or suppliers of XXX, or information received from others that XXX is obligated to treat as confidential. If Contractor has any questions as to what comprises such confidential information, Contractor agrees to consult with XXX. "Confidential information of XXX" shall not include information that was known to Contractor prior to XXX's disclosure to Contractor, or information that becomes publicly available through no fault of Contractor.

7. **Termination**. This Agreement shall commence on the Effective Date and shall continue until it is terminated under this paragraph. An Attachment will terminate when all obligations under it have been duly performed by the parties. XXX may terminate this Agreement or an Attachment (or both) at any time without cause and without further obligation to Contractor effective immediately upon notice in writing to Contractor, except for payment due for services performed prior to date of such termination. Sections 2, 4, 5, 6 and 8 shall survive termination of this Agreement.

8. **General**.

 8.1 Contractor agrees that upon termination of this Agreement or upon request by XXX, Contractor will return to XXX all drawings, blueprints, notes, memoranda, specifications, designs, devices, documents, and any other material containing or disclosing any confidential information of XXX. Contractor will not retain any such materials without XXX's written approval.

 8.2 Contractor is an independent contractor for XXX. Nothing in this Agreement shall be construed as creating an employer–employee relationship, or as a limitation upon XXX's sole discretion to terminate this Agreement at any time without cause. Contractor further agrees that Contractor shall bear all expenses in connection with the completion of the Work under this Agreement, including and without limiting the generality of the foregoing, income and other taxes, Workers' Compensation, Canada Pension Plan, Employment Insurance premiums and costs, including the procurement and costs of any other benefits. Contractor further warrants that in the event that Canada Revenue Agency or any other authority determines that Contractor is an employee of XXX and therefore subject to withholding, payroll and similar taxes or amounts (e.g. federal income tax, etc.), Contractor will fully indemnify and hold harmless XXX for all such taxes and amounts, and associated interest and penalties, if any, assessed against XXX in connection with such determination. In the event taxes are required to be withheld on payments made hereunder by any Canadian (provincial or federal) or foreign government, XXX may deduct such taxes from the amount owed Contractor and pay them to the appropriate taxing authority.

 8.3 Contractor acknowledges and agrees that XXX may use Contractor's name, voice, biography, and likeness in connection with XXX's use of the Work, and in related advertising, promotional, and publicity efforts.

8.4 Contractor is free to engage in other independent contracting activities, provided that Contractor does not engage in any such activities which are inconsistent with any provisions hereof, or that so occupy Contractor's time as to interfere with the proper and efficient performance of Contractor's services hereunder.

8.5 This Agreement may be assigned by XXX but shall not be assigned by Contractor without XXX's prior written approval. Except as otherwise provided, this Agreement shall be binding upon and inure to the benefit of the parties' successors and lawful assigns.

8.6 Contractor agrees that XXX will not be responsible for loss of or damage to any personal property located on XXX premises belonging to Contractor.

8.7 This Agreement shall be construed and controlled by the laws of the Province of Ontario and the laws of Canada applicable therein, and Contractor consents to non-exclusive jurisdiction of the Ontario Courts or the Federal Court of Canada and venue in the City of Toronto.

8.8 This Agreement does not constitute an offer by XXX and it shall not be effective until signed by both parties. This Agreement constitutes the entire agreement between parties with respect to the subject matter hereof and merges all prior and contemporaneous communications. It shall not be modified except by a written agreement signed by Contractor and XXX by their duly authorized representatives. For greater clarity, any terms and conditions contained in Contractor's invoice or other sales documentation are not enforceable to the extent that they may be inconsistent with any provision of this Agreement.

8.9 Any notice by one party hereunder to another under this Agreement shall be given in writing either by delivery by commercial courier (with evidence of receipt) or by registered mail to the address of the party on page 1 above. Notice shall be irrevocably deemed to have been given and received on the date of delivery by commercial courier or five days after it is mailed by registered mail. Notice may also be given to the Contractor at the fax number or e-mail address below, and shall be deemed to have been given or received at the time of transmission. A party may change its address for notices by giving notice in accordance with this paragraph.

8.10 The parties hereby confirm their express agreement that this Agreement and all documents directly or indirectly related thereto be drawn up in English.

XXX & COMPANY, INC.

NAME _____

ADDRESS _____

Phone:

Email:

By:

Signature Signature

Name (Print)

Editorial Director Freelance Writer

_____ _____

Title Title (If Applicable)

ATTACHMENT 1

This Attachment 1 is made effective as of *January 1, 2018*, pursuant to that certain Creative Services Agreement (the "**Agreement**") dated *January 1, 2018*, by and between [**NAME**] ("**Contractor**") and **XXX & COMPANY, INC.** ("**XXX**").

Description of the Services	Written content of 800 words for XXX
Description of the Deliverable(s)	Written content to be delivered as seen fit by the discretion of the Editorial Director
Fees	Base $350CAD per article, as assigned by the Editorial Director
Term	January 1 2017–January 1, 2018
Delivery Date(s) of the Deliverable(s)	To Be Determined as seen fit by Editorial Director

All payments due hereunder are conditional on XXX's written acceptance of the Work and XXX's receipt of a written invoice for all amounts due under this Agreement, the payment terms of which shall be not less than net thirty (30) days after receipt of invoice. Contractor shall bear sole responsibility for all expenses incurred in connection with the production of the Work, unless otherwise agreed in writing by XXX.

This Attachment 1 shall be incorporated into the Agreement, and is subject to all the terms and conditions of the Agreement.

XXX & COMPANY, INC.

By:

_____ _____

Editorial Director Signature

 Name: [insert name]

As you can see the contract spells out that they own the rights to my article once I submit it to them (2. Assignment of the Work), that they would pay me 30 days after the article had been accepted (3.2 Payment), and that any expenses I incurred while researching or writing the article would be my responsibility (3.2 Payment). The Termination section explains that the contract ends when its terms have been fulfilled under the attachment's deadlines. And the contract also explicitly states that because I'm a contractor and not an employee of the company, I am free to work for other companies in a similar capacity simultaneously while fulfilling my obligations to this contract and company.

Now let's look at a work for hire agreement that would be common for an artist or designer to sign, if they were creating a pattern or a design for dishware, shoes or t-shirts or any merchandise that a retail chain might then mass produce and sell.

WORK FOR HIRE AGREEMENT

This Agreement, dated _____, 2017, is by and between ABC Company, a limited liability company organized and existing under the laws of the Commonwealth of Massachusetts with a mailing address of xxx Street, New York, NY 10000 ("ABC"), and _____, a(n) [individual, corporation, limited liability company, etc.] with a mailing address of _____ _____ ("Contractor") (each individually a "Party" and collectively "the Parties").

RECITALS

WHEREAS, ABC is involved in the brand conception, design innovation and product development industry and is presently in the process of providing a client with relevant services (herein "Project");

WHEREAS, Contractor is involved and skilled in the artwork and graphic design industry;

WHEREAS, ABC has contracted Contractor to assist in the development of certain designs and artwork for the Project;

WHEREFORE, the Parties, intending to be legally bound, and in consideration of the promises made herein, agree as follows:

I. Collaboration

ABC and Contractor shall collaborate on the materials to be used for the Project as set forth in **Schedule A**, and Contractor shall take direction from ABC in conceiving, preparing and developing such materials to be incorporated into the Project ("Materials"). Contractor shall provide ABC with such Materials for ABC's consideration. The specific scope of work and rate schedule is referenced and herein incorporated as **Schedule A**.

II. Intellectual Property

Contractor hereby agrees and acknowledges that any and all Materials created by Contractor on behalf of ABC shall be considered works for hire ("Works for Hire"), and any intellectual property rights thereto shall be owned by ABC.

Contractor acknowledges that ABC owns all intellectual property rights in and to the Materials. Contractor's obligation to assign intellectual property and corresponding rights shall not apply to any intellectual property which: (i) was developed entirely on the Contractor's own time and effort; (ii) used no equipment, supplies, facility, trade secrets or confidential information of ABC in its development; (iii) does not relate to the business of ABC or to ABC's actual or anticipated research and development activities; and (iv) does not result from any work performed by the Contractor for ABC. Contractor agrees that it shall not use, in any way, any of the Materials owned by ABC, or created by Contractor for ABC at any time.

III. Use of Works

Contractor acknowledges that any transfer, distribution, publication or other use of any Materials, created for or by ABC that is not consistent with Contractor's capacity as an independent contractor for ABC will be considered a violation of ABC's intellectual property rights, and a breach of this Agreement. Contractor also acknowledges that upon such violation of ABC's rights by Contractor, ABC will not have any adequate remedy at law for the damage resulting therefrom, and accordingly ABC shall be entitled to equitable relief by way of temporary and permanent injunction.

IV. Assignments and Transfers

Contractor agrees that to the extent that Materials are not considered "works for hire" under any intellectual property laws, Contractor shall assign to ABC ownership of all right, title and interest in and to the Materials, and shall execute any and all papers necessary for ABC to perfect its ownership of the intellectual property rights in and to such Materials.

V. Warranty

Contractor represents and warrants that the Materials created by Contractor will not infringe the rights of any third party, and will not have been assigned, transferred, licensed or otherwise encumbered.

Contractor agrees to indemnify ABC against any and all claims of intellectual property infringement, and to hold ABC harmless against such claims. Should ABC be subject to intellectual property infringement claims due to Contractor's infringing activities, Contractor agrees that it shall cooperate in any and all manners necessary for ABC to defend such claims.

Notwithstanding the foregoing, any images or artwork provided to Contractor by ABC for Contractor to use in creating images or artwork are not subject to this Warranty paragraph, and ABC bears the liability for any copyright infringement claims related thereto and agrees to indemnify Contractor for liability related to any such claims.

VI. Confidentiality

Contractor agrees that any information obtained in any manner by it from ABC shall be kept strictly confidential and shall not be disclosed in any manner whatsoever, either in whole or in part, without the prior written consent of ABC during the term of this Agreement and following the termination of the Agreement. Confidential information includes, but is not limited to, financial information, intellectual property, trade secrets, product design, marketing and branding plans and strategies, product design and customer lists. In the event that this Agreement is terminated, all confidential information retained by Contractor shall be kept confidential or destroyed. This confidentiality provision shall not apply to the following: (a) information which is required by judicial or administrative process to be disclosed to a Court of competent jurisdiction; (b) information which becomes available on a non-confidential basis from a person other than ABC or its employees and who is not otherwise bound by a confidentiality agreement to ABC.

VII. No Joint Venture

The relationship between ABC and Contractor created hereby is that of independent contractors and not that of partners, joint venturers, principal and agent, employer and employee or any similar relationship, ABC and Contractor hereby expressly deny the existence of which. Contractor is not an employee of ABC, and thus Contractor is responsible for paying all taxes for the received remunerations under this Agreement.

VIII. Termination

Upon the termination of the collaboration relationship existing between ABC and Contractor, Contractor shall transfer all rights, title and interest to all Materials created as a result of the relationship between Contractor upon payment by ABC of compensation, as set forth in **Schedule A**, for the creation of such Materials.

IX. Governing Law

This Agreement shall be governed by the laws of the State of New York and any dispute arising under this Agreement shall be resolved solely in the state or federal courts of New York, each Party submitting to the jurisdiction and venue of such court. If any provision of this Agreement is held illegal or unenforceable by any arbitration panel or court of competent jurisdiction, such provision shall be deemed separable from the remaining provisions of this Agreement and shall not affect or impair the validity or enforceability of the remaining provisions of this Agreement.

X. No Waiver

The failure of either Party to enforce, in any one or more instances, any of the terms or conditions of the Agreement shall not be construed as a waiver of the future performance of any such term or condition.

XI. Entire Agreement

The Parties acknowledge that they have read this Agreement, understand it, and agree to be bound by its terms and further agree that it is the complete and exclusive statement of the agreement between the Parties relating to its subject matter and that this Agreement supersedes all prior and contemporaneous oral and written understandings, representations and agreements concerning the subject matter hereof and may not be modified except in writing signed by both Parties and specifically referring to this Agreement.

XII. Successors and Assigns

All covenants, representations, warranties and agreements of the Parties contained herein shall be binding upon and inure to the benefit of the respective successors and permitted assigns.

WHEREFORE, by their signatures below, the Parties acknowledge that they have reviewed carefully each and every term contained in this Agreement, which they understand is a legally binding document, and further acknowledge that the understandings and agreements expressed hereunder are binding upon them.

AGREED:

Signature Date

By: (Print Name)

By: ABC Date

(continued)

SCHEDULE A

FINAL DELIVERABLES BY CONTRACTOR:

DUTIES OF CONTRACTOR:

COMPENSATION TO CONTRACTOR:

Author's Note: This Work for Hire Agreement has been provided by and is reprinted with the permission of Emily A. Danchuck, Esq.

In this case, you'll see that the company ends up owning all of the intellectual property (designs, artwork, written copy, etc.) when the contractor

signs in agreement. This is a typical work for hire contract and legally its terms are similar to what would happen if you created something while on the company's clock if you were a full-time employee.

Sometimes artisans are given a different kind of contract. One that states the artist will design and manufacture a given product or products and company providing the contract will then sell the products (either after purchasing them at wholesale prices or by selling them on commission).

We will talk more about contracts for selling on commission, but first, let's read about Mimi Tsang of hello shiso and her experience designing and manufacturing hair clips for a major upscale department store and how it didn't end up being the joyous business transaction she initially thought (Case Study 3.3).

Case Study 3.3 Mimi Tsang

If you're going to start your own business, you'll need to be scrappy and do it all. I went to a liberal arts college, and I loved the experience so much! But none of my classes really prepared me for what I'm doing now, though I'm grateful that I was able to study whatever I wanted. We had no requirements, plus we had an arrangement with the art school next door, so I was able to develop my interests and explore pretty freely. I'm grateful that I had the opportunities to come up with an idea and pull it together in a can-do way. It can be challenging to go through a traditional four-year college when you don't want a conventional office job or career, because it can feel like your friends are so directed.

After I had my son, I was still teaching and working in museums, but I was really itching to be creative and make my own things. I started making little quilted personalized bibs and blankets to sell, and added other designs here and there. Back then Etsy and selling direct to consumers wasn't a big thing, so I was focused on building a wholesale business, and it soon became clear that my designs weren't a scalable wholesale business.

In 2012, I made some hair clips for my daughter, and these were the designs that really started selling and hello shiso was born. It's been a business that I've been able to build slowly and to scale, which was really important. It's funny, I had always wanted to make things that were gender neutral and look what happened: now I'm eyeball deep in pink, girly things all day long.

When you're running your business day-to-day and trying to grow your business, it can be hard to see the big picture and see accomplishment. But recently, I bought a car and filled out all the financial paperwork. And when I was waiting for all the paperwork to be finished, I glanced at the paperwork, saw the number under income, and thought, Holy moly, that's all hair clip money! That's a lot of hair clips! It's funny. I see that number all the time and write it down, but it was only when I was putting it in the context of making a big purchase that it finally seemed like a big number to me. It was one of the few times when I've stopped and felt amazed at what I've been able to do.

One of my seemingly biggest successes turned out to be one of my biggest struggles. I really chased an account with a big national retailer and was so excited when I finally got the order from them. It seemed like a dream come true, but it turned out to be a truly difficult account to manage. The retailer provided me with a huge manual of rules to follow (of how to do things their way), a huge bureaucracy to manage for even simple questions, and complicated shipping procedures for which you had to buy special boxes and stickers and packaging. I cried from frustration each and every order I shipped to them, and even had my payment docked when I didn't do things exactly the way they wanted (though I was unsure what I did wrong since I couldn't get anyone to answer that question). When they stopped ordering, I was relieved. I may want to return to having a relationship with them at some point again, but the experience made me realize that things are not as simple as they seem. And what looks like "success" on the outside may not feel as much like it internally. We've mostly been working with independent stores and larger children's retailers, and the relationship has been

much more advantageous for us. As a tiny company, it can be hard to figure out what opportunities to take, and which to let go of. It's an issue I still deal with on a regular basis.

When others ask me for advice on starting a business or on self-employment, I tell them take the first step and jump in and keep in mind that building a sustainable business is a long, steady climb. It takes a while to hit your groove, build your relationships, and figure out how to do it efficiently. Nobody does this overnight, though it may seem like it. It often feels like other businesses achieve success faster and better than you, and the comparison game can really take its toll, so it's important to keep the big picture in mind and keep working away at it. As I said before, if you're going to start your own business, you'll need to be scrappy and do it all, but be ready to give some of the work away or you'll be stalled, spending your time on jobs that other people can do better than you. You do better working on the things that make you happiest.

In the future, I really want to build my team. I'm doing too much on my own, and I'd love to find great people to work with every day and free up my time for more designs. I've got so many designs in my head and not enough time to work on them. I want to do collaborations with designers and artists that I admire. And I want to add other accessories to the line — I've been wanting to make bags forever, and shoes would be amazing, too.

It took me a little while to land on this business and build it up, but I feel so lucky to earn my living doing something I love.

Mimi Tsang
CEO of hello shiso, accessories for girls
www.helloshiso.com
Facebook: www.facebook.com/helloshiso
Instagram: @helloshiso
Pinterest: www.pinterest.com/helloshiso

Similar to the Work for Hire contract, a license agreement gives exclusive rights for specifically named creations or merchandise for a certain period of time to a "licensor" (the company "buying" the rights and the "licensee"

(artist/contractor). License agreements are sometimes used in designs created for the apparel, household goods, and jewelry industries. They may also be used when one line of goods is being created from another; for example, plush toys and action figures from a children's book or from a movie, or that could be covered in a license agreement, like the one that follows:

License Agreement

This Agreement is between Xxxxxx Xxxx Jewelry (hereinafter "Licensor"), located at Street Address, New York, New York (zip), and Xxxx (hereinafter "Licensee"), located at Street Address, New York, New York (zip).

Witnesseth:

WHEREAS, Licensor is the creator and owner of certain jewelry designs;

WHEREAS, Licensee is experienced in the manufacture, marketing and distribution of certain diamond jewelry designs;

WHEREAS, Licensee desires to obtain the right to use certain of Licensor's designs solely in connection with the manufacture and distribution of various jewelry designs, and Licensor is willing to grant to Licensee a license for this purpose under the terms and conditions set forth in this Agreement.

NOW, THEREFORE, in consideration of the mutual promises, covenants, and conditions contained herein, it is agreed as follows:

I. **License**

Licensor hereby grants to Licensee, during the term of this Agreement, the exclusive use of the original jewelry designs described and/or illustrated in Exhibit "A" (such original jewelry designs hereinafter referred to as "Licensed Property") solely on or in connection with the manufacture, sale, promotion, and distribution of the products identified in Exhibit "B" (such products hereinafter referred to as "Products") in the territory identified in Exhibit "C" (such territory hereinafter referred to as "Licensed Territory"). Licensor shall not enter into any other agreements granting a license of the Licensed Property to any other diamond jewelry manufacturers during the term of this Agreement. Such Agreement grants a non-transferable, non-assignable license, without the right to grant sub-licenses. All rights other than those specifically licensed under this Agreement are reserved by Licensor.

II. **Quality**

The quality and style of the Products shall be at least as high as the best quality of similar jewelry items currently sold or distributed by Licensee in the Licensed Territory and shall adhere to industry standards.

Before production of the Products, Licensee shall submit, at its cost, for Licensor's approval, two complete sets of samples including (a) pre-production samples; (b) finished cartons, labels, containers, packing and wrapping materials; and (c) advertising and promotional copy (the foregoing collectively referred to as "Samples") of all Products intended to be manufactured and distributed. No Products shall be offered for sale or sold until the Samples have been approved in writing by Licensor. All Products shall conform to the quality of the approved Samples.

Samples submitted by Licensee shall be deemed approved if Licensee has not received written disapproval from Licensor of the Samples in question within fifteen (15) business days after receipt of the Samples by Licensor. Nothing herein, however, shall be deemed to obligate Licensor to respond to any such submission prior to the expiration of the fifteen (15) business days period provided hereunder. Licensor shall return approval Samples to Licensee at Licensee's request and at Licensee's expense. After Samples have been approved, Licensee shall not depart therefrom in any material respect without Licensor's prior written consent.

Licensor may, from time to time, request individual samples of the Products and their related materials as herein before described, being manufactured and sold by Licensee hereunder, to insure that the quality of the Products conforms to the Samples approved. Such Samples will be provided at Licensee's cost and expense. In the event that the Products do not meet the quality of the approved Samples, Licensor shall notify Licensee in writing. Licensee shall have sixty (60) days to restore Products to the quality of the approved Samples.

III. **Term**

The initial term of this Agreement shall commence upon the date of its execution and shall, unless earlier terminated in accordance with Section IV hereof, expire on May 1, 2006. The term of this Agreement may be extended for an additional time period of one (1) year upon the mutual written agreement of both Parties.

IV. **Termination**

This Agreement shall terminate upon the earliest of the following dates or occurrences:

a) The date contemplated by Section III,

b) Licensee becomes insolvent or files for bankruptcy,

c) Licensee fails to account for sales and royalties due as specified in this Agreement,

d) Licensee fails to make royalty payments within the time allowed by this Agreement,

e) Licensee fails to have the Products manufactured and for sale within twelve (12) months of the execution of this Agreement,

or

f) Licensee fails to maintain quality of Products according to the approved Samples after notification from Licensor.

Licensee shall have 90 (ninety) days after the termination date to dispose of all inventory of Products on hand or in process of manufacture, subject to Licensee's payment of royalties. Within ten (10) days after termination of this Agreement, the Licensee shall provide Licensor with a list of its inventory on hand and in process. Upon termination of Agreement, Licensee grants to Licensor the right to purchase the remaining inventory at the lowest wholesale price. In the event Licensor does not wish to purchase remaining inventory, Licensor shall request in writing a certified declaration that inventory remaining after the 90-day period shall be destroyed, or donated to an appropriate charitable organization, such organization to be approved by Licensor. Except as provided in this paragraph, upon the termination of this Agreement, Licensee shall refrain from any use of this Licensed Property.

The provisions XI, XII and XIV shall survive the expiration or termination of this Agreement.

V. **Transparencies and Creative Approval Process**

Licensor shall provide to Licensee design molds of the Licensed Property so that Licensee may create the Products. Licensee agrees that it shall bear the costs or expenses associated with the creation or modification of the Licensed Property, and any and all costs or expenses associated with the creation of the molds of the Licensed Property. Licensee further agrees that it shall bear any and all costs of production of the Products. Licensor shall submit to Licensee any invoices and expense reports of Licensor's costs associated with the creation and modification of the Licensed Property, and such costs shall be payable upon receipt by Licensee. Licensor is not required to provide Licensee with the original molds of the Licensed Property, but may, at its discretion, provide

Licensee with a copy of the original mold or a mold of an acceptable derivative of the Licensed Property.

Licensor and Licensee agree to devote their best talents, efforts, abilities and adequate resources to the creation of the designs and Products and to the performance of the other duties and services set forth hereunder, and the parties hereto agree to continually communicate and cooperate with each other during the Term of this Agreement.

VI. **Insurance**

Licensor shall be named as additional insured in a general liability of all risks insurance policy to be maintained by Licensee during the term of this Agreement, covering liability related to Products of not less $1,000,000.

VII. **Royalties**

a) Licensee shall pay Licensor, for and in consideration of the rights and license granted herein, a royalty of ten percent (10%) of all net sales of all products sold which contain the Licensed Property. Such royalty shall be based on the net sales of all Products. Royalties shall be paid quarterly, within thirty (30) days of the end of each quarter, ending on the last day of March, June, September and December. An accounting certified by the Chief Financial Officer of Licensee or other Certified Public Accountant shall accompany the payment, and shall identify the dollar sales amount of each Licensed Product sold during the quarter.

1) Royalty checks shall be made out in United States currency to Licensor. Licensee shall provide its price list to Licensor's representative upon the request of Licensor's representative. All costs of collecting past due royalty payments shall be paid by Licensee.

2) The term "Net Sales" for purposes of determining the royalty shall mean Products sold at Licensee's regular sales price, as adjusted to reflect customary trade discounts, returns, cancellations, credits/rebates and allowances. In calculating net sales, no deductions shall be made for shipping costs, commissions, taxes or for delinquent, uncollected or uncorrectable amounts for taxes, fees, etc.

b) Licensee shall pay to Licensor an advance payment in the amount of Five Thousand Dollars ($5,000.00) upon the execution of this Agreement.

VIII. **Distribution**

Licensee agrees that during the term of this Agreement it will use its best efforts to sell, promote, market and distribute the Products. Licensee agrees

that it will produce promotional and advertising material for the Products for the purpose of marketing the Products. Licensor will have right of approval of all distribution channels.

IX. **Copyright**

All copyrights in and to the designs comprising or deriving from the Products and the Licensed Properties shall be owned by Licensor. All Products sold or distributed shall be individually marked with all appropriate copyright and trademark notices, such proper notice consisting of the following notices:

Copyright Notice: "© 2005 Xxxxxx Xxxxxx. All Rights Reserved."

Trademark Notice: "Xxxxxxxxxx for Xxxx $_{TM.}$"

Licensee shall not in any manner represent that it has any interest in Licensed Property except as Licensee of the Licensed Products. Upon the termination of this Agreement, Licensee shall immediately return all molds and production materials of the Licensed Property to Licensor, and shall forfeit any rights to use the Licensed Property, and the right to manufacture, distribute, sell or otherwise dispose of the Products, except as provided in Paragraph IV. Failure of Licensee to comply with any of its obligations under the provisions of this Agreement shall result in immediate forfeiture of its rights to market the Products and to use the Licensed Property or any derivative thereof, and Licensor shall have the right forthwith to an injunction to prevent further sale of any such products and to compel Licensee's surrender of the Licensed Property and the Products to Licensor.

Licensee recognizes Licensor's ownership of the Licensed Properties and will not at any time do or suffer to be done any act or thing which will in any way impair the rights of Licensor in and to the Licensed Properties. Only Licensor has the right to proceed against infringers and Licensee shall cooperate with Licensor in any action or matter. Licensee shall promptly notify Licensor of any actual or alleged infringement by any third party of the Licensed Properties of which Licensee is or becomes aware. Licensor will have the right, but not the obligation, to institute such suit at its own expense in the name of "Licensor" or "Licensee" or "Licensor and Licensee" and to retain the proceeds of any recovery, judgment, award or settlement attained therein.

XI. **Indemnity**

a) Licensee shall defend, indemnify, and hold harmless Licensor and its officers, employees and agents against any and all claims, causes of

action and judgments, cost or expenses arising from Licensee's manu-
facture, sales, distribution, promotion or advertising of Products.

b) Licensor states, to the best of its knowledge, that:

1) Licensor has the authority to enter into this Agreement,

2) Licensor has not previously assigned or otherwise transferred the
rights entered into in this Agreement to another party, and

3) The Licensed Property does not violate any existing copyright or
trademark.

c) Licensor and Licensee shall cooperate in any suit brought, and shall
provide to each other all documents, papers and information deemed
relevant to such suit.

XII. Applicable Law

This Agreement shall be governed by laws of the State of New York. All arbitra-
tions and litigations concerning this Agreement shall be held in the State of
New York. Each party submits to personal jurisdiction and venue in New York
for such arbitrations, successors and litigations.

XIII. Successors and Assigns

This Agreement shall be binding upon Licensor and Licensee, and shall inure
to the benefit of Licensor's and Licensee's heirs, executors, administrators,
successors or assigns.

XIV. Confidentiality

Licensor and Licensee agree to keep the terms of this Agreement confidential.
Licensee agrees to utilize the following Confidentiality Agreement with its con-
tractors involved in producing the Products.

All information obtained in any manner by either party to this Agreement
deemed by either party to be confidential, proprietary or otherwise non-public
in nature (hereinafter "Confidential Information") shall be kept strictly confi-
dential and shall not be disclosed in any manner whatsoever, either in whole
or in part, without prior written consent of the other party during the term of
this Agreement and following the termination of the Agreement. Confidential
Information includes, but is not limited to, financial information, intellectual
property, marketing plans and strategies, product development and methods,
sales force and administration, customer bids, quotations and customer lists.
In the event that this Agreement is terminated, all Confidential Information
retained by either party shall be kept confidential or destroyed. This confiden-
tiality provision shall not apply to the following:

a) information which is required by judicial or administrative process to be disclosed to a Court of competent jurisdiction;

b) information which becomes available on a non-confidential basis from a person other than Licensee or its employees and who is not otherwise bound by a confidentiality agreement to either party.

XV. Single Agreement

This Agreement supersedes all agreements previously made between the Licensor and Licensee relating to the subject matter hereof. This Agreement constitutes the entire understanding between the parties. This Agreement shall not be modified except in a writing assented to, and executed by, both parties.

XVI. Notices

All notices and payments to the Licensor shall be sent to the Licensor at the following address, and all notices to the Licensee shall be sent to the Licensee at the following address:

If to Licensor: Xxxxxxx Xxxx
 Xxxxxxx Xxxx
 Street Address
 New York, New York (zip)
 Telephone: (212) xxx-xxxx
 Fax: (212) xxx-xxxx

If to Licensee: Mr. Xxxx Xxxxx
 Xxxxxxxxxxx, Executive VP
 Street Address
 New York, New York (zip)
 Telephone: (212) xxx-xxxx
 Fax: (212) xxx-xxxx

XVII. Books and Records

Licensee agrees to keep accurate books of accounts and records concerning all transactions hereunder. Licensor shall have the right, during ordinary business hours, to examine and to take excerpts from such books of accounts and records, either itself or through a firm of independent accountants. Such right to examine is extended to Licensor, at its expense, unless an error of 5% or more for any given one month period is located, in which case Licensee shall bear the costs of the inspection, and any future inspections, by a certified public accountant, to be approved by Licensor. Such accounts and records shall be

preserved and maintained by Licensee for at least three (3) years from the end of each accounting period, and Licensee agrees to permit inspection thereof by Licensor or independent accountants during said period.

XVIII. **Statements**

On each date that Licensee makes payment of royalties to Licensor, Licensee shall submit to Licensor a written statement concerning the computation of royalties then due and payable to Licensor. Such written statement shall be in reasonably specific detail, and certified as true and accurate by Licensee. Each such statement shall show the item number and description, gross invoice amount billed, any deductible discounts, allowances and returns, and the reportable sales of each type of product. Receipt or acceptance by Licensor of any statement furnished hereunder shall not preclude Licensor from questioning the correctness thereof at any time, and if any inconsistencies or mistakes are discovered in such statement of payments, they shall be immediately rectified and prompt adjustments and corresponding payments shall be made to compensate therefore.

XIX. **No Joint Venture**

Licensee, when performing hereunder, shall, with respect to Licensor, be an independent entity. Nothing herein contained shall be construed to place the parties in the relationship of employee, agent, partners or joint venturers, and neither party shall have any power to obligate or bind the other party in any manner whatsoever.

XX. **Assignment**

No party to this Agreement may assign, by operation of law or otherwise, all or any portion of its rights, obligations or liabilities under this Agreement without the prior written consent of the other parties to this Agreement. Such consent may be withheld in the absolute discretion of the party asked to grant such consent. Any attempted assignment in violation of this Section shall be voidable and shall entitle the other parties to this Agreement to terminate this Agreement at their option.

XXI. **Waiver**

Failure of either party at any time to require the performance of any provision of this Agreement shall not affect the right of such party to require full performance thereafter. A waiver by either party of a breach of any provision of this Agreement shall not operate as a waiver of any further or similar breach or as nullifying the effectiveness of such provision.

XXII. **Interpretation**

When a reference is made in this Agreement to Sections, Paragraphs, Exhibits or Schedules, such reference shall be to a Section, Paragraph, Exhibit or Schedule to this Agreement unless otherwise indicated. The words "include," "includes," and "including" when used therein shall be deemed in each case to be followed by the words "without limitation."

This Agreement constitutes the entire understanding between the parties and shall be considered executed into and effective as of the _____ day of April, 2005.

ACCEPTED AND AGREED:

LICENSEE:	**LICENSOR:**
Xxxxxxxxx	**Xxxxxxx Xxxx**
By: _____	By: _____
Title: _____	Title: _____

Exhibit A: Licensed Properties
Exhibit B: Products
Exhibit C

Worldwide

Author's Note: This license agreement has been provided by and is reprinted with the permission of Emily A. Danchuck, Esq.

This sample license agreement has all of the parts of a contract: parties, terms, delivery, compensation, legal consequences, amendments, and signatures. It clearly spells out the insurance requirements, that confidentiality is expected, and who owns the copyrights to designs and for what time frame. The agreement also explains that the designer can access the financial records regarding the sales of his or her designs at any time.

Now let's take a few moments to discuss manufacturing your own products and then them selling on consignment, since galleries and stores like

to do this since it offers them little upfront financial risk. Smoller (2017) writes that the starting point for a gallery's commission is 50 percent.

In a consignment agreement, the first part needs to spell out the parties and their relationship. An agency grant clause needs to designate the gallery or store to represent the artist or creative in contract negotiations, acting in the creative's best interest. Another clause in the contract may speak to exclusivity (or is the store or gallery the only one to represent the work at this time or not and is it within a certain geographical area).

The next part of a consignment agreement speaks to inventory management, such as the physical descriptions of each product or piece and how the work will be stored, when inventory reports will be issued, and whether or not the artist or creator has the right to inspect the inventory in person.

The next section determines how pricing is set and by whom, and if the seller of the work has the right to offer discounts and if so, out of whose commission does the discount come? This is followed by language about payment: what the split ratio is, how the accounting will be done, and how expenses (such as promotional materials) will be handled and who will pay for them.

Smoller (2017) writes that it should be explicit in the agreement who owns the art or product and who is responsible for insuring it. These last two parts are especially important in case the place that is selling the products goes bankrupt and creditors come calling (if the artist owns the work, it cannot be confiscated by payment to the creditors), and if the products get damaged, who will pay?

I Want to Negotiate

Charles Craver in *The Intelligent Negotiator: What to Say, What to Do, How to Get What You Want Every Time* (2002), says the key to negotiations is intelligence, which to him means knowing your "opponents," including what they will give in to and what they will ask for and where they will draw the line even before you start the negotiations.

Many parts of a contract, work for hire, or licensing agreement may not be negotiable. Or rather one party may have more power than the other party and may not be willing to negotiate. But certain parts of the contract or agreement may be negotiable.

Gluck (2016) writes,

> Payment structure and fees are entirely up for negotiation. There are many ways to allocate the financial aspects of collaboration. The issues to consider would be: who pays for expenses and costs? Is there a flat fee payment to the collaborating artist/designer/ brand? Is there a sales royalty? Profit share? Auditing rights?

Another thing that may be negotiable is the exclusivity clause. For example, when Routledge presented me with the contract for this book, there was a section titled "Option on Future Work," stating that I, the author, would grant the publisher "the first refusal of (including the first opportunity to read and consider for publication) the Author's next work suitable for publication." Since I write in a variety of genres and for a variety of age groups and my next book is a children's picture book, I asked Routledge if that part of the contract could be modified to only to the types they publish, mainly for the academic market.

The length of time the contract covers and an upfront payment or advance may be negotiable too. But as pixel and video game artist Becca Bair learned (Case Study 3.4), getting money upfront doesn't always mean the person or company with whom you're making the agreement with will uphold their end of the contract.

Case Study 3.4 Becca Bair

I got started working in a freelance/entrepreneurial career when I was fed up with my office job and after plugging many hours into a pet project video game I'd been working on with my brother. I had a wild idea to look into making video game pixel artwork as a career. Making art for our game, *Genesis*, was something I really enjoyed, and I came to the realization that would be my dream job. I figured there was no way to do game art as a profession unless you specialized in 3D art and got hired on at one of the AAA game studios, so when I wrote "pixel art hire" into Google's search engine, I wasn't

expecting much. To my surprise, there were actually many forums and other resources for people to hire and be hired for pixel art gigs. I worked on my portfolio and posted it on some of the forums. That's when I started getting e-mails from people interested in hiring me to make the art for their games!

I bumbled my way through my first few gigs and clients until about a year later, when I was let go from my office job and was forced to make the plunge into full-time freelancing.

My first contract was a dream contract. Mike, who hired me, was professional. He gave me tons of creative freedom, and he was prompt with payment. That contract lasted about five months. I didn't know what I was doing when it came to contracts or negotiating. I threw out an hourly rate and he accepted with no question . . . definitely a sign I didn't ask for enough, ha ha. I was keeping track of my hours on a spreadsheet, and it took forever to gather everything up for the "invoice." After this first contract, I learned to look into time-tracking software and ways to send professional invoices. I got a lot of portfolio work out of the first job, which in turn, led to me getting new, better paying jobs.

In school, I never really learned anything about entrepreneurship, especially art entrepreneurship. I didn't take the types of classes that would have taught me something about those skills, because I thought art couldn't be a career. My schooling endeavors mostly focused on apparel design and architecture. When I decided to start freelancing, I had already dropped out of college. It would have been great to have taken some marketing and business classes, as I eventually did have to get some textbooks on those topics and read up on the subjects on my own time.

But I've also learned a lot through experience of running my freelance career, For example, early on I did some art for a client, and because he had paid 50 percent up front, I assumed he was good to pay the second half upon completion of the work. I foolishly sent him the finished artwork files and he ran off with the art and never paid for the other half. I never heard from him again. These days, I don't send finished artwork without a watermark until I'm paid in full.

I've gotten better at reading people after the span of the many different contracts under which I've worked. Typically now I can tell from the first conversation with a client whether we are a good match for each other. You learn which signs and wording are red flags. You get better at protecting your creations and your financial well-being.

In order to remain professional to clients, I think some minor tailoring of tweets and e-mails is a good idea. I personally don't like to tweet about anything specific to my professional relationship with any of my clients. I don't really touch on controversial topics. I also tend to go back through my e-mails before I send them, to remove many of the "!" I had placed throughout to come off more nonthreatening, I try to "business" them up more, so to speak. I do let my interests and personality come through in most other ways, though.

After I work with a client I encourage them to follow me on Twitter, and the reason for that is I regularly announce there when I'm available for more commission work. There have been many times that my previous clients have seen those tweets and either recommended a friend to me, or they themselves have commissioned me for additional work at that time.

My advice to anyone considering a freelance career in video games or pixel art is that there's no better time to get into video games. Video games are going through something of a renaissance right now. They're being embraced as art and in turn video games are further embracing the art side of things. Video games have always been a safe bet for AAA video game development employees, but now video games are a fulfilling career from the indie basement up, with the barrier to entry going down and potential quality levels increasing. I want to encourage everyone reading this to look into one of the many free game development tools and give it a go. That's what I did as an 11-year-old girl, and I haven't looked back since!

Becca Bair
Pixel and video game artist
Co-founder and creative director of Twin Otter Studios

www.pixelgirl.net
Twitter: @TupelosHoney; @ArcadianAtlas
Facebook: www.facebook.com/twinotterstudios
Instagram: @BeccaBair
LinkedIn: www.linkedin.com/in/becca-bair

How to Handle Disputes or Changing Workloads

It's inevitable that at some point in your freelance or entrepreneurial career you will sign a contract that either isn't in your best interests or whose scope of work ends up changing. In these cases, you may need to renegotiate the contract. As Salacruse (2005) writes, "The dynamics of renegotiating an existing agreement are quite different from hammering out a deal from scratch."

When we feel like things aren't looking favorable for us, it is easy for us to feel combative and negative. But negotiation experts suggest treating the person or company with whom we have a contract "as a partner, not an adversary" (Gill, 2007). And try to create value or benefits on both sides through the renegotiation process.

For example, many creative people sign contracts to design or write something and in their minds, they have a specific amount of time they think it will take them to do the project and so they agree to a price based on that projected number of hours. But maybe ideas evolve as the project gets underway and the project goes from being one thing to a much bigger thing, with multiple revisions or adaptations or parts. The scope of work has mushroomed so the contract should be renegotiated since the project now exceeds to original agreement.

Salacuse (2003, 2005) writes that the label "renegotiation" may sound negative and make one think of drastic revisions to the written contract, so asking for a contract review or a contract clarification may seem friendlier. No matter what you call it though, negotiations for contract changes would involve a dialogue regarding the details of how the work has expanded, the value of the bigger project to the client, with concrete

details of the new expectations, plus a new time schedule (if necessary)—we call this building a business case—before negotiating for more money or the additional compensation for the extra work.

And if for some reason you find yourself in heated renegotiations or feel out of your depth, you can always considering bringing in a meditator, a neutral third party or even a lawyer. (Some contracts, from their conception, have arbitration or meditation written into them as a way of dealing with disputes or contractual changes.)

Professionalism, Integrity, and Ethics

While dealing with conflicts and renegotiations, we often become the animals we are, with our brains kicking into fight or flight mode. But the emotions emanating from fight or flight mode may cause us to look unprofessional. Learning to run our businesses and to respond to potential clients/customers and to current clients and partners from a place of respect, integrity, ethics, and emotional intelligence (even if the person or company we are dealing with isn't acting that way) will contribute to our success.

Integrity is defined as the critical connection between ethics (the philosophy or code of conduct of a group or an industry) and moral action, by the University of Texas McCombs School of Business, and integrity includes honesty, fairness, and decency (Watch the UTMSB YouTube video "Ethics Defined: Integrity." www.youtube.com/watch?v=npSMzkQgiv8.) Integrity is seen as more personal, while ethics can be broader based, but both guide our actions and reactions.

According to Laura Wilcox (2018), emotional intelligence is "the ability to . . . understand your effect on others and manage yourself accordingly." Emotional intelligence is what keeps us "playing well with us," in order to achieve success. Daniel Goleman (2011) explains how emotional intelligence, along with self-motivation, affects business success in the Business Voice video at www.youtube.com/watch?v=wJhfKYzKc0s.

When we conduct ourselves with integrity and use our emotional intelligence, we speak, text, and e-mail others how they would like to be addressed. We speak truth both to ourselves and to everyone else, and when there is negotiation or conflict, we address it in a calm, rational, and

business-like manner, like the example of Stephen Zoepf, Massachusetts Institute of Technology scientist, who responded to Uber CEO's public mocking of him on Twitter by posting his own rebuttal, which said he was grateful for the feedback, addressed the criticism, and invited Uber and others to help him in his research endeavors (Bariso, 2018).

Chapter Summary

Amid all of the legal jargon, all contracts contain information regarding the parties involved, the terms, the delivery, the compensation, legal consequences of breaking the contract, amendments to the contract, and signatures. Contracts also contain information about who owns the rights to what is created under the terms of the contract, and for how long. A copyright applies to original literary, dramatic, musical, or artistic works, while patents are legal protection for inventions and discoveries. Disputes to contracts or changes in scopes of work from what the contract says need to be renegotiated. Doing so goes more smoothly when you consider what is beneficial to both sides, approach the client as a partner and not an adversary, and present a professional business case as to why the contract needs to be modified. Handling all of your business in a professional and ethic manner and with integrity ensures repeat business and business referrals, plus encourages people to want to collaborate with you, making your business be sustainable and grow.

Exercises

1. Research examples of three people or companies who broke contracts and compare and contrast the reasons and the damages.
2. Find three contracts for freelancers online and compare/contrast them.
3. Contently has a list of nine movies about freelancers every freelancer should watch: http://contently.net/2014/11/21/play/9-movies-every-free lancer-watch. Choose two of these films and write a comparison about the similarities and differences between two of the characters' careers.
4. Take the two characters in exercise 2 and analyze what they could have done differently in their careers to achieve alternative outcomes.

5. This chapter includes the example of Stephen Zoepf as an illustration of someone who has behaved professionally with respect, integrity, and emotional intelligence. Find three examples of other business people who handled themselves and advanced their businesses with dignity and grace.

References

Bariso, Justin. "Uber's CEO Called a Scientist's Work Incompetent. His Response Is a Lesson in Emotional Intelligence." *Inc*. Last modified March 7, 2018. www.inc.com/justin-bariso/uber-ceo-insult-top-scientist-response-criticism-emotional-intelligence.html.

Beesley, Caron. "Contract Law: How to Create a Legally Binding Contract." U.S. Small Business Administration. Last modified September 23, 2016. www.sba.gov/blogs/contract-law-how-create-legally-binding-contract.

"Copyright in General." U.S. Copyright Office. Accessed March 10, 2018. www.copyright.gov/help/faq/faq-general.html.

Craver, Charles. *The Intelligent Negotiator: What to Say, What to Do, How to Get What You Want Every Time*. New York: Crown Business, 2002.

"Ethics Defined: Integrity." University of Texas McCombs School of Business. Last modified February 19, 2017. www.youtube.com/watch?v=npSMzkQgiv8.

Fox, David J. "Kim Basinger Court Case Shines Light on Deal-Making." *Los Angeles Times*. March 1, 1993. http://articles.latimes.com/1993-03-01/entertainment/ca-150_1_boxing-helena-lawsuit.

Gill, Dee. "When Good Deals Go Bad: Renegotiating a Contract." *Inc*. Last modified November 1, 2007. www.inc.com/magazine/20071101/when-good-deals-go-bad.html.

Gluck, Jeff. "Here's What You Need to Know About Collaborations in Fashion and the Legality of It." Hypebeast. Last modified July 19, 2016. https://hypebeast.com/2016/7/legality-of-fashion-collaborations.

Goleman, Daniel. "Emotional Intelligence." The Business Voice. Last modified January 25, 2011. www.youtube.com/watch?v=wJhfKYzKc0s.

James, Thomas. "Do Watermarks Prevent Online Theft?" *ArtBistro*. Accessed March 8, 2018. http://artbistro.monster.com/benefits/articles/11879-do-watermarks-prevent-online-art-theft.

Reeves, Phil. "Kim Basinger's Contract Case Overturned on Appeal." *Independent*. September 23, 1994. www.independent.co.uk/news/world/kim-basingers-contract-case-overturned-on-appeal-1450700.html.

Salacuse, Jeswald W. *The Global Negotiator: Making, Managing, and Mending Deals Around the World in the Twenty-First Century*. New York: Palgrave Macmillian, 2003.

Salacuse, Jeswald, W. "Redoing the Deal." *Negotiation* 8, no. 8 (August 2005).

Smoller, Louis. "What to Include in an Art Consignment Agreement." *Art Law Journal*. Last modified December 18, 2017. http://alj.orangenius.com/art-con signment-agreement.

Surface Design News. "Watermark Your Images to Protect Your Work Online." Surface Design Association. Last modified November 24, 2014. www.surfa cedesign.org/watermark-your-images-to-protect-your-work-online.

Wilcox, Laura. "Emotional Intelligence is No Soft Skill." Harvard University Extension School Blog. Accessed March 10, 2018. www.extension.harvard. edu/professional-development/blog/emotional-intelligence-no-soft-skill.

How to Build Your Business and Your Brand

4

Chapter 4 covers having an online presence (website, Behance, LinkedIn, YouTube, and professional networking sites, social media accounts, portfolios on professional organization websites, etc.); professional organizations to join and why they are beneficial/what they offer; and local, national, and international networking opportunities and ways to take advantage of these. This chapter will also cover useful skills to develop that will help you build your brand, such as basic marketing concepts, mastering search engine optimization and understanding indexing, and how and why to keep your content fresh and engaging.

Have you ever typed the name of a company, maybe a restaurant or a bar or a spa, into a search engine only to find out the company didn't have a website or that their website had expired? Even if the business had a Facebook page and online reviews on Google or Yelp, the absence of a website made the business seem a bit suspect. We've come to expect that every business has an online address as well as a physical address, and that contact information is readily available. And maybe we even accept that a poorly designed website somehow seems better than no website at all (unless of course that bad looking website is for a website design company).

Back in 1789, Benjamin Franklin wrote in a letter that, "nothing is certain except death and taxes" (NCC Staff, 2017), but in the twenty-first century, it is certain that a freelancer or entrepreneur without an online presence will not get much business.

You Need an Online Presence

An online presence for a freelancer or entrepreneur is like oxygen, food, and water, essential for growth and survival. Through your website and social media, people worldwide can investigate you and what you have to offer. Your online presence helps build your brand, because as Ann Bastianelli (2017) points out in her "Powerful Personal Branding" TEDxTalk, "Branding is about how other people know you to be." And Bastianelli (2017) says a strong personal brand will help you "lead more, win more, and earn more."

Bastianelli says you will lead more because people will see you as a leader in whatever industry you are in. Your strong brand will set you apart as the go-to person for what companies need. And this will, in turn, help you win more contracts, thus earning more money.

But creating an online presence doesn't mean doing just one thing, like putting up a website or creating a Facebook page, and being done. Building a website or creating social media accounts are just parts of creating an online presence. An online presence needs to be built strategically, mindful of the critical question, "How do I want others to see me and know me and my business?" A strong online presence consists of a website, a portfolio (which may or may not be part of the website, but more about this later in this chapter), and social media presence, including LinkedIn.

The reasons why you need a website for your freelance or entrepreneurial business(es), according to *Forbes* (Muhammed, 2017), is because it:

- is the face of your business;
- is the best way to brand yourself;
- establishes credibility;
- is your online base;
- establishes your authority;
- is professional;
- can connect you with referrals;
- can bring your portfolio to life;
- can make you money.

As I stated at the start of this chapter, often the first place a potential client will go is online to do a quick search for you and about you. "Having a website that has your name as the URL" (or the name of your business) "is the quickest way to make sure they come straight to a website that you control, and see what you want them to see," explains writer Karen Banes (2017), regarding why every freelancer needs an online presence. Your online presence becomes your electronic face, if you will, 24 hours a day, 7 days per week, so that anyone, anywhere can get to you know your business and your brand at any time.

And a website is the best way to brand yourself because you can build the image you want your company to have. You can choose the colors and the layout and the information you send out into the world. You can make the website as informational or engaging or fun as you want, as long as it represents the image you want to portray. Rick Schank wanted to project Purple Couch as a unique, professional but humorous graphic design and branding company, so he crowned himself with the title of Senior Couch Po'tater Tot as you'll read in Case Study 4.1.

Case Study 4.1 Rick Schank

A study by Intuit predicted that by 2020, 40 percent of American workers would be independent contractors (Intuit, 2010). I've been freelancing, in one form or another, since I graduated from college in the mid 1980s. Throughout my career I have had four full-time positions. While I was a full-time employee, I would always take on freelance work to supplement my income. There have been intervals, like when I was in graduate school, where my income was generated solely from freelance work. My most recent full-time position was as the Director of Marketing Communications at a large state university in California. I retired early from that position and started a marketing and design studio. I learned early on to build a professional network and be attentive to maintaining relationships. This is primarily the way I get freelance work—through referrals and networking. When I finished graduate school, I started teaching on a part-time (contract) basis. I have been teaching in higher education

for the past 25 years. Now I teach part-time at two different universities and run my design studio. So, once again, my income is earned from contract employment. Some things that have changed since I started freelancing include the introduction of digital tools that make networking easier. But easier isn't always better. I think social networks like LinkedIn have allowed networking to become passive and, most of the time, sterile.

There are a few things I think people should know about marketing yourself in the "gig economy." One thing is marketing is not a bad thing. It's a necessary thing. Customers will not know you exist if you don't tell them. Keep in mind that we live in a time where an overwhelming number of messages compete for our attention every minute of every day. This means that you have to communicate often, on different platforms, and with a message that captures attention and delivers your point quickly. Many people think if you have a logo, you have a brand. A brand consists of many things: a logo, a color palette, a pattern, or accent graphics. But the most valuable asset of a brand is intangible: the feelings you get when you come in contact with the product or service. Branding is a part of marketing. Branding helps to build relationships with customers by tapping into emotions. In most cases, branding is the shortcut to allegiance. So it is important for freelancers to build and maintain a strong personal brand. This allows them to build a reputation that leads to repeat work and strong testimonials, in other words, allegiance.

The most important thing about maintaining a brand is consistency. You must align your mission and your values with your message and always stay true to this. It's always easier if you allow your true personality to come through. When I started my design studio I was determined to have fun creating great work. I am very serious about design and marketing but I wanted work to feel like play. I have a sense of humor and I wanted that to come through in the personality of the studio. The language on my website is casual and there are fun references to pop culture and movies. I also wanted to tell the story of the Purple Couch brand in a subtle

or covert way. One way that happens is through the name of the company, Purple Couch Creative, and my title, Senior Couch Po'tater Tot. Usually when I give someone my card they can't help but ask me, "Why is it called Purple Couch?" or "What's up with that title?" Now they have just invited me to tell them about the company, which I do in a fun and humorous way. This is the beginning of relationship with my brand. When they go to the website, the relationship gets deeper and the brand becomes clearer. When we work together, it is my intention to reinforce the brand and secure the relationship.

The best lesson I've learned and I always remember is: It's a small world. Your professional network is even smaller and strangely incestuous. Once you know this you have to behave accordingly. Never burn a bridge. Nurture relationships with people you admire. Always do your best work and be the best team member you can be, because you never know when you will run into that person or cross that bridge again. As I mentioned, I've been consulting and teaching part-time while working full-time for most of my career. I once had a student who was very lazy and didn't invest much effort into his work or into his learning experience. He would not finish his assignments and eventually he stopped showing up for class. A year later I was interviewing people for an open entry-level position and this student submitted an application and made it through to the interview phase. I don't think he remembered my name, but when he walked into the room and saw me, it was obvious that he remembered me. During the interview he showed his portfolio, which contained student projects from my class but they were refined and well done. I reminded him that he never finished any of the assignments in class and ended up never completing class. I asked him technical questions, trying to figure out if he had developed the skills needed to produce such refined work. I was also hoping that he would take the opportunity to renew the impression of him that was formed while he was a student. He couldn't answer the questions, and I started to doubt that he created the work. I couldn't get past the impression he had created the year before as a

student. Since then, I always tell my students to treat every interaction as a chance to define yourself.

And that chance to define yourself also applies to your online presence and interactions. I believe that maintaining an online presence is very important to the success of your freelance business. The Internet facilitated the gig economy and has changed everything. I've had clients in other parts of the United States, who I've never met in person. I've hired sub-contractors on the other side of the globe. Many of our relationships exist solely in the digital realm. We spend so much time in the digital space that it makes sense that an online presence is extremely important. Thankfully there are many tools available to help maintain this presence. LinkedIn is a great networking tool. Behance and other portfolio sites have social networking tools built in that make it easy to find qualified and skilled talent. Facebook, Twitter, Instagram, and Pinterest can all be useful to help you market yourself and your work. The best thing about these tools is they are not bound by geography. One of the drawbacks is they all require an enormous amount of time to properly maintain. I have to admit, I would much rather design communication solutions than write posts or update my portfolio. This is why I try to send handwritten notes with original art or calligraphy to employers and other people in my network. Not only are these wonderful ways to show off your skills and your professional investment, but they also stand out in this world of online communications. They get attention and sometimes elicit an emotional connection.

Another important resource I would recommend is local and national associations, such as AIGA, if you're a graphic designer. I've been a member of a few associations since I started my design studio. I value the resources like samples of business forms (invoices, contracts, non-disclosures, etc.) and access to important information that is specific to my industry. Many of these associations organize educational opportunities, visits to industry specialists, and networking events. They also have an annual awards competition with a great banquet.

Rick Schank
Senior Couch Po'tater Tot, Purple Couch Creative
Adjunct Professor
www.purple-couch.com
Facebook: www.facebook.com/purplecouchcreative
LinkedIn: www.linkedin.com/in/rick-schank-33849b3a
Pinterest: www.pinterest.com/getcomfy
www.behance.net/RSchank

As Rick Schank said, your website can connect you to people and make them feel something about your brand. Your credibility and authority will be established by the content of your site and by previous client or customer testimonials. (Though these could also be taken with a proverbial grain of salt because it's common knowledge that you wouldn't put a negative review or testimonial on your website. Linking to reviews on Yelp or Google or third-party review sites may be more useful.)

Your website can also contain a portfolio of your work (in part or in full). A portfolio on your website could be made up of samples of your work (with your client's permission, of course). Or some portfolios, like those of freelance writers on Contently or of designers and artists on Behance, may contain all of a freelancer's work, not just select pieces or examples. LinkedIn can be another place entrepreneurs and freelancers may display their awards and recognitions, articles they've written or in which they've been cited, books and papers they've published, and contracts they've landed.

The advantages of having an online portfolio, according to writer and editor Bryce Haga (2013), is because it:

- pulls in new clients (a portfolio can show off your skills better than talking about them does);
- generates an awesome first impression (Haga (2013) writes, "Clients don't constantly face problems finding great freelancers, but when it

gets hard to select the best, they generally opt out for professionals who have an online portfolio incorporated on their freelance business");

- boosts your online presence and visibility;
- describes your business perfectly (it becomes a visual 30-second elevator pitch);
- makes you more accessible.

Your website can also help you earn more money, but we'll talk more about that in Chapter 5.

If you choose to do an online portfolio separate from your website itself, make sure than in addition to your creative work, that you also include an "About" section, testimonials, and a "Contact" page (which some people substitute with a "Hire Me" page that includes a list of services and rates).

Some companies or websites that will house your online portfolios, if you want one separate from your website, include Behance, Carbonmade, Contently, Coroflot, Crevado, FolioHD, Format, Krop, My Portfolio, Pathbrite, Pixpa, PortfolioBox, and PortfolioGen. New portfolio sites crop up constantly with many tech companies getting into the game, such as the example of Google setting up a way for students to make e-portfolios in Google for Educators back in 2016 (Jones, 2016).

You may also choose to do a blog on your website, to provide consistent free information to clients and potential clients to further enhance the idea that you are an industry expert (like Kate Peters discussed in Case Study 2.2). Updating a blog or vlog (video blog) regularly will also help you in Google indexing and rankings and search engine optimization (discussed later in this chapter).

Once you have a website that reflects your business is up and running, and an online portfolio, then its time to invest in social media (if you didn't set everything up simultaneously). Your social media should mirror your website in that it should have the same look or branding and similar messaging. You should not post something on social media that is incongruent with the image you want to portray.

You need to set aside a few minutes per week every week to post on your social media accounts, as part of your ongoing marketing efforts. Food stylist Gabriel Cabrera told *Artrepreneur*,

I started sharing everything on Pinterest, Tumblr, and Instagram. I was trying to post something every single day but realized very quickly that that was not realistic. I had another job at the time as a photographer in a studio. Instagram couldn't be my full-time job. So I changed my strategy and allocated two or three days a week to create content for my social media profiles.

(Vaughn, 2018)

The beauty of social media is that it is a multi-faceted and multi-channeled approach to telling your story. In Case Study 4.2, Stephen Warley, founder of the Life Skills That Matter podcast, talks about how important your story is to attracting clients.

Case Study 4.2 Stephen Warley

On Election Day 2000 I got laid off as part of the fallout from the dot-com bubble. It would be the last time I ever held a full-time job. I never imagined I would ever work for myself. I was taught to be an employee. I was conditioned to think I needed to pick a path and to stick to it.

I worked in television news at CBS News Sunday Morning, CNBC, and ThirdAge.com, during the first five years of my career. I didn't realize it at the time, but those weren't jobs. They were apprenticeships preparing me to go out on my own.

Three months after losing my job I took my very first freelance gig. I did it out of necessity. I needed work. Back in 2000 that meant scouring every job website I could find. I eventually found a gig at a health care communications company to manage the development of an interactive CD-ROM. It was going to be used by a pharmaceutical company to market a new medical website they were launching for doctors.

I had to hire actors, scout locations, edit scripts, and I oversaw every detail of the production. I was never given this type of responsibility in any of my previous jobs.

It was the first time I wasn't hired for a job, but for my skills. I was being paid for my ability to produce media content. I guess I always knew my core strength lay in my ability to create clarity from chaos. I never realized people would ever want to pay me for it!

To my astonishment, I got paid almost double on a daily basis compared to my previous employment gig for doing similar work! Since then, I have interviewed hundreds of other freelancers, who have told me they have experienced the same phenomenon.

As our economy continues to evolve, traditional employment will become less and less secure. Sure, getting your freelance business off the ground can be tough. Once it gets established, however, you'll have multiple sources of revenue providing you with greater financial security. You'll no longer be at risk of losing all your income at once like I did when I got laid off.

My first freelance gig sparked my entrepreneurial curiosity. I was so frightened to work for myself, but only because I had never experienced it. As I made more money, had more control over my time, got to choose my work and got paid for doing what I love, I was hooked!

My career took several pivots after my first freelancing gig. Eventually, I built a digital advertising sales training firm focused on helping local broadcasters generate more digital ad revenue. That experience taught me how to generate passive income. I scaled it to $600,000 in annual revenue working an average of 20 hours a week.

My survival mode to make as much money as I could drove most of my business decisions during the first decade of my career as a freelancer, trainer, and entrepreneur.

By 2012, I had exceeded the financial goals I set for myself. I also lost my passion for running my sales training business, so I sold the online portion of it to one of my original trainers and let go of my last consulting gig in 2016.

I had been doing a lot of research about the future of work since 2013. I felt like I was already living the future of work and saw an opportunity to prepare more people for how work is fundamentally changing. Let's put it this way, if you are thinking about

freelancing, you are already on the right track! I believe the future of work is self-employment.

Today, I educate people why the future of work will be working for yourself and why it's never been easier to do.

The most valuable lesson freelancing taught me was to tell my story. Not the story I thought people wanted to hear when I was looking for a job, but the one I *really* wanted to tell about myself. Getting a job is about fitting in. Becoming a freelancer is about standing out.

I learned not to hold back my excitement. My clients loved my unique story. I shined when I geeked out on creating plans, organizing chaos, and finding solutions to vexing problems by analyzing patterns. I got paid for what naturally came to me.

If you want to build a successful freelance business, tell your story with clarity and confidence. You'll create instant rapport to spark the development of a trusted relationship.

Here are the three basic ingredients for telling your story to capture the attention of potential clients:

1. *Your mission.* Think of your mission as a statement of why you do what you do. What excites you about your work? What are you willing to struggle for? What problem are you trying to solve? What cause motivates you to work?

2. *Your unique advantage.* What can you do that few other people in your profession can do? Not sure what it is? Ask people who've worked with you what you do best. Think of why people recommend you. What do you do effortlessly that other people find difficult to do? Everyone has a unique advantage. What's yours?

3. *Your niche.* You will struggle if you don't define your niche. When you are all things to all people, no one knows how to recommend you. Be specific about who you want to work with. For example, it's no longer good enough to refer to yourself as a "graphic designer." You now have to be a "graphic designer that

designs highly engaging infographics for insurance companies." You will create more value for your clients and more revenue for yourself when you focus on a niche.

When you tell the story of how you are motivated to use your unique advantage to serve a particular niche, you liberate yourself from competing on price alone. You turn yourself into a sought-after resource that people value.

The whole point of becoming a freelancer is to work on your terms. Working on your terms starts by owning your story and not being afraid to share it!

Stephen Warley
Future of Work Advocate
www.LifeSkillsThatMatter.com
Twitter: @stephenwarley
Facebook: www/facebook.com/lifeskillsthatmatter
Instagram: @stephenfwarley
LinkedIn: www.linkedin.com/in/warley

When you consider telling your story on social media, think about what your clients and potential clients want. Who is your following on social media platforms? What is their demographic? What kinds of social media are they drawn to and what specifically do they follow and like? What trends are in your industry? This data-driven market research can formulate how you tell your story. For example, should your language be more formal or casual? Should your message be original artwork or photography by you or maybe meme-based? What draws your market on social media? Cabrera said, "If you want that market and those clients to pay you, you have to figure out how to bring that together with the things you love to do. And then focus on that . . . But that's also a fine line because I don't think you should do something just for the likes because you will end up producing the same work as everyone else. You should be incorporating all of that data you have gathered and figuring out how to capture that with your particular style (Vaughn, 2018).

Though social media posting takes time, when it is strategically thought out, it is worth it most when it makes sense with the current work you are doing and the work that you want to do in the future. Everything needs to contribute to your brand and to appeal to the people with whom you want to work.

In Case Study 4.3, composer Sahba Aminikia talks about his brand and how he sees his YouTube channel, his social media accounts, and everything he does as extensions and exact images of himself, and how this helps people around the world find him and know him and his work.

Case Study 4.3 Sahba Aminikia

I have a little black fish tattoo on my arm, an African art style fish, from a Persian tale that roughly translates to "Little Black Fish." The story is from the 1960s of Iran and is about a large group of fish swimming round and round in a tiny pond of water, but one little fish, a black one, stops spinning in circles with the others and heads off on her own, saying she's heading towards the ocean. She's an anarchist. The other fish are disturbed by her since she isn't following the group. That's me. I've always known I was that little black fish.

Art, your business, your brand, it all has to be the exact image of yourself. That is your best publicity. I'm not just the person I am when I walk on to a stage. I have many aspects to my personality and I am everything I created and it is me. I need to be as effective and contributing as I can be at all times, and I'm always looking for where I can be more useful and how and that's usually what the audience is also interested in.

I use music and my compositions to seek a deeper connection with human beings beyond language and culture. I was born in Iran, and I created a home recording studio in my home in the 1990s when I was a teenager and Iran was introduced to the digital world. I also became a Microsoft Certified Solutions Expert (MCSE) then as part of preparing for the future. I was trying to have my own pocket money and my own independence. I listened to Bach and

Beethoven, Queen and Pink Floyd, so many different kinds of music and found it all to be powerful because it was relevant to its time period and spoke to the people.

I, too, wanted to be able to influence and contribute and make things better in a world that I saw was so messed up. When I moved to the United States in my early twenties, as a refugee, I knew I couldn't create influence by owning a gas station or by becoming a piano teacher. But I did feel I could do that through creating cultural products, compositions, and storytelling. We're inevitably moving towards a shared-economy culture, if we want it or not. In fact it's being implemented in the U.S. economy right now as we speak. Companies like Uber, Airbnb, or Facebook are perfect examples of that. Also the new human being feels a strong urge for feeling free and defining a moment in his/her temporary life.

I studied music composition at a conservatory through the master's degree level, and when I graduated, I applied for and got a part-time teaching job, and got it but I knew I wasn't really a teacher. And when a full-time position opened up, I applied for that, because I was raised to believe that composers are supposed to teach. But the other thing I did right after graduation, I started sending my work to every ensemble I wanted to work with. Some of my teachers told me I was lowering my dignity by soliciting work by sending things to people for free. But if you really believe in something, you have to become that thing. And as one of my professors used to say, "And you have to let everyone know about it." I became my work and my work educates me in every moment of my life.

Some of those ensembles loved what I sent them and wanted to perform and record my work. I learned quickly that when a group of artists and musicians come together what is created is different than what each group or individual brings.

My teachers taught me that to succeed as a composer, you need to enter and win certain competitions and get commissions from certain orchestras and win certain awards or residencies. For decades, these were the things that drove this career, as well as getting coveted teaching positions.

But I'm the oldest of the Millennial generation and I see things shifting more to a shared economy. We grew up in the age of shared music on Napster. We've watched resources be scarce and people work jobs to make money but who didn't really have a life. Most of the people I encounter want something more. We want lives and we understand that many jobs that used to pay don't anymore or they don't pay as much. I came to this country as a refugee but I didn't try to get anything from this country. Getting things doesn't give you a sense of accomplishment. This is one reason my generation works hard, networks online constantly, and creates very multi-faceted careers/lives.

You can get a bunch of gigs from the Internet and travel and be a digital nomad and still support yourself. People from all over the world purchase my scores and perform them. I send them to them as downloadable PDFs. I don't copyright them because they are going to be copied. I know that. But any group who wants to work with me does buy the score. Even if they did copy it, though, working with people is an incredible opportunity and often leads to new projects.

Sometimes it feels like my entire life is filled with FaceTime and Skype meetings. People find me through the videos I have made on YouTube. (I had ads on my YouTube channel once but immediately removed them. It wasn't a great source of income for me, plus no one really wants to sit through the ads.) The people who have watched the videos and contacted me for scores or commissioned pieces, they are from China and Israel and all over, and they are constantly looking for something to be a part of that gives them a sense of purpose, that lets them tell stories. Storytelling gives people power.

Last year, I had two meetings with a publishing company in San Francisco who wanted me to write a book about my life. I debated for a few weeks but I decided not to pursue the offer, as I am not ready yet. My life changes rapidly and I don't feel I've accomplished enough to write that book yet. We are real different species today!

When I finish teaching this spring, I am resigning, as a non-profit in Turkey has contracted me to be the artistic director for a music festival held in a tiny border city (border of Syria) called Mardin.

This non-profit provides circus arts training to hundreds of children refugees who were settled along the border of Turkey and Syria in these tiny little cities. The circus moves from Syrian refugee camp to refugee camp, with clowns and musicians and all of the other circus acts, and trains children in circus arts. They've been doing this for six years now and I've agreed to join them for three or four months and create a music festival incorporating a large group of artists who already are active there, and another group of artists that I am bringing from several countries, including the United States and Iran, which is very close to Turkey. Once I return to the States, I've decided I will just do freelance work, contracts, and maybe a few private students.

One of the things I've realized on this journey is that the biggest part of marketing is showing that you're relevant. Higher art needs to be in service to the most needy parts of society, not just to the elite. Since it's actually the common who need education the most. And higher art should represent that in a society. And people think you cannot do a lot with few resources but that isn't true. I got the idea to work with a choir in Afghanistan and have them perform with a choir and Kronos Quartet in the United States. You don't need a million dollars any more to hire people and to make things happen. People are willing to collaborate. We have so much access to so many things because of the digital world. The old establishment of arts does not realize that and still asks for hard copies of the scores, which are barely used in common practice of today. They still try to maintain a certain system of hierarchy of arts, which has existed both in East and West for hundreds of years. But the fact of the matter is that the monopolization of arts is long gone, almost at the right moment when Napster emerged. The key is to not be afraid to reach out to people and to ask for what you need and in my experience, they might need something that I might have and this creates a healthy cycle of collaboration. When I brought the choirs together, I found people that made it happen, and I was clear about my intentions. I wanted it to be an entrepreneurial and cultural endeavor and exchange, not a political statement of any

kind. Art should bring people together, give them a narrative, and be cathartic. It should remind people of values.

Your instincts, if you listen to them, will take you where you need to go . . . but not necessarily where you *think* you need to go. That's the most valuable lesson you can learn.

Sahba Aminikia
Composer
www.sahbakia.com
www.soundcloud.com/sahbakia
Twitter: @sahbakia
Facebook: www.facebook.com/sahbakia
Instagram: @sahbakia

Professional Organizations and Networking

Just as your website and social media content can help market you and your business, professional organizations and networking opportunities can also help you find clients. And right now, some of the best networking opportunities and professional organizations are found online in the form of closed or "secret" Facebook groups. Facebook has thousands of groups, based on location, industry, hobby and leisure, school and/or education, and hundreds of other categories. For example, I'm a member of seven different writing and editing groups for women and non-binary persons, three publications-based groups, one marketing-focused group, three arts-related groups, and four groups for businesswomen or female entrepreneurs. And that's just on Facebook. LinkedIn has its own groups, all niche business focused. According to *Entrepreneur*, "Social media platforms seem to have replaced the old-fashioned professional organization" (Rampton, 2015).

The benefits of joining a professional organization or networking group include being exposed to educational resources, such as industry research, conferences and workshops, newsletters, online courses and seminars, and events; exposure to and increased social capital, meaning when like-minded intelligent people congregate they can help each

other reach goals; job opportunities; development of leadership skills (if you take an active role); access to exclusive benefits (such as discounted health insurance and invitation-only events). Professional organizations or networking groups are also places where you find potential clients or customers and work, or find out about opportunities. For example, I'm a member of one women's entrepreneur group called The F Bomb Breakfast Club. When Rick Schank said he needed twenty to thirty businesses that would be willing to work with his students so that they could design branding packages for the businesses as a course-culminating project, I reached out to my F Bomb sisterhood. Within one hour, Rick had double the amount that he needed of willing business owners who wanted free branding packages.

The Appendix at the end of this book has a list of some of the most established professional organizations in freelancing (for writing, editing, graphic design, interior design, fine and visual arts, theatre, film, dance, music, and computer and video games), along with the organizations' URLs. With so many online and in-person groups to choose from, but only so many hours in each week and month, let's consider how best to pick the organizations that are right for you.

First and foremost, does the organization's mission align with yours? If it doesn't, move on. If it does, consider the networking opportunities, their location, and your availability. I was involved with Women's Business Owners when I lived in Seattle and they had one two-hour lunch per month plus one cocktail party. The lunch, for me, was easy to get to, as it was usually within a 10-mile radius of my house. But the cocktail parties started at 5.30 p.m., which meant depending on where they were being held, I'd have to fight rush-hour traffic. The irony was that the mingling atmosphere of the cocktail party was better suited to meeting and talking to people than the structured sit-down lunch with a guest speaker. So when you look at networking opportunities, consider location, access, interaction possibilities, and length of the event when considering what works best for you. Many professional groups that charge a membership fee let you come to one or two events to try it out first, so take advantage of that kind of opportunity to see if it's a good fit.

Next, look at the jobs section if their website or group has one. Are they the types of jobs or clients you want? Next move on to the directory. Are these professionals the kind you want to network with or the type

you want as clients? Do you think you could help these people meet their goals and that they could help you meet yours? If one of your objectives for joining a group is to advance your career and business, then you need to consider each group through that lens.

In Case Study 4.4, freelance engineer, producer, composer, and musician Daniel Silberman divulges how he networks and why he does it a bit different than his peers.

Case Study 4.4 Daniel Silberman

I studied double bass performance as an undergrad at the San Francisco Conservatory of Music and received a graduate degree from the Royal Academy of Music in London. For years during my schooling I did gigs, playing double bass, electric bass or guitar, and I wrote music. When I returned to my hometown of Chicago after grad school, I knew I wanted to get into music producing and engineering so I built a music studio and did contract work for the Chicago Symphony Orchestra. Launching a studio and getting steady work for it alone was a struggle.

Three years after I started the studio, I realized that distancing myself from it would only strengthen my personal brand as people started to learn I wasn't just the studio. Knowing who you are and what to you bring to the table as a freelancer is so important. There will always be better, more skilled or knowledgeable people in any occupation anyone pursues. We need to accept that and know ourselves. When I started to cultivate what I was good at, I realized that people associated my name with those things. The same words pop out of their mouths when they talk about me and my skill set. They know what to expect from me and yet I can still surprise them by doing work that I'm happy with and that they are, too, without a lot of back and forth.

At least 80 percent of music contracts aren't just because someone is good at music. It is because the musician understands public relations and business. I get a lot of jobs not just because I'm just good at music but because I'm always asking the right questions,

have the right contacts, and I know the business. It's assumed that if you're playing music at a professional level that you can play. You have to understand phrasing and dynamics and how to play with others. If you try to wing any of these skills, you don't get consistent results and you won't be hired again because the sought-after consistency isn't there.

When it comes to making contacts, I don't follow the practice of many people I went to school with, who believe that the number of contacts matter and they network so their contact list has hundreds, if not thousands of people. Instead, I maybe have a contact list of 20 quality people, heavy industry hitters, if you will, that can make extended connections for me, if I need them. I believe in quality relationships over quantity. If I go into a networking event, I know that only 25 percent of the people in the room are the ones I need to connect with. That doesn't mean I ignore the others, as collaboration is the key to building a relationship with another person and you never know ahead of time what that outcome might be or what to expect. But I do know that even mentors do not move the world for you; moving your business forward is up to you.

Some of the biggest things I've learned as a freelance musician, producer, and engineer have been eye-openers. First, I must know myself and project a clear and consistent brand. Second, time management is so important. You want to be able to get the most work done at the highest level in the shortest time possible. And third, it's important to take a step back and plot out each and every facet of each job you're doing so that you're never winging it. And every year you have to set goals: yearly, bi-yearly, five-year goals. It can be a bit depressing to do it but it is very important to ask yourself where you and your business can go and what can you provide.

Some days I'd rather not be a freelancer due to the lack of stability, the long hours, and the lack of benefits such as health care, retirement, and vacation pay. I don't think people go into freelancing hoping to stay there their whole careers. But it is taking me to really cool places. I have unexpected job opportunities and gotten to work on some big projects with artists I grew up admiring. I don't

have to limit myself to doing one thing day in and day out. Sure, sometimes you get a job and wonder why they hired you, but that's all part of the process and the variety of work, especially if you're good and have a certain needed skill set. I like being my own boss and making my own hours—even if they are often long.

I have my personal studio where I'm comfortable and can always work with people there if we need to, but I can also work in other people's studios and locations or anywhere else I'm needed. I have flexibility. And as my business has started to expand, I have been able to cater and choose projects instead of early on instead of many early profession freelancers who feel the financial or career need to accept every contract.

At age 30, it is too early to state my biggest achievements but to date it would be two things: I have won three awards for the work I've done and I've gotten to the point where I don't have to worry about money. I find it rewarding to rely on my work, myself, and my name, as opposed to achieving success by being associated with someone else's name and business.

<div align="right">
Daniel L. Silberman

Award-winning freelance engineer, producer,

composer, and musician

www.RidgewayRecording.com

Twitter: @WindyCityMusik

Instagram: @LiveForTheMusik

Facebook: www.facebook.com/MusicByDLS and

www.facebook.com/RidgewayRecording

LinkedIn: www.linkedin.com/in/daniel-silberman
</div>

Being active in any professional organization or online group is all about being a part of the conversation. As Stephen Warley pointed out, people want to know our stories, and to be effective business people, we need to listen to and be engaged with the stories of others. This is how we learn client needs so that we can fulfill them. Because when we help others, we in turn, also help ourselves.

Now let's look at some specific skills you'll need to understand and master, in order to develop your brand.

Skills You'll Need to Develop Your Brand

Business, especially online business, is filled with jargon and buzzwords; some terms we know or think we know and some are more opaque or multi-dimensional. Marketing, sales, search engine optimization, indexing, sales leads, and conversions—these are just some of terms you will need to familiarize yourself with in your entrepreneurial career.

"Growing your career or business is an evolution, not a revolution," CEO of the Stella Group, Ryan Alovis, told *Forbes* (Dresdale, 2017). This is why you need to understand the basics of marketing, which has been defined as the "process of teaching consumers why they should choose your product or service over competitors" (Lake, 2017). But marketing is the study and management of relationships, in its purest form. It involves not only the creation of the product or service concept, identifying who would purchase it, the promotion of it, and then the moving of it through the selling channels, or what is referred to in marketing textbooks as the 4Ps: product, price, promotion, place.

The purpose of marketing, whether it is on social media, on your website, in paid advertising, on promotional giveaway items like pens and coffee mugs, or anywhere, is to capture the attention of the target market and encourage those people's purchasing decision while providing them with an easy, low-risk way of taking action.

To master the basics of digital marketing, you need brand identification and consistency (across all channels, including website, mobile apps, social networks, and e-mail), social media outreach that creates and encourages a conversation between you and your customers/clients, content optimization (meaning you have to have original, value-adding content on your website and blog), sales leads and conversions (meaning your website needs to be geared towards capturing customer information), and you must be found by and optimized for the search engines.

Before we delve into exactly how to do that or what that means, let's take a moment to discuss original, value-adding content. Early in this chapter, we talked about how that would set you up as an authority and

the go-to person or company for a specific niche market, which is true. Writing guest posts on other people's websites in your industry will do this, too. Websites that don't have original and valuable (educational, inspiring, informational, or humorous) content also do not perform well in searches (which in tech terms is called crawling, meaning Google visits your website and follows any links you have on it for tracking purposes, followed by indexing, meaning the results of Google's spider crawl gets put into Google's index). And this original and value-rich content is also a part of search engine optimization.

Search engine optimization, which often goes by its acronym SEO, is basically setting up your website to appear as close to the top ranking as possible when someone types in your product or service into Google or Bing or any other search engine. R.L. Adams, *Forbes* contributor and author of *SEO 2017: Master Search Engine Optimization* (2016), writes:

> Most people look at SEO the wrong way. They look at ways to do the least amount of work for the greatest initial return, when in fact it's quite the opposite. Obviously SEO is one of the best skills that you can possibly learn, but in order to succeed with it, you need to do the most amount of work for the least initial return.

Despite the cute and friendly names Google has given to its search algorithms (Panda, Penguin, Possum, Pigeon, Hummingbird, to name a few), understanding the way its algorithms work can seem less than friendly. After all, more than 200+ factors are involved in Google's core algorithms, and those algorithms change more than 500 times per year to combat unscrupulous users who try to game the system. So getting to the top rankings, or placing in the Google's Search Engine Results Page (SERPs, in GoogleSpeak) requires creating a relationship with Google, and like any relationship, getting Google to work with you and for you takes time. But there are ways to make Google "warm up to you" faster.

Adams says that the first real guiding principle in SEO is trust, and getting Google to trust you requires three key ingredients: your site's indexed age, its authority profile, and its underlying content. Indexed age is not the date you started the website, but the date Google first noticed the site, which is actually based on the other two key ingredients, the authority profile and the content.

The authority profile of a website includes the quality of the sites linking to your domain, how diverse these links are (meaning they shouldn't all be coming from the same domain) and the frequency and freshness of those links. Or in simpler terms, who is writing about you and your business and where, or to where (besides your own blog) are you contributing quality content, with a link back to your own site/blog?

And the third key ingredient is the content on your site or blog itself. Gone are the days when just putting up a website landed you on SERPs. Now your content must be rewritten or added to regularly, it must be engaging to the reader and it must add value to what's already on the Internet.

Michelle Sternbauer, EVP and Account Director of THAT Agency, writes,

> Content, now more than ever, is still king; however, the thought behind creating it must shift. Content MUST be created unselfishly now. Instead of thinking about creating the content that will generate an immediate sale, marketers need to think about creating content that is useful to customers. In return, you will build yourself as a thought leader, and your customers will keep coming back to you.
>
> Creating exceptional content should be based on:
>
> - well-researched customer personas;
> - answering specific questions;
> - optimized for appropriate keywords.
> (personal e-mail correspondence, March 7, 2017)

Sternbauer advises their clients to "Think more magnetic, and less sledgehammer," meaning you want to engage your website audience with information (as opposed to hitting them over the head with it) (personal e-mail correspondence, March 7, 2017).

If you are new to writing for the web, keywords are the words that users type into a search engine when looking for articles on a particular topic. For example, if a user is looking for a knitting pattern for alpaca yarn, s/he might type "alpaca yarn sweater patterns" into Google. Those four words—alpaca yarn sweater patterns— would be the keywords.

Blogging platforms, like WordPress, ask a writer to choose a focus keyword(s) (like those above) and then to choose other keywords that are also found in your blog. Effective SEO includes using the focus keyword in the title of the blog, in the first sentence and then repeated throughout the text. The number of times to repeat is determined by the word count of the blog itself, but around 0.8 percent of the word count is a positive SEO ratio.

While the minimum for a blog should be 300 words, Google considers this thin content, and it won't help the search engine trust your blog/website. Adams says that most of the top spots (the SERPs) were all over 2,000 words (laser-focused content that is well written and keyword focused). Longer articles tend to be better researched, contain links to authorities and data, and serve as sources to journalists and other bloggers who then link back to your site/blog as the source—which helps create and advance your authority profile.

Writing things that others want to mention and link to is a big part of "content marketing," and as Adams says, "Great content, when crafted the right way, can send you skyrocketing up Google's SERPs, but only if you stay consistent." Consistency in blogging terms does not mean that you have to write new content daily, but you do have to create high-quality content regularly (weekly, biweekly, or monthly). So think about the things you think your customers would like to know, and as Sternbauer implied, answer their unasked question, or show why you are the authority in your particular area.

And as far as Google or another search engine thinking you're an authority, well that's determined by the content on your page and that much of it is not duplicated within your own site, how many links to other quality sites you have, and how many backlinks you have (backlinks are how many other websites of quality are linked to your site, from theirs to yours), if you have internal links (meaning one part of your website links to another part of your website), if your URLs are SEO-friendly, and how unique and non-competitive or original your meta-tags are. (Meta-tags are snippets of text within the webpage's coding that tell the search engines what the web pages are about.)

While we have focused on the technology surrounding digital marketing and the ways it can enhance your presence and how customers can find you, the technology simply provides the tools. A marketing plan does not rely on technology; it is all about you, your story, your business, and your strategy.

Chapter Summary

This chapter discussed the importance of having an online, multi-faceted, and multi-platform presence with consistent brand recognition and image across all channels. Essential to business growth is to choose professional organizations to join and networking opportunities in which to take part that align with your business' mission and your goals. Your online content must be kept current, engaging, and fresh in order to be found near the top of any listing during an online search and for you to be seen as an expert in your industry. A marketing plan considers all facets of your relationship with your customers from the concept of a product or service to its creation, sales, and delivery. Part of any successful marketing strategy is consistent branding and messaging.

Exercises

1. Create a website for yourself or for a business you might start.
2. Create an online, professional-level portfolio showcasing your best work.
3. Create or update your LinkedIn profile, with specific attention to your summary statement and the level of detail you provide throughout your profile.
4. Research and list three local, three national, and three international professional organizations for your field.
5. Write a 1,000-word blog post, while identifying and paying attention to keywords, that would educate readers about some aspect or niche in your industry.

References

Adams, R.L. *SEO 2017: Master Search Engine Optimization*. CreateSpace. December 29, 2016.

Banes, Karen. "Why Every Freelance Writer Needs an Online Presence." Karen Banes Website. Last modified August 9, 2017. http://karenbanes.com/every-freelance-writer-needs-online-presence/.

Bastianelli, Ann. "Powerful Personal Branding." TEDx Talks (TEDxWabashCollege). Last modified February 22, 2017. www.youtube.com/watch?v=hcr3MshYe3g.

Dresdale, Rachel. "How This Millennial CEO of Three Companies Handles Work Life Balance." *Forbes*. Last modified March 23, 2017. www.forbes.com/sites/rachelritlop/2017/03/23/how-this-millennial-ceo-of-4-companies-handles-work-life-balance/#c88f88b58097.

Haga, Bryce. "Why an Online Portfolio Is Insanely Essential for Your Freelance Business Growth." InstantShift. Last modified September 23, 2013. www.instantshift.com/2013/09/23/importance-of-online-portfolio/.

Intuit. "Intuit 2020 Report: Twenty Trends that Will Shape the Next Decade." *Intuit 2020 Report*. Last modified October 2010. https://http-download.intuit.com/http.intuit/CMO/intuit/futureofsmallbusiness/intuit_2020_report.pdf.

Jones, Christine. "6 Easy Steps for Setting Up Google Portfolios." *EdTech*. Last modified July 5, 2016. https://edtechmagazine.com/k12/article/2016/07/6-easy-steps-setting-google-portfolios.

Kim, Larry. "22 Inspiring Billionaire Quotes About Successful Personal Branding." *Inc*. Last modified July 15, 2015. www.inc.com/larry-kim/22-inspiring-billionaire-quotes-about-successful-personal-branding.html.

Lake, Laura. "A Beginner's Guide to Marketing." *The Balance*. Last modified November 10, 2017. www.thebalance.com/what-is-marketing-2296057.

Muhammed, Abdullah. "9 Reasons Your Freelance Business Needs a Website." *Forbes*. Last modified January 25, 2017. www.forbes.com/sites/abdullahimuhammed/2017/01/25/9-reasons-your-freelance-business-needs-a-website/2/#7428d97971b9.

NCC Staff. "Benjamin Franklin's Last Great Quote and the Constitution." National Constitution Center. Last modified November 13, 2017. https://constitution-center.org/blog/benjamin-franklins-last-great-quote-and-the-constitution.

Rampton, John. "Millennials Have Rediscovered the Benefits of Joining a Professional Organization." *Entrepreneur*. Last modified June 5, 2015. www.entrepreneur.com/article/246691.

Vaughn, Kevin. "Food Stylist Gabriel Cabrera on Building Your Personal Brand." *Artrepreneuer*. Last modified January 18, 2018. https://atp.orangenius.com/food-stylist/.

Sustaining and Expanding Your Business

Chapter 5 explores the type of legal business entities that you may want for your business and why, and all of the financial requirements like claiming income, determining deductions, paying taxes, getting insurance, and setting up a self-employed retirement fund as well as keeping track of your contracts. This chapter also explores ways to generate extra business and income, such as selling photos to accompany text or as stand alones, how to start a column or get syndicated, where to look for corporate clients, how to put together a business or project proposal and how to apply for grants. This chapter will also cover the importance of having a multi-faceted presence. Briefly, passive income will also be covered, including pay-per-click ads such as Google AdSense on websites, the creation of online tutorials or courses, backlinks, and other ways freelance creatives make additional income.

What Legal Business Structure Should I Choose?

When you are just starting out in creative professions, it is easiest to do things as yourself, meaning that you do the work under your own name and use your social security number for the contract and tax purposes. And in the beginning of a writing, performance, or art career, that makes logical sense, but it may not be the safest choice in protecting your assets or future income.

As *Artrepreneur* points out, a number of artists (the term they use for visual and performing artists and musicians) "run their businesses without a corporate structure that protects them from personal liability. Without this, creditors can force these artists to liquidate personal assets, such as their homes or cars" (Schlackman, 2016). This is why business entity choice is so important. Your choice of entity can affect liability, the number and identity of shareholders and partners, the equity structure, the control and management of your company, as well as possible funding your business might be eligible to receive.

Now, I know you might be thinking, but I just want to get started with my business, to hang up my proverbial shingle and see if I can make a living. But determining what structure your business is going to take determines things like when and what kind of taxes you pay, if you can comingle your personal and business monies, and who gets sued when something goes wrong, such as your painting comes off the wall at a show and hits someone or the model you photographed for a campaign thinks she looks bad or a writer claims you stole his idea for your film or video.

Forbes says when you make a choice as to your business entity, you should know that your entity choice is state specific, meaning you choose and register your business with the states not the federal government (and each state doesn't offer all entities or treat them all the same way), and that your choice of corporate entity may be slightly different than you tax entity (Phillips Erb, 2015).

Basically, two types of company structures exist in the United States: corporations and non-corporations, with the big difference between the two being that corporations protect their owners from being personally responsible for things that the company does (Schlackman, 2016). Corporations can be further categorized as C-Corporations, S-Corporations, and Limited Liability Corporations (LLC). The non-corporations include partnership, with partnerships being of the general and limited kinds, including in some states, a Limited Liability Partnership (LLP) and a Limited Liability Limited Partnership (LLLP), and the sole proprietorship. We will explore these in this order, which is from most complex entities to the least complex.

In 2011, Mitt Romney said on the campaign trail in Iowa that "corporations are people" and he wasn't that far off base (Rucker, 2011).

Corporations are entitled to many of the rights people are: they are given a name, they receive a tax identification number very much like a social security number, they can enter into contracts, and they can be punished for doing things that are illegal.

Schlackman (2016) writes, "To spur entrepreneurship, the government had to find a way to mitigate some of the risk associated with forming a new business, so the corporation was born." The most common type of corporation is the C-Corp, which is the chosen entity of companies that are familiar household names (think Apple, Google, Coca-Cola, McDonald's, Walmart, etc.). But this type of corporation is the least favored by small business owners, who only have themselves or a few people as employees, because the management requirements of a C-Corp can be burdensome. A C-Corp is able to issue preferred and common stock, must have a Board of Directors, must pay quarterly taxes, must hold shareholder meetings where officers are elected and minutes are recorded, and must draft an annual report that must be filed, along with fees, with the state. C-Corps also have a double-taxation model, which in simple terms means that the corporation pays taxes on money it makes and then you as owner-shareholder pay income taxes on your salary and dividends so that the same revenue has now been taxed twice.

An S-Corp has many of the same rules, requirements, and liability protections as a C-Corp, but it doesn't have the double taxation or the quarterly taxes. As attorney Schlackman (2016) explains, "S-Corps allow the shareholders to 'pass-through' the corporate income as profit and loss on their individual tax returns, rather than a corporate tax return." To become an S-Corp, the business actually files as a C-Corp and then can change to an S-Corp if these requirements are met: only one class of stock, fewer than 100 shareholders, company owners are U.S. citizens or resident aliens.

A Limited Liability Company, or LLC as they are commonly called, has the personal liability protections of a C- or S-Corporation but its tax struc-ture and filing is much simpler as is its corporate structure. LLCs offer no stock so have no shareholders, its owners do not need to be U.S. citizens or permanent residents, they have no Board of Directors. Any income or loss from an LLC passes through to the owners' personal tax return and no corporate tax return (a federal form 1065) is required (though a state tax

return usually is). The only downside to considering an LLC is if you are in business by yourself, as some states do not permit LLCs with a single owner (in these states, the LLC must be a partnership). An LLC managed by partners will need either an Articles of Incorporation or an Operating or Partnership Agreement that spells out how decisions will be made, how the business will be run, and what happens if a member wants to leave the partnership or if the business fails.

A Limited Liability Partnership (LLP) is a partnership that has formally acknowledged itself as an entity and registered with the state. And though the rules vary from state to state, the partners in an LLP have the same limited liability protection that those in a corporation have.

A Limited Liability Limited Partnership (LLLP) is only available in some states and is described by *Forbes* as a "limited partnership with limited liability" (Phillips Erb, 2015). An LLLP often has some general partners and some limited partners, with the general partners having some liability protection and the limited partners not having much say in how the business is run.

Unlike LLPs and LLLPs, general partnerships have no legal requirements of forms to fill out or papers to file stating two or more people have entered into a business arrangement for profit (though of course, it is wise to fill out the forms and have Operating Agreements and Partnership Agreements, from both a business and a legal perspective). In a general partnership, each partner shares the liability for business obligations and splits the profits, as recorded on their individual tax returns.

A sole proprietorship is the simplest form for a business to take. No forms are necessary, nor are there any real accounting requirements. But the owner or sole proprietor is personally liable for any debts and obligations of the business, which means personal possessions can be seized if the business incurs debt and goes under. A sole proprietor reports income and expenses from his or her business on their taxpayer form 1040, Schedule C. A sole proprietorship is not required to pay payroll taxes on income, to withhold income tax, to file employment tax returns or to pay state or federal unemployment taxes, but it does have to pay Medicare, Social Security, and federal and state taxes at tax time for the year.

Because there is no legal distinction between the owner of the business and the business itself, people who run sole proprietorships (or their

contracts under their own social security number) often comingle their funds, meaning money earned goes into their personal bank accounts instead of a business account. And this is perfectly legal. But you can also choose, with a sole proprietorship, to have a distinct business name, a business bank account, and employ people. Just remember that the business is not a separate entity from you so you have no legal protection if something goes wrong, liability wise.

Now that we've discussed all of the possible business entity choices, let's move on to finances.

Finances 101

Freelance workers fill out W-9s (as opposed to the W-4 an employee fills out) for each of the companies with which they have contracts. The paperwork provides the company with your social security number or employer identification number (EIN) and your address so they can report you as an expense to the IRS, and so they know where to send your tax paperwork the following January.

Claiming Income

Under the Internal Revenue Service guidelines, you must keep track of all monies you receive from sales or services rendered, regardless of the dollar amount. You can do this in a simple Excel spreadsheet or in any bookkeeping program. (Quicken makes a version for the self-employed, and PayPal and other payment sites also allow you to invoice and bill through them, though they will take a percentage of the money you receive.) The organizations and companies you contract with have to issue you a 1099 by January 31, of the following year, only if they have paid you more than $600 the preceding year. So when you do your taxes, you may be reporting more income than the accumulated totals of your 1099s if you did work for some places than paid you $1 to $599.99, or if you did work for any dollar amount for any companies not based in the United States.

Determining Deductions and Paying Taxes

As an independent contractor or a self-employed person, your deductions are numerous. You can deduct equipment used in your business (computers, printers, cameras, etc.), the cost of work-related phone or Internet services, packaging and mailing, duplicating, advertising, and business travel. Things like your premium LinkedIn account monthly fees or Behance Pro portfolio fees and those cloud service backup fees are deductible. The cost of joining professional organizations and attending conferences also are deductible business expenses, as are health insurance premiums and business insurance premiums. And as Kimberly Lankford writes on *Kiplinger* (2017):

> You can also deduct legal and professional fees for your business, books and publications you purchase for your business, and the cost to rent an office space (or you may qualify for the home-office deduction if you work regularly and exclusively in your home). Half of the Social Security and Medicare taxes you pay is also deductible.

To take the accumulated deductions of your business expenses, it is easiest to keep track of them as you incur them, meaning do your bookkeeping regularly. In the last chapter, we discussed setting aside time each week for marketing efforts and social media posting. Setting aside time each week to attend to bookkeeping matters is equally, or maybe even more, important. Personally, when I incur a business expense, I put the receipt in a stack with the other week's receipts on a corner of my desk and then one morning per week, I enter the expenses into a cash flow spreadsheet that has expenses listed by category. And then I put the receipts into that year's manila envelope. This way, when tax time comes, I can enter the cumulative numbers from each category of expenses into the appropriate spaces on the tax preparation software. And I don't have to spend hours trying to pull that stuff together right then since I've been on top of the recording keeping all year.

As said earlier in this chapter, if your company status is anything other than a C-Corp, you won't have to file taxes until the end of each year, and

the income and expenses may be combined on your personal tax returns. With a C-Corp you will need to file corporate taxes quarterly.

Business Insurance

Thinking about legal entities of your business, taxes, and deductions may not be fun, and thinking about insurance may not be either, because thinking about insurance means we are acknowledging everything that could go wrong and what could happen if they did. As attorney Chris Reed (2016) writes, "Insurance is a way of managing risk." And like certain types of business entities that keep you from being personally liable for a defective product, an injury, a defamation claim, insurance is an added layer of protection.

> In short, insurance allows people (and companies) to engage in activities that could cause harm—either physical or economic, to yourself or others—without having to take on all of the risk. It is a way of protecting against liabilities that could exceed your ability to pay, leading to financial distress or bankruptcy.
>
> (Reed, 2016)

Three main types of insurance may be of interest to your self-employment or entrepreneurial endeavors: commercial professional property, general liability, and errors and omissions. The first, commercial professional property is protection for all of the things or equipment that is essential to your business. If you're a music composer and arranger, this may mean computers, expensive audio equipment, and musical instruments. If you're a photographer, this may mean cameras and lenses, tripods, large screen monitors and computers, and lighting equipment.

Commercial professional property insurance is essential if you use expensive equipment in your line of work—equipment that could not be easily replaced by paying from your bank accounts. And if you think this equipment may be covered under your homeowners or renters insurance, please check your policy, as those usually only cover equipment for personal not business use.

Liability insurance covers any mishaps that may happen, such as the painting on the wall falling and hitting someone, like the example from the business entity section of this chapter. General or commercial liability insurance protects the insured (the person or company who took out and pays for the policy) against lawsuits and claims that fall within the policy coverage.

Lastly, errors and ommissions insurance, sometimes called E&O, is for when things don't go as planned, when a job fails or was done in a less than professional manner. "E&O policies also typically cover things like copyright and trademark infringement, invasion of privacy, failing to get a model or property release, and related issues," according to attorney Chris Reed (2016).

All of these types of insurance are available individually or as a package policy (meaning lumped together, sometimes with a multiple policy discount). The things to pay attention to with any insurance policy are: how much will it cost (the premium); how much coverage does the policy offer; what are the limits; what are the risks and exclusions; how much are the deductibles; and does the policy cover replacement costs (meaning how much it would cost to buy a new one to replace the old) or actual cash values (meaning depreciation is factored into the amount when calculating replacement cost of a damaged or stolen item).

The premium is how much you have to pay for the insurance. The coverage is what kinds of things or incidents can be claimed. The limit is the maximum amount of money the policy will pay out for an incident or claim. The risks are things that are covered (for example, fires, floods, or theft) and the exclusions are things that are not (for example, acts of God and terrorism). The deductible is how much you must pay out of pocket if there is a claim against the policy.

If you decide you need business insurance, check with the trade associations to which you belong (or check the list in the Appendix of this book for one), as many professional organizations have developed relationships with insurance companies to get members discounted rates.

Saving for Retirement (and a Rainy Day)

In addition to insurance providing us and our businesses with an amount of protection, a savings account or having money in the bank does too. Savings can be used, if necessary, during the leaner months of self-employment, and it can be used if we have to replace a piece

of equipment or to expand our businesses to fulfill unexpected orders. Having money in the bank also tides us over when we have to shell out for expenses covered in our contracts, such as plane tickets to fly to a consulting gig, and then wait for the reimbursement check to come.

In Case Study 5.1, interior designer Jane Hughes talks about how savings is what got her business through its first two years in the aftermath of the national tragedy of September 11, 2001.

Case Study 5.1 Jane Hughes

I was working for an interior designer who did primarily resort work in Florida. I was unhappy and decided to take a job in Cincinnati, Ohio, to move back near my family. The day before the moving truck showed up, I received a letter saying the firm I had been hired by could no longer afford to hire me. I moved anyway since I had already given up my home; a few days after moving back to Cincinnati I received contact from a builder I had sent my resume to, and they offered me part-time work, then I received another call with similar results. Therefore, I decided I could go into business for myself so I contacted a woman who owned a residential firm and asked her if she would let me run my projects through her company to help her support carrying more furniture lines for her clients and designers to utilize. I negotiated a rate of payment that was advantageous to me and helped her keep her company afloat. After six months, I hired my first employee because my business grew so much. I had more work than I could do on my own and didn't want to disappoint my clients or miss out on anything.

So, I became an independent contractor (with my own business license, tax number, etc.) and then four years later I bought the firm I was working from. I kept the existing staff and other designers to provide a secondary form of money coming into the firm, besides what I was already generating. And I made sure I let the office manager handle the payroll, quarterly and yearly taxes, and the office manger was in constant contact with our contracted accountant to make sure we were doing it correctly. I had grown up around my

uncle and my father who were businessmen, and they always told me, "Hire people best suited for jobs and let them do their jobs. You can't do everything by yourself well."

My time was better spent doing what I was good at and letting others do what they were good at. And the cost of hiring staff, it was a positive situation for me. I hired design assistants and paid them hourly, and then encouraged them to act as independent contractors and develop their own clients, of which the firm took a percentage to supply access to vendors, office supplies, office space, working showroom, office support, etc.

One of my clients was an existing client from the firm I worked for in Florida. I did not solicit any of my previous clients, but after I left the firm, this client remembered my family was from Cincinnati and my father's first name; he called every Hughes in the Cincinnati phonebook until he found my father who then passed on my contact information. I evolved from designing for the resort and hospitality industries to designing residences and multi-family complexes and now to consulting on senior living facility designs. Really it is all of the same as you are selling an experience through your design.

I feel like I created a brand for myself and my business by having an open book policy. I was transparent in my business practices before it was a buzzword. I started working for myself in the mid 1990s and was very clear in my contracts how I would charge my fees and supply furniture, accessories, etc. at cost plus a percentage and my clients were able to access my project binders at any time they would like. I was always open and honest with my clients and they were open and honest with me. I had three main clients for almost 20 years.

But even with the steady clients, it wasn't always smooth sailing. I signed the bank loan paper work and wiped out my savings to purchase the business three days prior to September 11, 2001. I knew that the attack on the United States would wreak havoc with the economy and I was worried I was going to lose everything I had just started. I knew enough about the construction business to know my client's projects were purchased and then developed in a two-year cycle. So, I knew that the properties they had bought up until September 11

still had to be developed in the next two years to satisfy their bank loans, so I was guaranteed work for two years. I also reasoned my clients wouldn't buy land in those same two years, so I need to save every dime I made during the first years to weather us through years three and four. It did indeed happen that way, but because I had paid attention to the business cycles ebbs and flows, it allowed us to stay in business when many firms had to close their doors.

The greatest lesson I have learned running my own interior design business is you need to keep the workflow going, you can't focus on just one job at a time, you need to be creating new contacts/possibilities to keep the cash flow moving. I learned this the hard way by watching my dad's architecture firm fail. They were always focused on the job at hand and wouldn't look for the next project until the current one was done. He cautioned me to do things differently, and learn from their mistakes. Fortunately, my portion of the business I really didn't market; my work was all word of mouth for my three clients and they just kept me really busy.

I did advertise to help bring in clients for the designers working as independent contractors. I advertised in magazines, we designed a Designer Show House, and used color brochures. Honestly, none of these brought us many additional clients; our best advertising was with existing clients, friends, and family word of mouth. It's important to find your niche and work to your strengths, surround yourself with people whose strengths balance your weaknesses. When you treat your employees and clients with respect, they help spread the word and expand the business for you.

One thing I wish someone would have told me as I prepared for my career, and that I try to instill in the future interior designers I work with now, is work your hardest on every project in school, as these are the items your future employer is going to judge you on. You want to be considered for the best available job out there. The higher the level you start the quicker your career will take off.

Jane Hughes
Interior designer and interior design professor
LinkedIn: www.linkedin.com/in/jane-hughes-92707339

As Jane Hughes said, understanding her industry and saving money is what kept her and her employees and contractors afloat during lean years. When we are at the beginning of our careers is when it seems the hardest for us to save for retirement. Retirement seems like a far-off time period, plus our wallets may not be fat enough for us to sock a bunch of money away.

But when you are self-employed, even though you may not have the financial resources to do so, the federal government permits us to save more of our own monies for retirement—and to deduct this money from our taxable income for the year—than it would if we were employees somewhere. Take this example: in 2018, the maximum an employee can contribute to a 401(k), 403(b), 457, and SARSEPs retirement plan is $18,500, and that is the total amount they can deduct as taxable income. (Meaning if you make $68,500 in 2018, and put $18,500 in the retirement account, you pay taxes like you made $50,000 worth of income. The maximum your employer can contribute to your account is $36,500, for a total of $55,000 being put into your retirement plan for the year.)

When you are self-employed, you are considered both the employee and the employer. So if you set up a SOLO 401(k) or an Individual 401(k), sometimes called an I-401(k), you can deposit both parts yourself into the account and lower your taxable income by up to $55,000 . . . as along as you have enough income. Financial adviser Aaren Strand, of Paracle Personal Financial Management, explains that if you're self-employed and work for someone else as an employee, you can contribute to both, within the income limits of the $18,500 of "employee" contributions in both retirement accounts, while still adding up the employer profit sharing portion ($36,500) to the SOLO account (Personal communication, February 2018).

Plus, depending on your income levels, you could also contribute to a traditional or a Roth IRA. (Or both if you're making lots of money and want to squirrel it away for retirement.) Both the traditional and Roth IRA have a maximum contribution limit of $5,500 per year.

While these numbers may seem overwhelming as you're starting your freelance career, when it comes to saving for a rainy day and for retirement, it's important to get into the habit. Even earmarking a small amount to weekly or monthly go into both a savings account and a retirement

account will accumulate, providing a cushion and some benefits when you're older and grayer.

Now let's talk about ways to make more money to fund all of the aforementioned things and more.

Business Plans and Project Proposals

Freelancers often are asked to put together proposals as a way to bid on or pitch a project. Or they may be asked for their company's business plan, when applying for grants or other awards. Knowing what these documents are and what the usual sections of them should be is essential in an entrepreneurial career.

First let's talk about the business plan. A business plan is literally a plan that explains how your business runs. As the Small Business Administration (2018) says, "A good business plan guides you through each stage of starting and managing your business. You'll use a business plan as a roadmap for how to structure, run, and grow your new business." You will need a business plan if you go to a bank to get a loan for your business, if you try to acquire seed or venture capital or angel investor money, if you apply for grants or other monetary awards, and if you bring on partners or investors of any kind.

And while there are many ways to write a business plan, plans usually are classified into the categories of traditional and lean startup. Templates for both are numerous online. Traditional ones are the most common, though, and use a standard, very detailed structure that includes sections titled Executive Summary, Company Description, Market Analysis, Organization and Management, Service or Product Line, Marketing and Sales, Financials (might be projections), and if you're asking for money, Funding Requests (Small Business Administration, 2018).

The Lean Startup Model of a business plan contains sections on key partnerships, key activities, key resources, a value proposition (meaning what unique contribution does your business make to the industry or market or world), customers relationships and experiences, customer segments (who is your target market?), distribution channels (how will you reach your customers or clients?), and revenue streams (how will your company make money?).

Once you've answered those questions by writing out a detailed business plan, you can start pitching companies and prospective clients/customers using a project plan. A project plan can look like a pitch e-mail or letter from Chapter 2, or it can be more detailed, depending on what type of business and industry you are in.

If you run a photography or videography company, your project plan would include services provided, supplies provided (if any), timeline of the event and of enhancements or editing and delivery and maybe a payment schedule, plus costs. For example, when my company Women's Wellness Weekends sponsored a four-hour workshop that we had videotaped, the videographer's project plan specified four hours of videoing with two cameras on a specific date at the agreed upon location, two weeks afterwards for editing and adding text to the film, a final product delivery date, the total cost with a request for 50 percent of the fee upfront with the balance paid upon film delivery. It was a simple, one-page plan, and once agreed upon, he sent over a longer contract (covering all of the things in Chapter 3, like rights and liability) for us to sign.

A few words about pricing on proposals: some people write project plans that lump the costs into one sum; others prefer to parcel it into hours or activities or other easily identifiable bits. Either choice can be beneficial or detrimental, depending on how you look at it. With a lump sum, the client or person receiving the proposal may not have any idea how much time it will take for you to do a particular thing, so your price may look really high or really low. But if you're faster at a task than some people may be, you may be at an advantage of pricing per project. If you're slower, it may not be to your advantage as you could end up with an abysmal hourly rate. If you price per hour or activity, you may get into a discussion with the client that will end in you being asked to cap the number of hours, as a cost control measure. The advantage with pricing per activity is that activities can be added (with an extra fee) or taken away (with a loss of that fee) to get you to the contract stage.

Grant Applications

Grants are semi-free money. I say semi-free because applying for grants is a lot of work so it may eat into time you could use doing paid work for

clients. But, on the other hand, grant money can help you obtain equipment or fund a passion project or take your art to the next level of public exposure so it may be well worth your time and pursuit.

In order to apply for any grants, you must have a comprehensive and financially viable business plan. After that's done, think up some ideas of projects you want to do, and then click on grants.gov, as that's the website for federal, state, and local government grant programs. Government agencies are the biggest distributors of grants in the United States, though searching through the grants administered by a wealth of government agencies can seen daunting, both because of the sheer number and scope and because of all of the jargon.

You'll need to register as a grant applicant in their system by clicking on "Register" and then wait for a couple of weeks until they approve you. In the meantime, you can start spooling through all of the grant opportunities by going to "Search Grants." For example, if you use a generic term like "art" you end up with six pages of grant possibilities involving everything from global health to Historically Black Colleges and Universities to Disability and Rehabilitation Research Projects. Choose the ones that seem closest to the projects you want to do.

Then research past grant recipients for those awards, and look specifically at what kinds of projects got funded and how much money they got to understand if that grant is really a fit for you, and if it fits into the amount you need for your project. The key is to be able to tailor your grant application to what you think they are looking for, based on past funding that they've done.

Grants.gov offers special grant programs for women, minorities, veterans, people with disabilities, and American Indians, and business owners who fall into these categories can take advantage of special grants and an accelerated grant application progress (Zoldak, 2018).

And if for some reason you can't find a grant at grants.gov, check out grants from state or regional small business agencies such as the Economic Development Administration and your local Small Business Development Centers, or look to private grants, such as FedEx's Small Business Grant, LendingTree, or the National Association for the Self-Employed.

If you have any questions or don't understand anything on the grant application, reach out via e-mail or phone to the grants administrator. It is that person's job to answer questions about the grants, just be sure to read

all the materials about the grant BEFORE you contact the administrator so you can have all of your questions ready in one go and so you know what you're talking about.

And know that once you are awarded a grant, after the project period is complete, you will be expected to write and turn in a grant report that answers questions about how you use the money and what results you got, along with providing evidence, which can be in the form of photos, video, flyers, or whatever makes most sense as evidence of your project and its completion.

Other Ways to Generate Income

Other than grants or getting a business loan, freelancers and entrepreneurs finance their businesses and projects in creative ways. Some turn to crowd sourcing. Others turn something they've created into a different format. For example, some industrious folks turn their books into online courses or their online courses into books. Or they turn their creation of artwork into inspiring how-to videos (check out Andrew Cadima's YouTube channel for an example of this www.youtube.com/channel/UC0hIZT3YH2IXWwVhlS2QuiQ).

Or sometimes, paid contract work finds us in unexpected ways. Take the example of Jill Gleeson, a former radio personality turned travel journalist, who started a blog called GleesonReboots.com to deal with the heartbreaks of her brother's heroin overdose and death, her boyfriend moving out and leaving no forwarding address, and her parents' failing health. Gleeson founded the blog to help keep herself sane and to feel like she wasn't alone, thanks to people's comments. But the blog did more than that. It caught the interest of editors at *Woman's Day* magazine, and they ended up offering Gleeson column space in their magazine. Since the end of 2016, Gleeson has written not only about her brother's death and her failed relationships, she's written about caring for her elderly parents, miscarriages and divorce, going on a yoga retreat in the Galapagos (though she despises yoga), how horses relate to humans' emotional pain, sex, antidepressants, and all kinds of other topics.

Regardless of the industry you are in, there are always opportunities of things you can add to what you are doing or of ways to expand your

offerings. If you write, you can learn some photography skills and add photographs for extra income to the articles you sell. Or you can syndicate your writing. Sarah Smiley (2018), nationally syndicated columnist, explains that you can syndicate through an agency or on your own. If you go through an agency, they do all of the marketing and proposal writing for you and the pitching to publications. If you do it on your own, you'll have to write the columns and pitch them to all of the publications and do all of the invoicing . . . but you get to keep all of the money instead of sharing it with an agency.

The other way to make income is by bringing people into your business as either contractors or employees. Two professionals ideally can make twice the money that one can. In Case Study 5.2, Kristen Gill talks about how she started freelancing and then when she knew it was time to expand what she was offering and bring more people into her business.

Case Study 5.2 Kristen Gill

I've been a writer for most of my life, sometimes working full-time for a company, but mostly as a freelancer or contractor. The way I started my own business came about in an odd way: I was laid off from my job as a technical writer for one of Paul Allen's startup companies in Seattle. I had worked there four years and knew the lingo and systems very well. Since they cut our entire department, but still needed the same jobs done, I decided to quickly form my own business (which wasn't as hard as I thought) and guess who became my very first client? Yep, the same company that laid me off weeks earlier. I was even able to charge twice as much for my hourly rate.

I've been a freelancer ever since, and have recently expanded my new company, Kristen Gill Media, to provide storytelling services. Using film, photography, and the written word, we help businesses tell their stories. We recently signed two new clients for 2018 that will keep us busy for a while.

After a few years of freelancing as a solo entrepreneur I realized that I could potentially land larger (and better-paying) gigs if

I had some additional help, so I recruited a couple other writers and editors, as well as photographers and videographers, to add to the team. Now I can bid on bigger-scale projects knowing that I've got the manpower to do it. I pay most of these as subcontractors, meaning that they are paid for their time on the job, rather than as an actual salaried employee.

I also hired a virtual assistant, a part-time bookkeeper and a tax consultant on a yearly basis. As these are not things I do well, I made the decision to hire outside for these three positions. I only wish I had figured this out earlier and saved myself lots of time and headaches.

One important lesson I learned early on in my career was to overcome my fear of going for the job or getting the client:

In order to be successful, you need to diversify your portfolio and create niche markets. My core skills are writing and photography. Whether I'm working in the travel and tourism industry or the tech industry, the skill set is the same. You need to be good at researching, asking the right questions, outlining, writing, editing, etc.

When I first moved to Seattle, I knew there were a lot of tech companies looking to hire, but I wouldn't say that I was tech-savvy, and at first stayed away from those positions feeling like I lacked the skills necessary for the job. But when I interviewed, what turned out to be my very first boss at Microsoft told me that I should go for it, as the job basically meant I would be translating technical jargon into language that everyone could understand. She said my skills would be a good fit, and I trusted her (even if I didn't yet trust myself), and I worked for that company on and off as a freelancer for over 12 years.

To this day, I write for a wide variety of industries, so if one area dries up, there are others to lean into.

I would say that before trying to expand your business, make sure you have all of your ducks in a row. Do you have templates for all of your needs, such as contracts, sample Statements of Work, legal documents, business name registered, etc.? Before you start adding others to your company, you'll want to have some sort of solid system in place.

You should always be networking. I've found clients via a friend of a friend that I met at an art gallery opening. Of course, I also regularly attend industry meet-ups and use tools like LinkedIn to network.

You will want to take a hard look at the numbers and figure out how much to set aside for taxes (this can be alarming sometimes), and also figure out how much you can afford to invest in your retirement funds.

Know the market rate for what you do, and do not go below what you consider fair. I always like to tell people, "I won't charge you a dime more than I'm worth."

Pick only one cause to do pro bono or below cost per year. This way you can give back without depleting your resources or your bank account.

While I don't have too much going in regards to passive income, it's a good idea. If you can sell something repeatedly by only doing the legwork only once, by all means it's a good idea.

Some of the important lessons I've learned over the years include:

- Stay focused.
- Don't be afraid to readjust your business to the times.
- Put in the work.
- Be passionate.
- Do the best you can.
- Always believe in yourself, because if you do, others will believe in you, too.

Kristen Gill
Founder and CEO, Kristen Gill Media
Twitter: @kristengill
Facebook: www.facebook.com/kristengillmedia
Instagram: @TheGiller

A Multi-Faceted Approach

Kristen Gill talked about her multi-faceted approach by having clients in a variety of industries, and by offering multiple channels (written words, photography, etc.) for people to tell their stories. Most of the people

included in the case studies in this book have that approach: they do more than one thing and have all kinds of clients from all over the United States, if not the world.

Having a multi-faceted approach and multiple streams of income helps freelancers and entrepreneurs weather changes in the economy overall or in certain sectors. As Stephen Warley and Kristen Gill pointed out, companies hire people for their skills, not necessarily for their job titles, so by developing fine art or writing or design or sales skills, you can do work in any kind of industry.

Let's take a few moments and discuss ways you can monetize some of the things we've already mentioned in this book. In the last chapter, we reviewed the importance of having a website as it establishes your credibility and your authority, especially if you're providing quality and up-to-date information on the site. One way your website can make money is if your blog posts contain branded content. Branded content is literally a company paying you money to mention their product(s) or to include a quote from their representative. It's sometimes referred to as pay-per-post. News websites throughout the United States have branded content on their pages (and it is usually marked as such with "paid advertisement" or "branded content" above or below the headline or article). In order to have companies pay you to put branded content on your blog, you usually need to reach a minimum amount of website visitors on a regular basis. Or if you don't want to write the blog yourself, sometimes companies or individuals will pay for you to publish a blog post they have written.

Other ways to make money include turning your blogs into a book and then selling the book, or creating podcasts or online courses. Laura C. Browne, co-author of my book *Raise Rules for Women: How to Make More Money at Work*, created a Udemy course titled "Successful Tips for Women in Business—5 Practical Steps," using some ideas in the book, plus many others she's learned in her career, as a way to make money, promote her coaching program, and promote her books. Other people join speakers bureaus—of which there are many—to get paid speaking gigs at corporate events, retreats, university commencements, and many other places.

In Case Study 5.3, serial entrepreneur Kristie Burns explains how she lets her interests guide the work she does and the businesses she starts, which are very multi-faceted.

Case Study 5.3 Kristie Burns

My biggest success was when I finally decided to take my freelance/self-employment business to the "next level" and form a corporation and start hiring people to help me. Before I did that it seems like I focused too much on the "self" part of self-employment and put a lot of pressure on myself to do everything. I was earning a modest income at the time and felt "safe" doing hard work and earning "enough" without the commitment of having employees or a lot of structure. I resisted allowing my work to grow because I felt comfortable.

Allowing myself to take a risk and get out of my "comfort zone" was the best decision I ever made. It forced me to get more organized. The year after I incorporated I created a 63-page company manual on how to run my company, purchased life insurance for the company, created videos on how to run the company, hired a public relations assistant and started hiring contractors to do a lot of work that had been piling up, like editing and creating more tutorials.

I was still self-employed but I was now much more organized, taking my company a lot more seriously, and gaining more respect from those around me. The value of the company has almost doubled every year since this.

My biggest learning experience happened the first time someone asked, "Do you provide this product?" and I said, "yes," even though I had to scramble to create what they had asked for. This was my first step in learning that it was much easier to make money by filling people's needs rather than telling them what they needed. As an entrepreneur, I didn't have the big advertising budget to persuade people to buy my product. Instead, I started listening to what they wanted and providing that. Whenever I heard someone say, "I really wish someone would offer . . . " or "Do you offer . . . ? I'm having a hard time finding it," I would immediately think of adding that to my business plan.

Looking back I think that was probably one of the most valuable lessons I learned. If I had gone the direction I first intended, I would now be struggling in a market that is filled with intense competition

and large companies with big advertising budgets. Instead, I have found my own little niche markets and discovered that there is a lot of money to be made in niche markets.

If you are setting your goals based on big corporations or famous CEOs who make large salaries, you might be surprised to know that you can earn quite a lot of money in a niche market. You don't need to "go big" or be a big name to make a great income that is on par with some of the bigger names.

Rather than letting my experience and degree define me, I let them lead me directly into business opportunities instead. Every time I pursued a new interest, I asked myself, "How can I earn money doing this instead of just doing it for myself?" I slowly learned that a person can make money doing anything—even if they are a student of the topic themselves. The simple formula I followed over time was (1) find something I want to do (travel, photography, learning about another culture, learn a language, study naturopathy, etc.), and (2) find a way to make money doing that thing. When I wanted to travel, I would try to find someone to pay me to do a photo job in that location. When I wanted to learn a language, I took a photography job in a country that spoke that language. While I was studying naturopathy, I started writing a newsletter that shared what I was learning.

One of my current companies was formed when I decided to raise my children using nature-based lifestyle choices such as purchasing natural clothing, natural toys, and earth-based education. To accomplish this for my own family, I had to do a lot of research and create nature-based lessons for them in the home. During this process I noticed how few resources were available so I decided to offer the resources I had created for my family to other families.

By doing this I found out there was a great need in the community for resources on this topic. Many people wanted earth-based curriculum and lifestyle choices for their children and families, but

at that time (23 years ago) the Internet was not as developed as it is now, social media did not exist and there were almost no resources online that covered the topics of natural well-being, naturopathy and earth-based education. This prompted me to keep creating more resources. I created an online blog, an online newsletter, a small website, video tutorials, small lessons and more.

These small offerings were sold through eBay and a one page website I created using HTML coding I learned from my brother. I continued to listen to my customers' needs and added new things every month. Soon I had to expand the website. Sometimes I tried things that did not work, but I was always trying new things. That one-page website with a few listings on eBay has now grown to a 200-page website with an on-call webmaster and offers over 500 products and services.

When people ask me what I do now I say, "I am the CEO of my own company." I used to be shy about telling people what I do and had a hard time explaining it. However, now I am very proud of my work and enjoy sharing. I spent more than 23 years building this business and have learned a lot during those years.

I am able to set my own hours, be my own boss, make my own decisions, do things I love doing, and work from any location on earth. This is attractive to a lot of people, so I meet a lot of people who see my lifestyle and express interest in knowing how they can start their own business, too.

I always tell them that they need to be committed to it and know that the first year or two might be really hard. That is normal so don't be hard on yourself if you don't get a response right away to a social media campaign or it takes a while for people to find you. You are not doing anything wrong. It is normal for a business to take time to build a clientele.

The second thing every potential freelancer or business owner needs to do is to choose something they are passionate about. Since building a customer base and finding your way takes time be sure to

choose something you love doing so you won't mind all the thankless unpaid hours you work in the beginning.

Third, you need to set up yourself professionally from the very beginning. Once you have a website, a company e-mail, a business name, a tax ID, a logo, and business cards, you will hold yourself more accountable for the success of the business and customers will take you more seriously. It is okay to start small on a shoestring budget, but don't start so small that you skimp on the website, logo, or other essentials. Make sure you have a solid base. You are putting a lot of hours into this. In some cases you are putting your heart and soul into this, so make sure you plan to honor that and leave a legacy. Don't build something shaky that will crumble if you get sick or can't work on your business for a few weeks. Build a legacy.

Fourth, be efficient. Capitalize on the things you do. Are you already traveling to a remote area? Contact some media outlets to see if they need photos or articles. Are you planning on attending a special event? Offer to take photos of the event and sell them afterwards. Do you have a special story you created for your children because you couldn't find the message you wanted in other books? Self-publish your story. Do you always bake a lot for the holidays? Get a permit that allows you to sell your baked goods and offer to save some friends and contacts time over the holidays by selling them some trays of baked goods as well. Are you going to spend the weekend organizing your closet or basement? Invite over some people and hold a class in "how to organize." Are you making some herbal syrup for the flu season? Hold a class for your contacts, charge a small fee, and make the syrup together.

Last, but not least, seek out help. I tried to do everything on my own, but I didn't sleep a lot and only made a moderate income. Once I started networking, cooperating with others, and hiring staff and contractors, the business grew exponentially, my income increased and my work hours decreased to one to two hours a day

with occasional longer days for projects. I've been spending the extra time building my photography business again, developing new curriculum and products for clients, and expanding the business in general.

Another aspect of seeking help is that the people who help you also become part of your network. They will naturally promote you, and if their work is part of your business (like an illustrator for your book), they will be invested enough to promote you even more.

Then, once you get the business going the three things I "wish I knew in the beginning" are:

1. *Take good care of customers.* If someone purchases from you, make sure that is not the last time they hear from you. Send out newsletters, a yearly card or something that let's them know you are there for them and will continue to support your product. This will encourage them to purchase from you again, refer you to friends and family, and feel happy in general about their purchase. They will also be able to easily contact you if something goes wrong and this can help you improve your product.

2. *Remember you have a business relationship with your clients— not a friendship.* You can have friends that are clients, but when it comes to your business it should be 100 percent business. The prices, rules, and interactions should be the same for everyone. To help you with this, you should create "form letters" and "standard responses" to frequently asked questions (FAQs). Everyone should receive the same response to the same question. You can add a personal "hello" or response to personal information they shared but the message should be the same. These FAQs and policies should also be posted on your website. Customers get angry when they feel you have different rules for different people. If you don't have a standard response then family and friends may try to ask for special consideration,

and customers will feel comfortable writing you with personal requests. This will be very stressful over time and will cause you to lose income and efficiency. For me, creating these "standard responses" is an ongoing project.

3. *Use social media to market and adapt to changing times.* You should hire someone to help you with this because more than 50 percent of the success of your business depends on your social media and public relations. The person you hire can be trained to run your public relations campaign if they have that skill set or you can take some time to create the campaign yourself and hire someone to post the advertisements and posts for you. I create a new set of campaigns every couple of months and add them to my "PR folder." I then have a student post these in rotation on all my social media platforms a few times a day. Repetition is good and as you create more campaigns (sets of quotes, sets of questions, sets of links to your blog or products, articles, etc.) your customers will see almost no repetition because not every customer is going to see each platform.

<div align="right">

Kristie Burns
CEO, The BEarth Institute
www.TheBEarthInstitute.com
Twitter: @BEarthInstitute
Facebook: www.facebook.com/TheBEarthInstitute
Instagram: @BEarthImages and @Earthschooling
LinkedIn: www.linkedin.com/in/kristieburns

</div>

As Kristie Burns explained, she has structured her businesses in such a way that they generate active and passive income, so let's explore what that means.

Active vs. Passive Income

Investopedia (2018) defines active income as "income received from performing a service. This includes wages, tips, salaries, commissions and

income from businesses in which there is material participation." Active income is what you get for speaking engagements, consulting gigs, commissioned paintings, or musical arrangements or scores, and book royalty advances. It is pay we get for work.

Its counterpart is passive income, which Investopedia (2018) defines as "earnings derived from a rental property, limited partnership or other enterprise in which a person is not actively involved." Royalties from book and e-book sales and musical recordings, affiliate advertising programs, affiliate marketing, and arguably prints created from original artwork or an e-book created from a self-published book that was originally in print format could all be considered passive income. The key to passive income is that it is generated with little effort on the part of the person who receives the income.

So let's explore its options more in-depth, with special attention to affiliate marketing and affiliate advertising programs, as these are the most common (and easiest) ways to monetize your website beyond directly selling things. In simple terms, affiliate marketing is when you recommend a product to your readers or website visitors and then you get a percentage of the sales made if your website visitors click through your site and purchase the product.

Affiliate advertising programs have several different set ups and ways you can get paid. We've already discussed the pay-per-post method of words or a company's name embedded on your blog. The most popular affiliate advertising program is the pay-per-click program, which means you get paid any time someone clicks an embedded ad on your website. Google AdSense is the most popular pay-per-click affiliate network and it is free to join.

Other types of affiliate advertising programs you can tie to your website include:

- Pay-Per-Lead, where advertisers who want to enroll people in something place ads on your website and then you get a commission for every person who signs up through you.
- Pay-Per-Sale is what it sounds like. You post the ad and anyone who buys something through the ad makes you money as a commission on the sale. Amazon has an affiliate program that operates this way.

- Pay-Per-Action is similar to pay-per-sale, but website owners get paid if people hover over ads or call numbers on the ads.

At last Google search, about four-dozen companies are in the affiliate marketing business as their main sources of revenue generation, companies like Bidvertiser and Affiliate.com. This count does not include health and wellness companies who pay affiliates kick-backs for hawking courses or products or any type of businesses that do one thing but then have an affiliate program on the side. The opportunities to make money this way are limitless, but the amounts of money received per click may take a while before you see any serious money, unless of course, you have a high-traffic website.

Chapter Summary

The legal structures most commonly used for businesses are C-Corporations, S-Corporations, Limited Liability Corporations, Partnerships, and Sole Proprietorships. Each structure has its benefits and drawbacks. The IRS expects all monies generated from a business to be reported as income, and deductions may be taken on most business expenses. Insurance is one of those expenses and is necessary to help protect companies and their owners in the case of claims filed against them. Self-employed persons and their businesses generate revenue or income from a number of ways, both actively and passively, and having multiple streams of income from multiple industries and through multiple channels helps keep businesses afloat and profitable.

Exercises

1. For the town you live in or plan to live in, research the requirements for starting a business (as a sole proprietor under your own social security number and as a separate business entity such as an LLC). Will you need a business license? Will you need to file quarterly taxes?

2. Explore possible software options for keeping track of invoicing, accounts receivable, accounts payable, etc. Is using something like Excel or QuickBooks or Mint or something else best for your business and why? Compare prices and the benefits and drawbacks to using each system.

3. Explore grants.gov and find six grants to which your business could apply. List the past winners, their projects, and the amounts received. Then write a paragraph for each about why your project fits that grant idea.

4. What are four affiliated ideas you could do to create more income in your potential business?

5. Brainstorm five ways you might make passive income either based on your skill set or your interests. How much time investment would each take? What would the potential income upside be?

References

"Active Income." *Investopedia*. Accessed March 15, 2018. www.investopedia.com/terms/a/activeincome.asp.

Cadima, Andrew. YouTube. Accessed March 15, 2018. www.youtube.com/channel/UC0hIZT3YH2IXWwVhlS2QuiQ.

Gleeson, Jill. "Gleeson Reboots." Last modified February 27, 2018. www.gleesonreboots.com.

Lankford, Kimberley. "Tax Deductions for Independent Contractors." *Kiplinger*. Last modified January 2017. www.kiplinger.com/article/taxes/T055-C001-S003-tax-deductions-for-independent-contractors.html.

"Passive Income." *Investopedia*. Accessed March 15, 2018. www.investopedia.com/terms/p/passiveincome.asp.

Phillips Erb, Kelly. "LLCs, S Corps & PCs: Choosing a Business Entity." *Forbes*. Last modified August 19, 2015. www.forbes.com/sites/kellyphilliperb/2015/08/19/llcs-s-corps-and-pcs-choosing-a-business-entity/#3ed60ab96b8a.

Reed, Chris. "The Basics of Insurance for Artists." *Artrepreneur*. Last modified August 30, 2016. https://atp.orangenius.com/basics-insurance-artists.

Rucker, Philip. "Mitt Romney Says 'Corporations Are People.'" *Washington Post*. August 11, 2011. www.washingtonpost.com/politics/mitt-romney-says-corporations-are-people/2011/08/11/gIQABwZ38I_story.html?utm_term=.93cfea7d423d.

Schlackman, Steven. "Should I Open a Corporation for My Art Business?" *Artrepreneur*. Last modified September 10, 2016. https://atp.orangenius.com/art-business.

Smiley, Sarah. "How I Became a Syndicated Columnist, And You Can Too!" *Freelance Writing*. Accessed February 24, 2018. www.freelancewriting.com/freelancing/how-i-became-a-syndicated-columnist.

"Write Your Business Plan." U.S. Small Business Administration. Last modified February 24, 2018. www.sba.gov/business-guide/plan-your-business/write-your-business-plan.

Zoldak, Anastasia. "How to Apply for Grants to Start a Business." *The Chronicle*. Accessed February 24, 2018. http://smallbusiness.chron.com/apply-grants-start-business-1857.html.

So You Want to Write a Book or Publish Other Content?

Chapter 6 explores why people write books in the first place, the book publishing process from idea inception to making initial contact through a query letter—if going the traditional publishing route—through book proposal and then the actual writing of the book and the publishing process. It also explores whether or not one should get an agent, self-publishing options like Amazon's CreateSpace and BookBaby, and provides tips on how to make some money from your book(s). Chapter 6 includes query letter and book proposal examples, plus stories from people who have written books and suffered through pitfalls of not making much money (especially for the time and energy) and those who have found success (either the book itself or using the book to set themselves up as an expert in a given field). Chapter 6 explores not only the traditional process and ideas of "book" but also includes information on publishing books of photos or designs, music, and prints of artistic work.

Why People Write Books

According to *Publishing Perspectives*, 200 million Americans want to write a book (Goldberg, 2011), but their reasons for wanting to write books vary widely. Some people want to see their names in print or on a front cover. Other people think writing a book or a series of books may bring them fame or fortune, like it did to J.K. Rowling, whose fortune is now listed at more than one billion dollars thanks to Harry Potter and

its offshoots of movies, amusement park rides, children's toys, and other merchandise (Zillman, 2016). Or some people choose to write books so that the books establish them as an expert in a certain field or the books help market whatever business(es) they have. And some authors create books to fulfill a need, as they see it, in the publishing industry.

Professional modern dancer and dance teacher Alison Rose decided to write a children's book after she found few to no picture books about modern dance. She talks about that process in Case Study 6.1.

Case Study 6.1 Alison Rose

Recently at the school where I teach, a second grader came up to me and said, "Oh you wrote a book. But you're a dance teacher," as if a person couldn't be a dancer and an author. This is one of the reasons why I thought writing *Shoes Off, Mommy?* was important.

When I was younger, I loved dance. I took tap, ballet, and jazz classes but none of it felt quite like me. It wasn't until I discovered modern dance, a form of dance that anyone of any shape and size can do, that is done with no shoes, with the dancer connecting to the stage and the earth, that I felt like I found my dance home. But the thing was, no books for children seemed to introduce them to modern dance. Plenty of books were about ballet, and a few were about tap, but modern dance children's literature seemed to be lacking.

I spent my academic training studying dance and dance education. I danced with Randy James Dance Works and have toured both nationally and internationally and this fulfilled my dream to become a professional modern dancer. But I didn't stop there. When you follow your passions, it takes you on incredible journeys.

Shoes Off, Mommy? was a story burning inside me. I really didn't know much about writing a children's book, but I started writing and talking about the project with the people around me. My next-door neighbor, who is a University of Southern California English

professor, helped me get the language and the ending of the book just right. And my mom has a friend who works for DreamWorks, a friend who danced in her youth, so she understood my concepts and made beautiful illustrations. We had the perfect collaboration.

An online marketing guy I knew told me that I needed to create an online presence and a ShoesOffMommy brand BEFORE the book came out. So I started the website www.shoesoffmommy.com and created social media accounts and a blog to get my name and the book's title out there. Once I created the presence and people started paying attention to it, it made it easy to sell 75 copies on the day of the book's release.

I decided to go the self-publishing route since I had all of the pieces (the story, the illustrations, and a marketing plan, plus a built-in audience among my students, their parents, and the workshops I teach for children at the Walt Disney Concert Hall in Los Angeles). Self-publishing has options to help you design the book's cover and the book's interior, if you need it, and some print-on-demand companies also offer editing help, all for a fee or a package, of course.

I've had a few issues with the self-publishing platform I chose. Some books have been put together with the insides upside down compared to the cover, and sometimes the colors of the illustrations aren't the same in every copy; they are a bit off. But like any first experience, you learn, and maybe I'll try a different company for my next book.

And yes, there will be more books, because now that I did *Shoes Off, Mommy?* and had success (*Dance Teacher Magazine* recommended it as "a new and popular release") I feel like I've been bitten by a bug. I joined the Society of Children's Book Writers and Illustrators to network and to learn more about children's book publishing.

I'm also exploring traditional publishing options for future books. I've worked with a writing coach to create a compelling query letter for my next book idea and I've started sending it out . . . and getting

rejection letters on it, too. I don't know what the future holds as far as who might publish my books or whether I should just keep publishing them myself, as that does give me a higher royalty rate. But I do know how important it is to keep writing, especially about modern dance, and introducing the art to young people, and showing those same young people that they don't have to limit themselves in what they do in their lives. They can have as many careers in succession or simultaneously that they want.

Alison Rose, MA
Modern dancer, dance teacher, author
www.shoesoffmommy.com

Author Lisa Earle McLeod (2012) writes on *Huffington Post* that she believes everyone has a book in them. She writes,

Writing a book is hard enough. Getting it published is even more challenging. You have to want it pretty badly. People want to write books for a lot of reasons. They want to be famous. They want to make a pile of money. They want everybody from high school to see that they're not a big fat loser after all. But there's really only one good reason to write a book: because you can't stand not to write it.

While McLeod's advice may sound cynical, the fact is, most books do not sell a lot of copies. The Independent Publishers Association reports that in 2015 (the year of the most recent statistics), the United States published 339 million titles (second only in the world to China) (Ha, 2017). The Authors Guild did a survey of their members in 2015 and found that "more than half of the respondents earned less than $11,670 (the 2014 federal poverty level) for their writing related income" (Neary, 2015). NPD Bookscan (formerly Nielsen) tracks book sales in the United States via the International Standard Book Number (ISBN, the 13-digit number that publishers purchase for each edition and variation they publish). And while there are a few bestselling outliers, even award-nominated

books sell few copies. For example, National Public Radio reported that the two of 2015 finalists of Man Booker Prize had sales of 3,600 and 3,000 copies, with only one of the six finalists selling in the six figures (Neary, 2015).

This is the reality of why you need more than money as a motivator when it comes to writing a book.

Types of Book Publishing

And if you've found a motivator other than money and you still want to write a book, let's explore your publishing options. First, you could go the route of generations of writers who came before you and try to find a traditional publisher (also called trade or commercial publishers). Publishing houses come in huge range of sizes from those that specialize in a niche market and publish only a few titles per year to big conglomerates with many sub-companies or imprints as they are called in book publishing, that publish in a variety of genres. An example of a huge publishing company is American publisher Penguin Random House, which is owned jointly by the German media company Bertlesmann and the British educational publishing company Pearson PLC. Random House's imprints publish fiction and non fiction in all formats, according to their website and include Ballantine Bantam Dell, Del Rey/Spectra, Dial Press, LucasBooks, Modern Library, Random House, and Spiegel & Grau.

To find all of the traditional book publishers, you can visit the website of the Association of American Publishers (www.publishers.org), *Publishers Weekly* (www.publishersweekly.com), or get an annual copy of *Writer's Market* (at major booksellers or at www.writersmarket.com). All of these sources provide information about the types of books and how many titles per year the publishing houses publish and contact information.

To publish through a traditional publishing house, you may or may not need to go through a literary agent (more about that later in the chapter). And you would begin any contact, agented or not, with a query letter, like we discussed in Chapter 2, and will review again in a few pages. Publishing with a commercial or trade publisher involves no expense to the writer. The publishing company buys rights to the content from

the writer and pays the writer in royalties after the book is published. Royalties are a percentage (often 8–20 percent depending on the rights bought and the publishing house) of the list or retail price of the book, and may be paid quarterly or twice per year to the writer, depending on the payment schedule in the publisher's contract. The publishing house handles the marketing of the book title, though the writer is encouraged to help market the title, too.

If you don't want to go the route of traditional publishing, there are basically two other options: vanity or subsidy presses and self-publishing. Vanity or subsidy presses, according to Science Fiction and Fantasy Writers of America,

> charges a fee to produce a book, or requires the author to buy something as a condition of publication, such as finished books or marketing services. As with traditional publishing, a vanity or subsidy publisher contracts rights on an exclusive basis.
>
> ("Definitions," 2018)

Vanity and subsidy presses have little incentive to market your book since they make their money upfront, rather than from book sales.

Self-publishing, on the other hand, is where you do everything (or contract out parts such as editing or cover design). And though it is a lot of work, you may decide you want to self-publish, and retain all creative control. Publishing Perspectives reports that the ratio of self-published books to traditionally published books has exceeded 2:1 for the first time ever (Goldberg, 2011). Science Fiction and Fantasy Writers of America says self-publishing

> requires the author to bear the entire cost of publication, and also leaves marketing and promotion to the author. However, rather than paying for a pre-set package of services, the author puts those services together him/herself, hiring editors, cover designers, publicists, etc. Because every aspect of the process can be put out to bid, self-publishing can be more cost effective than vanity/subsidy or hybrid publishing, and result in a higher-quality product.
>
> ("Definitions," 2018)

In self-publishing, often a writer sets up a publishing company with a unique name and secures ISBN from Bowker (www.bowker.com/prod ucts/ISBN-US.html) themselves.

What Science Fiction and Fantasy Writers of America called hybrid publishing is when a writer publishes through a platform (such as BookBaby or Amazon's CreateSpace) and buys some services offered by the publishing platform, such as cover design or marketing, or even securing of the ISBN.

Now that you have an overview of the book publishing options—for any type of book, be it a graphic novel, children's picture book, art-filled tome, novel, or nonfiction—let's look at the publishing process.

The Book Publishing Process: From Inception to Product

Bill Swainson, a former senior commissioning editor at Bloomsbury, explains to *Writers and Artists* that books come to trade and commercial publishing houses in a number of ways, from an agent, an editor at a foreign publishing house, from an editor who has commissioned a writer, or even occasionally from what is called *the slush pile*, the name for the pile of unsolicited queries manuscripts that get sent to publishing houses by writers, even though the publishing house didn't ask for said queries or manuscripts.

Swainson (2018) writes,

The in-house selection process goes something like this:

- The commissioning editor finds a book from among his or her regular weekly reading and makes a case for taking on a book at an "acquisitions meeting," which is attended by all the other departments directly involved in publishing the book, including sales, marketing, publicity, and rights.
- Lively discussions follow and final decisions are determined from a mixture of commercial good sense (estimated sales figures, likely production costs and author's track record) and taste—and every company's and every editor's preferences are different.

163

Swainson (2018) says after the book has been acquired, a fact sheet about the book is written up and distributed among the different departments at the publishers to start getting the word out.

Then the editing process takes place, first with a structural edit (making sure all of the pieces are there and its structure is sound), followed by a copy-edit, the purpose of which is to catch typos, style inconsistencies, punctuation, or any kinds of errors. The manuscript may be returned to the author after copy-editing to clear up any points or to answer any questions.

And then the book goes into the design and typesetting phase, where bindings and paper may be chosen and other features that enhance a book's physical appearance. It is also at this time that the publishing house may determine the print run (the number of books to be physically published for the first printing) based on pre-sales figures. (Some small publishing houses are using print-on-demand systems in 2018, meaning the book is published or printed once it has been ordered, as opposed to boxes of books sitting in a warehouse awaiting someone to purchase them.)

Proofs result from the book design phase and these will be reviewed by the editor and the author to ensure no errors have happened during the design process. Swainson (2018) says that e-books may have their own proofing process since e-books paginate differently to printed books.

Once everything has been approved, the books go to press, in other words they go for printing, if they are being published in a hardback or paperback format. And while all of this is happening, the sales and marketing teams at the publishing house are hard at work getting word out about the book and getting booksellers and libraries and warehouse stores, etc. to agree to orders. And then when the books are printed, they ship to the various retailers.

Now that you understand a bit about the publishing process flow, you can also see how vanity and self-publishing would involve many of the same steps except you, as the author, would have to do much of the work yourself or outsource it to other freelancers who are experts in copy-editing, designing book covers and book interiors, and publicity. And because getting word out is so important and the only way people will know about your book, if you self-publish, you'll have a leg up on that if you have a built-in audience.

In Case Study 6.2, Kristie Burns explains how she got into book publishing, based on the needs of her audience.

Case Study 6.2 Kristie Burns

I studied anthropology at university because I had always been fascinated with learning about different people and cultures. I studied Spanish, Arabic, French, and German in high school and college. I didn't really know what I wanted to do with all these studies. When I talked to the university career counselor she suggested that I look for a career as a diplomat or a translator. Those seemed like logical choices.

But I started my journalism career by working for my university newspaper. This allowed me to get a lot of experience in an environment where I was given a lot of assignments I might not have gotten at a larger paper. Our newspaper, the *Daily Northwestern* covered some of the same events as the larger newspapers. However, because it was a student paper the competition for jobs was not as intense as it would have been in the city. Working for a smaller paper also gave me the chance to learn from other students who worked for the paper and make mistakes in a safe environment.

By the time I finished this job I had a large portfolio, two solid years of experience with a variety of subjects, and an education from the senior staff photographer that far exceeded what I would have gotten at another job or even in a classroom.

In my third year as a photographer I moved up to taking "real jobs" but I found a market in which my skills were unique. I traveled to Cairo, Egypt, for my last year of college to continue my studies in the Arabic language and once I arrived I started shooting photos for a local magazine in Cairo. If I had stayed in Chicago I would have remained a photographer's assistant for a few years and then perhaps been moved into a better position at a small paper. It might have been years before I got to do work I really loved.

In Cairo, however, my skills were unique. I was a female who spoke Arabic and English and had experience in photography. At that time I was one of only three female photographers in the region and only one of two who spoke Arabic. I was not the most experienced photographer but I was able to get into areas that other photographers could not enter simply because I was female and/ or I spoke Arabic. I was assigned jobs all over the region by the magazine *Cairo Today*. The magazine did not pay very much but the value in this second job was in the connections as well as the experience. I was looking to build my portfolio and the magazine was my "ticket" into places I might not have been able to enter if not for their connections.

In addition, through my connections with the magazine I met journalists from all over the world, and since the magazine was a central contact point for journalists traveling to Egypt, I ended up shooting photos for newspapers and magazines in France, Germany, and Australia. Within my first year I ended up shooting photos at a party thrown by Jehan Sadat and shooting portraits of Luciano Benetton (of Benetton clothing) for a magazine spread. The people producing the movie "Stargate" contacted me for photos of the pyramids and ended up using my photo in the movie (this was before the days of advanced CGI so they needed real photos to work from).

I was also able to work with some of the advertisers who worked with the magazine. Those jobs paid much better than magazine work. Although I did not enjoy advertising photography as much, it was a great way to earn enough money to support myself while working for the magazine and working on my own photography projects. Some of the jobs came with perks like free hotel stays or lavish meals. In my second year there I did an exhibit at the Sony Gallery in Cairo called "Women of Egypt."

The more photos I took, the more I realized that photography was my window into other cultures and that my language skills were an asset in this field. So although I had a degree in anthropology and linguistics, I decided to think "outside of the box" and pursue a

different career. I was still using my degree, just not in the way it was intended to be used.

This is something I have continued to do as my career turned into a business, and then another business and then another . . . I have always found ways to use my skills, the classes I have taken and the experiences I have had in my businesses. I don't let the title of the class or degree define what I will do. Instead I create opportunities based on my unique mixture of skills, education, and experience.

In both of my first jobs I was able to identify what I needed to get where I was going and find a way to get that in the jobs I chose. When you first start out with any job your priorities are experience and connections. If you can find a job that will give you these two things, even in an internship or in volunteer situation, you are off to a very strong start in your career.

Currently, I do two types of publishing—physical books and online books. All of the curricula I write comes in the form of online books. These naturally evolved from the small "lesson plans" I first offered to customers. As I added to the lesson plans over time and the market became more competitive I realized I needed to upgrade what I was offering. So instead of sending customers an e-mail attachment with a pdf I started creating curriculum books. As the demands of the market have changed I have updated these books accordingly. The great thing about publishing e-books is that these updates can happen on an ongoing basis and can be published and available to the consumer immediately. Since my business started, I have updated my curriculum guides six times.

When I first started many people said, "You can't put an earth-based curriculum online. That doesn't make sense." But I saw a need and I saw that people were using the Internet more and the market was growing so I persisted. While other similar companies focused on physical books I focused on creating the best online content and web-based curriculum service I could create and insisted on keeping it exclusively online.

My customers ended up growing into my business. It started small and tentative but I had seen what was coming so when people

started using the Internet more and seeking more online solutions to their needs I was already there and ready for them.

In the area of physical publishing, I started by writing newsletter articles and blog posts about different topics I was interested in. I think if someone would have told me to write a book, I would have been intimidated. I always preferred to do things with more immediate gratification such as taking a photo and developing it or writing a short article and putting it on the blog.

However, one day, as I was preparing a speech for a conference I was invited to I realized I had written so many articles on the topic of the temperaments that I already had a book. I just needed to put it into chapters and edit it. I then realized that the best place to launch this new book would be at the conference. This only gave me two months to complete the book. So I gathered all my articles, re-wrote many of them, created the book, asked more than 16 people to edit one chapter in exchange for a free book and then self-published it.

The book was well received at the conference and afterwards it got many good reviews so I was encouraged. And once I had self-published my first book, the process was no longer a mystery. I realized how easy it was so I was encouraged to do it again. This became a great outlet for creative ideas I had. I found I was even more inspired to keep creating new things, knowing that I could have a nice tidy package in the form of a book when I was finished. Rather than using publishing as an income generator, I used the books I wrote to inspire me and to promote me as a business or a consultant.

Kristie Burns
CEO, The BEarth Institute
www.TheBEarthInstitute.com
Twitter: @BEarthInstitute
Facebook: www.facebook.com/TheBEarthInstitute
Instagram: @BEarthImages; @Earthschooling
LinkedIn: www.linkedin.com/in/kristieburns

Because she already had an audience, Kristie Burns decided self-publishing was her best option. But let's take a moment to explore the pros and cons of the three main types of book publishing.

Publishing Options

Determining what publishing option is best for you goes back to the question we pondered at the start of this chapter: Why do you want to write or create or publish a book? The why drives your choice more than anything else does. If you want to publish a book because you're a writer and you think that the only people taken seriously as writers are the ones who are published by trade or commercial houses and get nominated for awards, then you need to find an agent and get published by the big boys and girls or a very reputable artsy or academic press.

If you are a photographer or a designer and you want to publish a book of photos or designs as a showcase for what you can do and as a marketing piece to help you woo clients, then maybe a hybrid or self-publishing model works best for you. In 2015, Allan Murabayashi wrote a fascinating article for *PetaPixels*, titled "Three Approaches to Publishing Your Photobook." Murabayashi explored the cost-benefits of what he called traditional publishing, independent publishing (small publishers), and self-publishing, using print-on-demand and e-books, using photographers Thomas Mangelsen, Scott Strazzante, and Dave Black as examples. While these examples explore publishing books of photographs, the similar comments and outcomes would apply to any kind of art books. Books that are mainly words, without a lot of graphics or color images, would have a lower per unit price.

Murabayashi (2015) writes,

The traditional publisher brings two major advantages to the table: distribution and marketing. This includes negotiating shelf space and promotion at bookstores as well as coordinating special sales through book clubs and online retailers like Amazon. Generating PR, mailing out advance copies to book reviewers, etc. can be

done by independent publishers, but large publishers have staff, know-how and connections that help to increase the visibility of the titles they represent.

Though it took Mangelsen and his staff many hours to choose and edit photos and get those to the publisher, it was up to the publisher to do the layout, design, the purchase of the materials, and the printing, marketing, and distribution of the book. The downside for the author is that he may not get much money per unit sold. But Mangelsen also has a built-in book market: he has his own galleries.

When Scott Strazzante wanted to publish his photograph-laden book *Common Ground*, according to Murabayashi (2015), he originally started a Kickstarter campaign, and raised plenty to publish the book himself. But he totally underestimated it the time it would take to get the book finished and then to find the addresses of the people who donated to the campaign and to get the books out. More than a year later, Strazzante reached out to a small publisher, who then helped him re-edit the materials and redesign the book. The editor estimates that it costs $14,000 to make the 192-page hardcover book with a print-run of 1,000 books, and that doesn't include the costs for the "a designer ($30–$100/page), editor ($500–$5000/project), proofreader, writer, or any other consultants," writes Murabayashi (2015).

Photographer Dave Black originally decided to create a beautiful book chronicling his career for his daughter. He decided to self-publish through Blurb.com (Murabayashi, 2015). Over three months, he put together a 120-page book that cost him $88.95 per copy, which he sold at a $10 markup. Eventually, he created an app of his photos that he sells for $5 through the Apple App Store, and then he converted the book file to a digital PDF that he sells on his website for $29.95 (Murabayashi, 2015). The only fees he has to pay are PayPal transaction fees; the rest of the money from the books sales is his.

All three photographers got what they wanted—a published book—but went about it in very different ways and got different and yet similar results. Table 6.1 summarizes the pros and cons of the various ways we can publish a book.

Table 6.1 The pros and cons of different methods of publishing a book

	Pros	Cons
Trade/ Commercial Publisher	Company handles all layout, design, marketing, production, publicity Company pays for everything Company has better reach than most individuals	Author has less control over final product Author gets a percentage of the proceeds No out of pocket costs to the author
Vanity/ Subsidy Press	May have professional book designers and layout people May have easy to use packages available for marketing, book design, etc.	High out of pocket cost to the author Little marketing done on the part of the press May be limited in book trim sizes by whatever they offer
Self-Publishing	You have total creative control Your publishing business can be one of your entrepreneurial endeavors You can work with print on demand companies that make it easier to publish You get to keep all of the money generated by your book	You foot the bill for everything, unless you use something like CreateSpace that pays royalties and whose set up is free You have to do everything yourself or find some way to outsource to experts Can be very time consuming

Query Letters

If you decide you want to try the traditional publishing route, you will need to master the query letter (or the pitch that we discussed in Chapter 2) as that will be your initial contact with an agent or an editor.

New York Book Editors called the query letter the most important thing you'll ever write. They write, "In essence, a query letter is your marketing page that talks up your book without overselling it" ("How to Write a Darn Good Query Letter," 2015). In three to five paragraphs, you want to woo the agent or the publisher. The first paragraph is the hook. Share any connections you have (Did you meet at a conference? Are you a fan of author X who she represents or publishes? Do you both have Corgis

named Tabasco?) And then use your book's title, its genre, and word count in this paragraph.

Paragraph two spells out the details of the story or book in a very concise format. If your book is a novel, this might be a good place for a cliffhanger to whet the agent or editor's appetite to want to read the sample pages or the manuscript . . . or if the book is nonfiction, to see the proposal.

Paragraph three is your biography as it is relevant to writing or publishing or the subject matter. And in paragraph four, I always ask the question (e.g. would you be interested in seeing the proposal, sample chapters, or whatever my ask is) and then express gratitude (e.g. "Thank you for your time and consideration. I look forward to your reply.").

And then end with a "Sincerely" and your name and signature.

Of course, before you write that query letter, make sure you check the website to see if the agent or publisher has any specific submission requirements. (Even in 2018, some agents and publishers are still asking for things to be sent via snail mail as opposed to e-mail.) And then run spellcheck and grammar check and double check the spelling on the name of the person you are sending it to.

And don't feel bad if you need to send the same query letter out to a number of people before getting a positive response. As New York Book Editors (2015) reports, Margaret Mitchell got 38 rejections before *Gone with the Wind* sold, J.K Rowling got 8, and mystery writer Agatha Christie got 5 years of continual rejection. But when the timing and the connection with a reader aligns, it is publication magic (and history).

This was certainly the case of Ali Wunderman, when her extended query letter and clips (examples of previous published writing) was all it took to land a travel guide book writing contract, as she explains in Case Study 6.3.

Case Study 6.3 Ali Wunderman

Since I was young I enjoyed writing as a hobby, but didn't know that doing it as a full-time career was an option. After graduating college I went to work 9–5 jobs, believing this to be what adults did. A friend encouraged me to write for her sister's new digital magazine, and I

found myself loving the time I spent doing that, even though I wasn't even getting paid. I quickly began exploring paid opportunities, and I wrote for hours every night after my desk job. This is when I felt like I was alive. It truly suited me to be exploring a new subject or project every day, expressing myself through words. After several years of balancing a regular job and moonlighting as a writer, I decided my entire day should be spent in pursuit of my own dreams, not someone else's, and I began freelancing full-time. Despite a massive pay differential and subsequent lifestyle changes, I haven't looked back.

I just finished writing a travel guide for Frommer's, and I'm so excited to see the published book. How I ended up writing the book was because a colleague was kind enough to inform me that Frommer's was seeking a Belize writer, knowing that I was quite familiar with the country. I e-mailed the publisher with my interest and my portfolio, and quickly got on board the project. I did not create a book proposal, though I believe this is partly because they were strapped for time. I wasn't given a particular outline, but I was provided with a writer's guide. I negotiated a higher rate than what was offered, largely because I've neglected to in the past, and know that in general women don't pursue this step. I wanted to know that I tried for more money even if it meant I lost the opportunity. I felt I was the best person for the job because I love Belize as if it were my own home, and was constantly being asked by friends to create itineraries for them. I wanted to represent Belize the way I felt it deserved—an eco-paradise characterized by friendly people, excellent food, and bountiful wildlife. Plus it gave me an excuse to go back for another extended visit, though I would have found any excuse no matter what.

Writing a book was quite difficult for me. This is the longest-form project I've ever tackled, and writing books requires a different mental attitude than magazine and blog writing. When you write an 800-word article, there is a sense of instant gratification when it's published in the same week. With a book, you're putting together 300 pages over the course of several months, then editing everything, and then waiting more time for it to come out, and it feels like doing a lot for very little. Plus, some days you don't want to write,

or are totally uninspired. Writing is an inherently creative process, and trying to force it typically has the opposite of the desired effect. If (and let's be honest, when) you fall behind, the added stress contributes to being unproductive. I learned a lot about planning, time management, and coping with a lack of productivity from the experience, but I also know I'll wait a while before doing a book again.

My advice to aspiring book writers is to love what you're writing about. Unless you're the kind of person who could do any job and feel satisfied by being productive, regardless of what you're producing, then you need to be devoting yourself to a topic or concept that moves you. Fiction, non-fiction, it doesn't matter. Most authors share with me a sense of suffering when working on a book, so spend your time on something worth suffering for.

Whether it's a book or something shorter, being your own boss means setting and adhering to a schedule of your choosing. Find others who have done what you're attempting and ask for best practices. Consider what works best for you, be it a daily routine or the electric charge of having procrastinated. Being a freelancer is not easy—monthly income varies, projects fall apart, communication falters—but it can be an incredibly rewarding lifestyle, which makes it worth it to me.

<div align="right">

Ali Wunderman
Writer, author, founder of The Naturalist
www.thenaturalist.org
Twitter: @aliwunderman
Instagram: @aliwunderman

</div>

Ali Wunderman's story is inspirational but most times landing a nonfiction book contract requires the writing of a book proposal so let's explore what that entails.

Book Proposals

A template for a nonfiction book proposal has standard parts: book overview, chapter by chapter descriptions, a market analysis, a competitor

analysis, the author's biography, and at least one sample chapter. All total, your book proposal will run between 35–100 pages, double-spaced. As Michael Larsen (2018) writes for *Writers Digest*, "The Golden Rule of Writing a Book Proposal is that every word in your proposal should answer one of two questions: Why should a publisher invest in your book, and why are you the person to write it?"

The overview of your book is the hook. Its purpose is to get the agent or the editor or publisher interested in your idea. The overview could start with a quote, an event, a trend, a statistic, a story, an idea, a joke, or even a question. When my friend Laura Browne was shopping around her book, *Why Can't You Communicate Like Me? How Smart Women Get Results in Business*, the query letters and book proposal that she sent to female agents and editors started with the question: Are you a bitch? Browne's book discussed four communication styles that were originally bitch, bimbo, babysitter, and brain until being toned down by a publisher to bossy, bubbly, buddy, and brainy. While the question may have been inflammatory, it almost guaranteed responses from its recipients.

Larsen (2018) says to make sure your book hook contains the book title, your selling handle, and the book's length. Book length can be estimated and given either as a word count (i.e. 75,000 words) or as a page count. The calculation is approximately 250 words on every 12-point font double-spaced page.

The overview should also set the tone of the book, explain if it uses illustrations or graphs and charts or photos, exercises, or any other special features. And if you plan to have a famous person or someone renown in his or her field write a foreword, that should be mentioned also.

The chapter-by-chapter outline is just that: a paragraph or two summarizing the contents in each chapter, including any special features of the chapter. This outline should show that you've put thought into each chapter, the research and examples that will be used and how each part fits into the whole book.

The marketing analysis is an explanation of who is the audience for your book, starting with the largest audience first, and what will be the channels through which the book can be sold. Also, if you see your book as part of a series of books, you can mention it here. If you have a promotion plan for your book, maybe based on your current work or business, that is also part of the marketing analysis.

The competitive analysis is a book-by-book comparison of the books that have already been published that would compete for sales with yours. The trick in this section is to be honest in your comparison (never say there is none since that isn't true) and to compare your book without bashing the others. A good way to do this, as Larsen (2018) explains is by saying, "Includes x. Fails to cover y.".

In the final section, "About the Author," use one page and only one page, to prove that you are qualified to write this book. Write this section in the third person (meaning avoid "I" statements) and start with the most relevant experience you have for the book, include media appearances and other writing or publishing experience. Some websites and books on writing book proposals say to include a professional headshot in this section and others say to leave it off, so the choice is up to you.

Now to see what all this put together would visually look like, I've included part of the book proposal (it's missing two of the sample chapters) J. Joseph Hoey IV and I sent our publisher, when we wanted to write a follow-up to our 2014 book *Assessment in Creative Disciplines: Quantifying and Qualifying the Aesthetic*.

Reframing Quality Assurance in Creative Disciplines

Evidence from Practice

By

J. Joseph Hoey IV
Jill L. Ferguson

Jill L. Ferguson
PO Box XXX
Renton, WA 98056
650.999.9999
jill@jillferguson.com

Reframing Quality Assurance in Creative Disciplines

Evidence from Practice

Book Proposal Table of Contents

Overview

Reframing Quality Assurance in Creative Disciplines: Evidence from Practice is the second book in a series by J. Joseph Hoey IV and Jill L. Ferguson to examine assessment practices in Creative Disciplines. The first book, *Assessment in Creative Disciplines: Quantifying and Qualifying the Aesthetic* (Common Ground, May 2014), explores creativity and its assessment using easy-to-grasp concepts, concrete examples, and case studies to form a blueprint that the reader can use to assess endeavors in music, art, and design on both an individual basis and as a collective (course, cohort, department, program, etc.) *Reframing Quality Assurance in Creative Disciplines: Evidence from Practice* covers assessment and quality assurance on the individual student level to mapping course level learning outcomes to program learning outcomes (and to institutional learning outcomes in many cases) to promising and well-established good principles of practice in creative disciplines. The book follows the links between quality assurance and teaching and learning; delves into good practices and then provides a myriad of examples of those practices through case studies in 17 creative disciplines. Finally, *Reframing Quality Assurance in Creative Disciplines: Evidence from Practice* places quality assurance within the institutional context by exploring requirements of both national and regional accrediting bodies, and then within the international context by looking at the recognition of competencies.

This book grew out of the research, writings, and presentations of the authors J. Joseph Hoey IV, Executive Vice President at Ashford University and Bridgepoint Education and former Vice President for Institutional Effectiveness at Savannah College of Art and Design, and Jill L. Ferguson, higher education consultant, former Assessment Coordinator and Chair of General Education at the San Francisco Conservatory of Music, lecturer in the School of Business at Notre Dame de Namur University, and artist.

Marketing Analysis

Reframing Quality Assurance in Creative Disciplines: Evidence from Practice's intended audience is faculty, assessment coordinators, administration, graduate education arts students, and anyone else interested in the evaluation of creative works. We think a direct campaign (e-mail or flyer-based) to deans, faculty, and assessment coordinators of arts programs would be one way to market this book, in addition to the usual notices to college and university bookstores and libraries and to graduate education programs to suggest adoption of the book as a textbook.

The authors of *Reframing Quality Assurance in Creative Disciplines: Evidence from Practice* have been laying the groundwork for marketing the book by sending proposals to speak at, and getting acceptances to speak at, assessment conferences in the United States and Europe. David Mills Chase and Joseph spoke on arts assessment at the 2014 WASC Annual Resource Conference in San Diego, California. Joseph presented in June 2014 at the AALHE conference in New Mexico. Jill spoke at ATINER's 4th Annual Assessment in Performing and Visual Arts Conference in Athens, Greece, in June 2013 and at the annual conference sponsored by LiveText in Chicago also in July 2013. Jill and Joseph presented at the Hawaii International Arts and Humanities Conference in Honolulu in January 2014 and at the Arts in Society Conference in Rome in June 2014. Jill also presented at the Higher Education Teaching and Learning Conference in Anchorage in late May 2014. Joseph presented at the LiveText regional workshop in San Diego in November 2013. The authors spoke collectively at Trudy Banta's Assessment Institute in October 2013, and Joseph ran another workshop at the Assessment Institute in October 2014. All of these speaking engagements created buzz and anticipation for their first book together and for the publication of *Reframing Quality Assurance in Creative Disciplines: Evidence from Practice*. The authors will continue the publicity and electronic campaigns through targeted social media, and through their substantial network of academic colleagues after the book's release date. They will feature the book on their website www.assessmentincreativedisciplines.com and advertise for it with their consultancy projects.

Competitive Analysis

While dozens of books about assessment have been written and published over the last two decades, only a few of these books have dealt with assessing students and with quality assurance in creative academic disciplines, and many of them are very discipline specific or look at the assessment of creativity through one distinct lens (such as psychology). In addition to their first book, the following books, or parts of these books, could be considered competitors with *Reframing Quality Assurance in Creative Disciplines: Evidence from Practice:*

1. *Assessment in Practice: Putting Principles to Work on College Campuses* by Trudy W. Banta and Associates, Jon P. Lund, Karen E. Black, and Francis W. Oblander (published in 1995 by Jossey-Bass) became an instantly indispensible primer on the best assessment methods in the United States upon its publication

in late 1995, and this book of case studies (86 of which are reported in their entirety) is still one of the best books on assessment almost two decades later. The tome covers all types of assessment from individual and classroom to program or department levels to institutional assessment and many, many disciplines (math, foreign language, technology, etc.) have examples.

2. *Assessing 21st Century Skills: A Guide to Evaluating Mastery and Authentic Learning* by Laura M. Greenstein (published by Corwin in July 2012) includes one chapter (nine pages that are part of Chapter 5) on assessing creativity. Also, one line on the rubric on page 198 covers creativity. Greenstein includes creativity as one of the 21st-century intellectual skills that are part of authentic learning.

3. Part of the *Essentials of Psychological Assessment* series, *Essentials of Creativity Assessment*, by psychologists James C. Kaufman, Jonathan A. Plucker, and John Baer (published by Wiley in August 2008) covers the self-assessment of creativity and assessment by others, including teachers, peers, and parents. The book focuses on standardized testing measurements and other psychological tools.

4. Also published in 2008, *Assessment in Music Education: Integrating Curriculum, Theory, and Practice*, edited by Timothy S. Brophy (GIA Publications), is a compilation of 27 papers that were presented at the 2007 symposium of the Florida Symposium on Assessment in Music Education. The primary focus of the papers is assessments for K-12 music education, but some of the ideas are applicable for higher education.

5. *The Problem of Assessment in Art and Design* by Trevor Rayment (published by Intellect Books in 2007) presents both historical and philosophical perspectives of assessment of artistic endeavors. This book is a collection of chapters written by arts and education experts.

6. *Assessment in Art Education* by Donna Kay Beattle (published by Davis in 1997) is a short book that is part of the "Art Education in Practice Series." This book covers the assessment of arts portfolios, journals, and performances. It also covers scoring and judging strategies.

Author Information

Dr. J. Joseph Hoey, IV serves as Vice President for Accreditation Relations and Policy at Bridgepoint Education. Dr. Hoey's background includes development of an institutional effectiveness function at the Savannah College of Art and Design (SCAD) from 2006–2010. In 2009, he developed and presented MUSE (Measuring Unique

Studies Effectively) at SCAD, the first conference of its kind in the United States on assessment in art and design. Dr. Hoey spent eight years as the founding director of the Office of Assessment at the Georgia Institute of Technology, a prior five years in University Planning and Analysis at NC State University, and seven years in the North Carolina Community College System. His published research encompasses engineering program assessment, graduate program assessment, academic program review, building trust in assessment processes, alumni and employer feedback, validating student engagement research, community college transfer, and evaluation of online academic programs.

Dr. Hoey is past president of the Southern Association for Institutional Research, past board member at large for the Association for Institutional Research, and is both a frequent speaker and presenter on assessment, evaluation, and accreditation issues.

Prior to his career in higher education administration, Dr. Hoey enjoyed a satisfying first career in classical guitar performance. He holds a Master of Music in Guitar Performance from the Florida State University, where he studied under Bruce Holzman, and a Bachelor of Arts in Music from the University of California, San Diego, where he studied under Celin and Pepe Romero. He studied at the Hochschule der Kuenste in Berlin under Carlo Domeniconi and privately with Gilbert Biberian in London. Dr. Hoey has taught studio classical guitar at the University of Reading (UK) and at Barton College. His performance career includes four years as a full-time resident artist in the Visiting Artist Program in North Carolina, as well as stints on the Touring Artist Roster for both North Carolina and South Carolina. Discography includes a CD for Liscio Recordings with fellow guitarist Brian Morris as *Les Deux Amis*. He is one of the co-authors of *Assessment in Creative Disciplines: Quantifying and Qualifying the Aesthetic* (Common Ground, 2014) and of the chapter "Examining Inquiry-Based Education in Creative Disciplines Through Assessment" in the book *Inquiry-Based Learning for the Arts, Humanities, and Social Sciences* (Emerald Publishing, 2014).

Jill L. Ferguson is the author or co-author of four published books, *Sometimes Art Can't Save You* (In Your Face Ink, 2005); *Raise Rules for Women: How to Make More Money at Work* (In Your Face Ink, 2007); *WOMEN Are Changing the Corporate Landscape: Rules for Cultivating Leadership Excellence* (WOMEN Unlimited, 2008); *Assessment in Creative Disciplines: Quantifying and Qualifying the Aesthetic* (Common Ground, 2014); and of the chapter "Extending Inquiry-Based Education in Creative Disciplines Through Assessment" in the book *Inquiry-Based Learning for the Arts, Humanities, and Social Sciences* (Emerald

Publishing, 2014), and of hundreds of published articles, essays, and poems. She is a frequent presenter and keynote speaker on topics including assessment and accreditation. Ms. Ferguson currently works as a business and higher educational consultant, artist, writer, and editor; she was most recently chief of staff at the Western Association of Schools and Colleges, Accrediting Commission of Senior Colleges and Universities. Previously, she spent 12 academic years as a Professor of English, Writing, And Communications; department chair of General Education; and assessment coordinator at the San Francisco Conservatory of Music. She also spent over a decade teaching in the School of Business and Management at Notre Dame de Namur University.

As an undergraduate and after, Ms. Ferguson studied printmaking, painting, jewelry making, and pottery. Her paintings have been for sale in an art gallery in Pennsylvania and in stores in California, Japan, and online.

Section by Section Outline

This book will be broken into three major sections, in addition to seven traditional chapters, with section two being the longest because it will have case studies for 17 distinct disciplines.

Section I: Reframing Quality Assurance

This section provides the background for why the book was written, covers approaches to quality assurance, explores the links between quality assurance and teaching and learning, delves deep into cognitive and affective learning in creative disciplines, and finishes with good principles of practice.

Chapter 1: Reframing Quality Assurance in the Creative Disciplines

This chapter introduces key concepts explored throughout the book, such as why assessment in the arts is different from other disciplines, advances in assessment practice that now permit authentic, valid, and reliable assessment in the arts and at scale, the multiple ways in which technology may be leveraged for assessment in the arts, the tremendous role of metacognition and self-reflection as cornerstones of artistic development, and the need to assess the formation of those critical faculties in students. The chapter continues with a broad overview of the book, describing in general each section.

Chapter 2: Quality Assurance and the Link to Teaching and Learning

In assessing learning in the creative and performing arts, one size definitely does not fit all. Different kinds of tasks call for different learning strategies, and different learning strategies call for different pedagogical approaches. Students encounter a variety of academic subjects and ways of knowing as they progress through their degree programs. This chapter will explore the connection of assessment strategy to the design and intentionality of the curriculum within programs of study in the arts, and the connection of arts to curricula and assessment across disciplines, including those commonly found in general education programs.

Over the past 25 years, psychologists have developed a deep understanding of the role of deliberate practice in developing expert performance capabilities. The findings both reinforce what many in arts education already know about developing artistic mastery and challenge conventional ideas about teaching and learning. This chapter reviews the expert performance and deliberate practice theoretical frameworks and suggests how they can be used in assessing learning in the arts.

Chapter 3: Quality Assurance in Online Creative Programs

Chapter 3 takes up quality assurance in the rapidly expanding field of online learning as it is being applied to creative disciplines, looking at changes to teaching practice, incorporation of universal design principles to facilitate online learning in the arts, new opportunities for students to create works online, and how those works might be assessed.

Chapter 4: Cognitive and Affective Learning in Creative Disciplines

This chapter delves into the triumvirate of learning domains: cognitive, affective, and psychomotor, and provides examples of how each domain is critical to effective assessment of learning in the arts.

Chapter 5: Good Principles of Practice in Quality Assurance for the Creative Disciplines

This chapter provides a set of principles and a model of what might constitute good practice in assessment and quality assurance within the creative disciplines. The

chapter features a discussion of each aspect of what we might consider good practice and provides examples.

Section II: Case Studies: Evidence from Practice

Chapters 6–13: Quality Assurance in the Context of Creative Disciplines

The case studies presented in these chapters are broken into eight broad disciplinary categories (performing arts; fine art; art history and art therapy; film, video, and recording arts; architecture and interior design; industrial/product design; fashion design, illustration, accessory design, textile and fiber, jewelry, costume design; digital and graphic design) categories and are cross-referenced so the reader can easily and readily determine which case studies feature using results for continuous improvement, a triangulation of assessment methods, transparency in communication, leverage information technology, feature principles of learner feedback, and/or well-defined student learning outcomes.

Section III: Setting Quality Assurance in the Creative Disciplines in Context

Chapter 14: Quality Assurance in Creative Disciplines in the Institutional Context

This chapter reviews the requirements of the regional accreditors in the United States and specialized accreditors in creative disciplines relative to assessment and quality assurance in student learning—including the National Architectural Accrediting Board (NAAB), the Council for Interior Design Accreditation (CIDA), the National Association of Schools of Art and Design (NASAD), the National Association of Schools of Music (NASM), and the National Association of Schools of Dance (NASD).

Chapter 15: Quality Assurance in Creative Disciplines in the International Context

The chapter explores quality assurance in creative disciplines in the international context, covering applicable standards, and exploring joint recognition of competencies in the arts across geographical and political boundaries. We include information about the tuning process, the Australian Quality Framework for the Arts, and ramifications of the Lumina Foundation Degree Qualification Profile for assessment of the arts in the United States.

VI Sample Sections/Chapters

Book Introduction

Change your opinions, keep to your principles;

change your leaves, keep intact your roots.

—Victor Hugo

At various points in our lives, change is thrust upon us. It is how we respond positively or negatively that determines the outcomes. As a seasoned classical guitarist and studio instructor, in 1990 I was faced with a daunting prospect: the need to assess student learning outcomes not just individually as I had always done, but across students, based on a common set of competencies. I believed strongly in the primacy of frequent, formative assessment between student and expert instructor as the cornerstone of individual musical instruction, and still do. At that point in the development of national student learning outcomes assessment practice, most of the assessment methods being put forward centered on standardized exams and indirect methods such as student surveys—hardly suitable for assessment of student learning in music! As a natural first instinct, I began looking around for examples of good assessment practice in other institution—back then, there was a dearth of good examples available from other schools. Eventually I got wind of the American Association of Higher Education's (AAHE) annual assessment forum, and from attending those conferences as well as meetings of the South Carolina Higher Education Assessment (SCHEA) network, I began to gather examples of assessment in disciplines besides music. In the intervening decades, a solid body of assessment theory and practice has been developed that works for most disciplines—but again, it is surprising and disappointing that creative disciplines such as music, architecture, fashion design, and film have been largely neglected in the assessment literature, and the first attempt of any consequence to bring together assessment of creative disciplines in an interactive conference did not take place until the 2009 MUSE (Measuring Unique Studies Effectively) conference at the Savannah College of Art and Design in Savannah, Georgia.

Since the creation of our first mutual, comprehensive work on assessment in the creative disciplines (*Assessment in Creative Disciplines: Quantifying and Qualifying the Aesthetic*, published by Common Ground in 2014), my co-authors and I have received numerous requests for a work that brings together promising assessment practices across the creative disciplines. This current work is a direct consequence of those

requests. Having experienced first-hand the frustration of not being able to find good examples of assessment practice, we have brought together in this volume a number of case studies across the spectrum of visual, performing, and design arts. Our intention in doing so is to provide a common basis for not only furthering student learning outcomes assessment in each of the creative disciplines, but also advancing assessment practice and quality assurance within the creative disciplines overall. It is our conviction that as ideas such as competency-based education steadily advance within Academe, the creative disciplines, with our long traditions of authentic assessment of student competence, have much to offer.

New creations stand on the shoulders of what has come before, and to not acknowledge that heritage in this context would be inauthentic. Specifically, we owe a large debt of gratitude to Dr. Trudy Banta and her colleagues who in 1996 published *Assessment in Practice*, a purposeful compendium of case studies in assessment that showcased good practices and related those practices to the AAHE *Principles of Good Practice in Assessment* (1992). Furthermore, in 2001, Banta and Palomba published an edited volume, *Assessing Student Competence in Accredited Disciplines: Pioneering Approaches to Assessment in Higher Education*, that included a chapter by Kristi Nelson, Sr. Vice Provost at the University of Cincinnati, on assessing student competence in the visual arts. Since the advent of those groundbreaking publications, organizations such as the Association for Institutional Research (AIR) have also produced several volumes dedicated to assessment within specific disciplines, such as Engineering, Chemistry, Writing, Mathematics, and Business. In fact, an updated version of Banta et al.'s *Assessment Essentials* was published in October 2014. But a substantial gap remains in the availability of a meaningful collection of case studies to showcase successful assessment and quality assurance practice within the visual, performing, and design arts. We hope our readers will judge that the results contained herein are worthy of consideration, reflection, and adaptation to other programs and institutions.

J. Joseph Hoey IV, San Diego, Month, Date, 2014

Chapter 1: Reframing quality assurance in creative disciplines: Evidence from practice

This volume brings together a number of streams of thought and practice in assessing the arts within higher education. Assessment of student learning has been a growing trend over the last three decades as one facet of general advances in teaching and learning, developments in cognitive science, and the widespread use of information

technology in higher education—for teaching and learning as well as for the creation of cogent knowledge management systems. Regional accreditors and higher education quality assurance authorities have developed and promulgated criteria for institutions to develop and utilize systems that yield information on the extent to which students are meeting learning goals, and to steadily improve their institutions based on the findings of systematic study of student outcomes. For institutions, there are now fiscal consequences to be considered in an institution's ability to demonstrate mission fulfillment and achievement of appropriate student outcomes. Increasingly, funding decisions are affected by an institution's ability to demonstrate the efficacy of student learning. The stakes are as high as the need for workable approaches to facilitating student learning and demonstrating its positive effects.

Assessment in the Arts Is Different

We approached the development of this volume from several standpoints. One standpoint with which we share a number of concerns is articulated in *Assessment on Our Own Terms*, published in 2009 by the National Association of Schools of Art and Design (NASAD), a volume itself based on a presentation in 2007 and positions articulated even earlier. As noted in the NASAD (2009) work, assessment and quality assurance in creative disciplines is bound to be different both in theory and practice from other fields of endeavor. We acknowledge the primacy of expert judgment in assessment and the historical precedent of an exclusive focus on individual student achievement. As Nelson (2001) notes, "A critical problem that persists is how to take efforts that are individually based and focus on self-reflection and make these programmatically centered" (p. 196). We understand the need for holistic appraisal of student works, and value the role of informed experts in defining what constitutes varying levels of performance and achievement. Including students' artistic intentions and the process by which they develop artistic works is important as part of an assessment schema. Affective, psychomotor and cognitive learning outcomes are all vital in art making and any reasonable assessment/quality assurance framework should take that into account.

Advances in Teaching, Learning and Assessment

In this work, we also take the standpoint that the deepened literature on assessment that reflects 30 years of endeavor has resulted in the development of approaches that

permit authentic, valid, and reliable assessment to take place in a way that permits us to utilize assessment information at individual and collective levels. Three decades ago, the United States Department of Education (USDOEd) first articulated a shift in the requirements for accreditation agencies from input-based criteria such as the number of buildings and faculty to the outcomes of education. Accreditation agencies, in turn, began to translate the USDOEd requirements into criteria for assessing student learning as part of initial or reaffirmation of institutional accreditation, but the availability of assessment instrumentation, especially as relevant and palatable to faculty sensibilities, was scarce. As recently as 1987,

> Only a handful of instruments were available designed specifically to assess the effectiveness of undergraduate education. As a result, most institutions engaging in assessment used a mixture of surveys (both commercial and home-grown) and a collection of cognitive examinations like the ACT Assessment or the Graduate Record Examination that were designed for something else.
>
> (Ewell, 2009, p. 7)

In the intervening years, teaching, learning and assessment in higher education have made notable advances, spurred on in. part by the ascendance of differing modes of thought about scholarship, for example Boyer's classic *Scholarship Reconsidered* (1990). New, disruptive educational models have appeared. Online education has exploded. Competency-based models of education—a time-honored educational cornerstone for the arts—have also gained wider acceptance. Assessment practice has matured as well, for example as demonstrated by the current prevalence of faculty development initiatives for assessment, faculty-developed rubrics for assessing student learning, national initiatives such as the Association of American Colleges & Universities (AAC&U) VALUE rubrics, and the efforts of the National Institute on Learning Outcomes Assessment (NILOA).

Important Learning Outcomes

There are several learning outcomes we posit as fundamental to creative disciplines and artistic development and that deserve mention at the outset. Creativity, for example, is fundamental. While creativity is multifaceted and complex, we believe that the

assessment of student creativity must be included in any meaningful assessment schema within arts assessment, and we expand upon concepts first laid out in by Chase, Ferguson, and Hoey (2014) in describing models and practices to understand the assessment of creativity. The reflective and metacognitive aspects of higher education, always crucial to the lifelong artistic development of our students, have become a true focal point of education and must also be included. Reflection and metacognition can be furthered through known teaching strategies, and can be assessed with methods now available. We believe that the ubiquity of content availability, the ease with which students can search for information, and the deconstruction of traditional notions of higher education are all factors that are leading us as educators to the point where we are no longer exclusively content experts, but mentors who actively push our students to expand their mental boundaries, their capacity for self-critique, and their capacity to solve artistic problems as they occur. As Jose Antonio Bowen notes, "Your job is to increase the complexity of their mental models" (2014, oral communication).

Outliers

Unlike most traditions of assessment where measures of central tendency received the lion's share of focus, in assessing the arts the case can easily be made that a different paradigm is also highly informative: the assessment of exceptions and outliers. This type of assessment is important, since exceptions to the rule, statistical aberrations, and other outliers point the way for new insights and may represent a potential focus for further inquiry, a different formulation of theory, or improvement of practice. Malcolm Gladwell (2008) devoted an entire volume to outliers in various fields, named appropriately enough *Outliers*. Speaking in the context of statistical analysis, Osborne and Overbay (2004, p. 4) observe:

> We all know that interesting research is often as much a matter of serendipity as planning and inspiration. Outliers can represent a nuisance, error, or legitimate data. They can also be inspiration for inquiry. When researchers in Africa discovered that some women were living with HIV just fine for years and years, untreated, those rare cases were outliers compared to most untreated women, who die fairly rapidly. They could have been discarded as noise or error, but instead they serve as inspiration for inquiry: what makes these women different or unique, and what can we learn from them?

Using Appropriate Technology

Another standpoint we take is that technology in higher education has advanced to the point where meaningful, direct, and nuanced assessment of student learning in the arts is not only possible at individual and collective levels but highly feasible for faculty. Rich, deep, and connected pedagogical content can be presented in ways that were not feasible several years ago. Significant data can be collected, both actively and unobtrusively through online systems, as Prineas and Cini (2011) point out. The advent of widely available, flexible e-portfolio platforms with copious storage capacity has meant that previously prohibitive barriers to direct assessment of student growth and development have receded; for example full-length videos of student performance can be uploaded, annotated and commented upon at specific points in time, used by students as part of their evidence of growth and mastery in a reflective analysis, and referenced back to an assessment rubric for grading. Extraordinary amounts of data can be collected, stored, and compared longitudinally in online assessment management systems to permit assessment at the individual and collective levels of student growth and development across a number of facets of expertise in the discipline—we don't have to just sample and approximate any more. We can now use hard performance evidence. The power of social media, peer commentary and critique, and the social construction of meaning can be harnessed and utilized to better understand how our students are interacting, growing, and developing as artists. In short, the forces that once constrained assessment and kept it on a narrow path have begun to go the way of the Pony Express and the telegraph.

Our Aim in the Volume

Our aim in this work is not only to showcase the current state of practice, but also to open up new paths and possibilities that demonstrate ways in which colleagues in creative disciplines have taken creative steps forward, to incorporate assessment at multiple levels within their teaching practice, and to develop systems for quality assurance that achieve their intended ends. Accreditors and quality assurance agencies have the dual roles of being on the one hand partners in the advancement of higher education standards, and on the other hand of assuring that those standards are being met. Our intention in this volume is to include and highlight the advancements in quality for which they have acted as catalysts, as well as those advances for

which they continue to advocate. With those aims in mind, we organized this volume to present a useful, robust, and high-quality set of case studies in assessment and quality assurance across the visual, performing, and design arts, which we refer to collectively as the creative disciplines.

Organization of the Book

Similar to Caesar's division of ancient Gaul, this book is divided into three parts to sufficiently cover the territory: (1) reframing student learning outcomes assessment and quality assurance in the context of the creative disciplines, (2) presentation of case studies of assessment and quality assurance in the arts, and (3) setting assessment and quality assurance in creative disciplines in the context of specialized and regional accreditation and international recognition of competencies.

Section I

To set both practical context and theoretical grounding, we designed the first section of the book as an overview of how we are considering quality assurance and assessment in the artistic context, how that links to teaching and learning in the creative disciplines, and the importance of considering affective and psychomotor outcomes as well as cognitive outcomes in creative disciplines. Building upon the extant assessment and creative arts literature bases and positions outlined in our first book, this section also advances a conceptual model of principles of good practice in assessment and quality assurance for the creative disciplines and a discussion of how those principles may be exemplified in practice.

Instead of limiting the paradigm to assessment, Chapter 1 sets out to broaden the scope of consideration to quality assurance in creative disciplines, and to present ways in which we may take a more inclusive, systemic approach to making sure our students are learning what faculty have specified, can demonstrate their learning, and that college systems are working in concert to optimize student learning and success. Chapter 2 continues that discussion with a specific focus on what we know about successful teaching and learning models in the arts. While atelier/master–apprentice models have dominated the field for a long time, the emergence of collaborative, constructivist, and other approaches are increasingly finding currency. Chapter 3 takes up quality assurance in the rapidly expanding field of online learning as it is being applied to creative disciplines, looking at changes to teaching

practice, incorporation of universal design principles to facilitate online learning in the arts, new opportunities for students to create works online, and how those works might be assessed. Chapter 4 delves into the triumvirate of learning domains: cognitive, affective, and psychomotor, and provides examples of how each domain is critical to effective assessment of learning in the arts. Drawing on earlier principles of good practice in teaching, learning, and assessment in general, Chapter 5 provides a set of principles and a model of what might constitute good practice in assessment and quality assurance within the creative disciplines. The chapter features a discussion of each aspect of what we might consider good practice and provides examples.

Section II

Section II of the book explores the heart of the matter: the varied approaches brought by a number of our colleagues in the international higher education arts community to the task of assessing student learning, and to designing, implementing, and evaluating quality assurance systems for doing so. Within each discipline represented, we have sought to showcase promising and established good practice within both two-year and senior institutions. We present the case studies grouped by cognate or related disciplines to facilitate comparisons, as follows:

6. Performing Arts: Music, Theatre, Dance, Musical Theatre
7. Fine Art: Photography, Illustration, Sculpture, Painting, and Printmaking
8. Art History and Art Therapy
9. Film, Video, and Recording Arts: Film, Sound Design, Production Design, Set Design
10. Architecture, Landscape, and Interior Design
11. Industrial/Product Design
12. Fashion Design, Illustration, Accessory Design, Textile and Fibers, Jewelry, Costume Design
13. Digital and Graphic Design (Game Design included)

Beyond this grouping by cognate/related discipline, we wanted to make this book both a purposeful and highly user-friendly compendium. To make sure our readers can get to the information they need quickly and can compare that information across contexts, we have included cross-referencing across multiple facets of teaching, learning

and assessment—those facets we recognize as important to having a comprehensive and well-designed schema for assessment and quality assurance, as laid out in Section I of the book. For example, it can be highly enlightening to see how a learning outcome such as achievement of communicative competence is assessed in graphic design compared to film, or to fashion design. Wherever practical, we have cross-referenced the case studies to permit readers to gain multiple perspectives on each aspect of assessment represented in the case studies.

Section III

Section III takes up the threads of quality assurance in creative disciplines at the institutional level, covering the topic of assessment and quality assurance from the standpoint of the requirements of regional and national accreditors and quality assurance agencies. In Chapter 14 we review the requirements of the regional accreditors in the United States and specialized accreditors in creative disciplines relative to assessment and quality assurance in student learning—including the National Architectural Accrediting Board (NAAB), the Council for Interior Design Accreditation (CIDA), the National Association of Schools of Art and Design (NASAD), the National Association of Schools of Music (NASM), and the National Association of Schools of Dance (NASD). In Chapter 15 we explore quality assurance in creative disciplines in the international context, covering applicable standards, and exploring joint recognition of competencies in the arts across geographical and political boundaries.

Summary

The design, performing, and visual arts occupy a unique place in higher education and have until recently been outside of the mainstream of the assessment and quality assurance movement that has grown so decisively in higher education over the last three decades. Over that time period, the theory and practice of college teaching, learning, and assessment have greatly advanced, as has the availability of appropriate information technologies to support those advances. The time is right to move forward in assessment and quality assurance in the creative disciplines. Not only do we have much to gain, but we also have much to offer in terms of how we in the creative disciplines develop and assess student competence. As creative practitioners ourselves, we respect the creativity and diverse talents of our

colleagues and hope this book becomes a useful guide to your own assessment adventures. As a side note, it seems appropriate to mention that the dissemination of a book without pictures or conversation strikes us as an unnecessary constraint. To provide multiple ways of accessing the appropriate information, the case studies herein have provided pictures, graphs, charts, tables, and graphics, as necessary to enhance each department's or college's story. This book and our website www. assessmentincreativedisciplines.com are parts of the larger conversation about assessment in creative disciplines. We'd love to hear what you are doing on your campus. Feel free to e-mail us.

References

Bowen, J. (2014). Teaching Naked: How Moving Technology Out of Your College Classroom Will Improve Student Learning. Presentation at Association of American Colleges and Universities conference, Washington, DC, January 24, 2014.

Boyer, E. (1997). *Scholarship Reconsidered: Priorities of the Professoriate.* San Francisco, CA: Jossey-Bass.

Ewell, P. (2009). *Assessment, Accountability, and Improvement: Revisiting the Tension.* National Institute for Learning Outcomes Assessment Occasional Paper #1. Champaign, IL: University of Illinois and Indiana, National Institute for Learning Outcomes Assessment.

National Association of Schools of Art and Design (2009). *Assessment on Our Own Terms.* Reston, VA: Author.

Nelson, K. (2001). Assessing Student Competence in the Visual Arts. In Palomba, K. and Banta, T. (Eds.), *Assessing Student Competence in Accredited Disciplines: Pioneering Approaches to Assessment in Higher Education.* Sterling, VA: Stylus.

Prineas, M., and Cini, M. (2011). *Assessing Learning in Online Education: The Role of Technology in Improving Student Outcomes.* National Institute for Learning Outcomes Assessment Occasional Paper #12. Champaign, IL: Author.

So as you can see writing a book proposal takes a lot of time and a lot of work. And while you don't have to have the book written before you write the proposal, you must spend time thinking it through, outlining it, and getting started on it.

In Case Study 6.4, Abby Glassenberg, who blogs, designs sewing patterns, and founded the Craft Industry Alliance, explains how and why she came to write a book.

Case Study 6.4 Abby Glassenberg

I've always been a creative person who liked to make things. I took lots of art classes in high school and some in college and always enjoyed them and I especially liked making practical things that I could use or give as gifts.

I have a master's degree in education and was working as a sixth-grade social studies teacher in 2005 when I had my daughter, Roxanne. My husband and I planned for me to stay home with the baby and I always figured I would be totally satisfied as a stay-at-home mom. And I'm super glad I was able to do that, but I quickly found that missed work, too. Right around that time I read an article in *The New York Times* about blogs. I'd never heard of a blog and began to wonder if there might be blogs about crafting.

To my excitement I did find a few blogs that were about craft, and I started to read them, comment on posts, and become part of this tiny, but burgeoning online craft community. I started my own blog, whileshenaps.com, in May of 2005 as a place to record the things I was making while our baby daughter napped. My blog quickly began to be about sewing, specifically sewing stuffed animals and dolls, because that was what I was enjoying most.

I still have my blog all these years later and I credit it with leading to my career as an entrepreneur and freelancer. Through my blog I've gotten countless opportunities including three book contracts, several licensing deals, and work-for-hire contracts. I've also built an audience that I sell my self-published sewing pattern and e-books to. I've gotten national teaching and speaking gigs as well, and all of it is truly rooted in blogging regularly and thoughtfully for 13 years.

My very first customers were Etsy customers back in 2005 when Etsy launched. I had been blogging for a few months already and sent traffic to Etsy to browse and buy.

In 2009, I got a book contract. I had an idea for a book that I really wanted, but couldn't find so I thought maybe I could write it myself. In my mind, though, a book had to be really long and complicated, so my book proposal was way too complex. I sent it off

to five publishers, nonetheless, and to my surprise my phone rang 45 minutes later. It was the acquisitions editor at my top choice of publishing houses. In the end, all five of the publishers got in touch (this was back when craft book publishing was still thriving).

I think it was really important to not be afraid to try. I had no idea how to write a book query or book proposal at that time, and I really didn't know anything about publishing houses or how the process worked. I did a lot of research online looking at how to format a query and what it needed to include, and I went to the bookstore and examined all the craft books on the shelf to figure out which publishers I liked best. Once I had some acquisitions editors on the phone, I listened carefully to their feedback and worked to improve my pitch to make it better fit what they were looking for. I learned so much from each of my books and from submitting patterns to magazines. Seeing how these mass-market publications needed my work to look and sound helped me to tailor future work to sell better.

I sometimes say that being self-employed like pedaling a bicycle. You have to constantly pedal or the bike stops. It's a lot of work and a constant hustle. Where can I pitch this idea? What product could I make next? At the same time, it's entirely controlled by me and that's a huge plus. I only take on projects I really want to work on and I'm able to turn down or avoid things I don't enjoy.

I like to do-it-yourself (DIY), and for a long time I took a DIY approach to my business, for better and for worse. For example, I'm not great at graphic design, but in the beginning I designed all of my own self-published sewing patterns in Microsoft Word. It's not an ideal program for design (by a long shot!), but it did the job with no upfront costs. Once I had momentum and my patterns were selling, though, I really wanted to upgrade their layout so I hired a graphic designer who specializes in formatting sewing patterns. She created a professional template that matches my branding and looks terrific. At that point, though, I had so many patterns and it was a lot of work to go back and reformat each one. If I had it to do over, I would have invested in the right design from the beginning and saved myself a lot of time and hassle.

Over time I've become better at recognizing my own strengths and weaknesses and outsourcing those things I'm either not good at or don't want to spend time on. I'm thrifty by nature, so allowing myself to spend money on these contractors was tough at the beginning, but now I'm so happy I've learned to let go.

The following three things have been crucial to my success as a freelancer and an entrepreneur. First, I'm very self-disciplined when it comes to work (not when it comes to snacks, though!). I really treat my days like I would if I were working in a traditional job in an office or classroom, which means I show up at work on time, dressed nicely, and am ready to work. I'm a stay-at-home mom to three daughters so I have limited work hours and I try to make the best of them.

Second, I'm very consistent. I have a podcast that I've been publishing for three years now and without fail it comes out on the first and third Monday of the month at 8 a.m. I also send a weekly e-mail newsletter every Wednesday morning at 10 a.m. Being consistent is really important for building an online audience because it builds trust and shows that you're a reliable person. Very often I will get e-mails in reply to my newsletter from editors asking me to write articles for their magazines, or from other people in the sewing industry inviting me to collaborate. Putting things out into the world on a consistent basis is definitely a driver of new work for me.

Third, I respond with grace. I get a lot of e-mail and I strive for inbox zero at the end of each day. Some of the people who write to me are frustrated or upset because they can't figure out how to sew the project they're working on or because they disagree with a point of view I've expressed in an article. I take the time to write back to each person, and I try hard to be professional and grateful for their message. Often just the act of getting a response from me will diffuse their anger or frustration and we are able to move on. Of course, that's not always the case, but nonetheless I write back to each person with grace and I think that's really important. Businesses are built one relationship at a time.

Self-employment isn't the right fit for everyone. My husband is a great example of someone who does best while working for a large

organization with a boss to report to. I think you need to carefully examine your working style and think about whether you feel motivated enough to get your work done each and every day all on your own. I love it, but not everybody does and that's okay.

One way to approach self-employment if you're just getting used to the idea is to phase it in. Keep your day job and start taking on freelance assignments that you can work on in your spare time. If you enjoy these gigs and do well at them, you will likely be offered more and, hopefully, at some point you can scale back your hours at your day job. In other words, there's no need to jump in with both feet right away.

I also think it's important to have a support network of other people, locally or not, who are trying to do something similar. Being able to reach out and ask questions, celebrate your accomplishments, or just kind of wallow in the lows, with people who totally get it is super important. Nobody should be trying to do this kind of work completely alone.

<div align="right">

Abby Glassenberg
Author, blogger, podcast host, sewing pattern designer
Co-founder of the Craft Industry Alliance
www.whileshenaps.com
www.craftindustryalliance.org
Twitter: @abbyglassenberg
Facebook: www.facebook.com/abbyglassenbergdesign
Instagram: @abbyglassenberg

</div>

To Agent or Not Agent, That Is the Question

As previously stated, if your goal is to publish with the big trade or commercial publishing companies, then chances are, you will need a literary agent to represent. (And even some of the smaller houses, like Hay House, publisher of self-help and inspirational books, say on their website that they will not look at any queries or book proposals unless they are sent through an agent.) "The major houses, as a rule, do not accept unsolicited

submissions. They rely on agents to supply them with a steady stream of publishable possibilities" (Simmons, 2009).

Literary agents, like agents in most other professions, such as real estate, sports, theater, etc., work only on commission, so if they don't sell your book, they don't get paid. But sometimes landing a literary agent feels like a bit like the chicken and the egg dilemma, meaning it can be difficult to get a publishing deal without an agent but it can also be as difficult to get an agent, unless you've been published.

Back in the mid-2000s, I had an agent who shopped around *Sometimes Art Can't Save You*, but she wasn't successful in selling it within our contract time frame. Eventually, I found a place for it myself. But there are plenty of things that agents can do that authors either can't do or can't do well.

Sandra Bond, of Bond Literary Agency, told *Independent Publisher* that agents

> submit work to the larger publishing houses; represent foreign, film/TV, audio and other subsidiary rights; have experience with and understand publishing contracts (an author can always hire a publishing lawyer, though); have contacts at publishing houses; be fully immersed in the publishing world and generally informed about industry news—who is doing what, who is going where, know how the industry is changing, how publishers are changing, how contracts are changing, etc. This is our world and we work at it full-time.
>
> (Bergmas, 2018)

And this is why if you want a big publishing deal, you need to find an agent who can be your advocate and cheerleader. Two good ways to find agents are to look at the acknowledgments page of published books similar to yours to see who authors have thanked and check out the deals section of Publishers Marketplace (www.publishersmarketplace.com) to find out who has been selling what to whom.

Then draft up a query letter, showing you understand who they represent and what their interests in books are, and send it off and see what happens. You'll never know what kind of agent you'll get or book deal is in your future, until you try.

How to Publish Articles, Songs, and Art

Or maybe a book-length work sounds grueling and unnecessary to your life. That same query or pitch letter we talked about is the way to get articles published, too. You just address it to the editor at the newspaper, magazine, blog, or website for which you want to write and follow the same three- to five-paragraph format to pitch your idea.

But if songs are your thing, publishing those is a little different of a process. Music publishing is all about the rights of songwriters and song owners and who gets the money or royalties that the songs generate. TuneCore points out that a song (composition) and a recording of a song (sound recording) are two different things, and they each come with intellectual property rights (Goes, 2018). The composition and the sound recording both usually have copyrights.

The songwriter or composer is the owner of the song, but as Goes (2018) says,

> most songwriters do not look after the rights to their songs. Issuing licenses for the use of a song, collecting the royalties, accounting, etc. is a lot of work . . . In most cases, songwriters have music publishing companies do this administration for them.

Jason Blume (2015), author of *The Business of Songwriting and* instructor of the BMI Nashville Songwriters' Workshop, says,

> Few songwriters have the professional relationships and credibility required to get their songs heard by successful recording artists . . . You need someone who has the ability and the connections to get your song to the decision-makers—artists' managers, producers, and A&R executives—and in some instances, directly to the artists. That person will likely be a music publisher.

Blume (2015) says music publishers acquire songs either one at a time (a single song agreement) or by signing writers to exclusive publishing agreements that often come with advances against future royalties, though not enough to money to make people quit their day jobs.

In the music business, the royalty rate is determined by the Copyright Royalty Board (part of the Library of Congress), and the 2018 rate is 11.4 percent of revenue. (The entire rate for the next few years is in a table on the Copyright Royalty Board website www.crb.gov.) And it is The Harry Fox Agency that administers the music publishing rights in the United States.

Blume says the best way to get songs published is to network, where you can work with co-writers who already have publishing deals or to attend music festivals and songwriters' conferences and nights so you can get your song in front of the right people.

Or another option is to be your own publisher, and then pitch your work to people in the *A&R Registry* or to the tip sheets, such as *RowFax*, *SongLink*, and *SongQuarters* to find artists who are seeking songs (Blume, 2015).

If you want to learn how to set up your publishing company with BMI, you can watch this video: www.youtube.com/watch?v=9RQu07Ux8bY.

Or if you are an artist who would love to get prints made of your work, either full-size or notecards, to supplement your fine art income, you have plenty of options. Companies like Fine Art Publishing (http://fineart publishing.com) offer digitization, giclee, and design and offset printing, with reasonable set-up costs, and the option to print on demand so you don't have to warehouse a lot of inventory. And companies like VistaPrint and Thoughtco.com offer affordable options for turning scanned or digital photos of artwork into notecards or greeting cards, but if you want to go more classy and old-school, esteemed paper company Crane & Co. (www.crane.com/use-your-own-artwork) now has a way to use your original artwork on their stationery, notecards, and invitations. If you need some visual examples of how artists have created prints from their work, YouTube has a plethora of videos if you search "turn your art into notecards."

Chapter Summary

Book publishing, whether the book is of artwork, photographs, songs, or words, can be done through traditional commercial publishers, through vanity or subsidy presses, or through self-publishing. Each way has its pros and cons, and the method that is best for your project

should be determined by (1) why you want to publish a book in the first place and (2) what type of work it is.

The process of traditional book publishing and of article publishing starts with a query letter to an agent (for nonfiction or fiction books that would be submitted to big publishing houses), editor, or publisher. And then for nonfiction books, the next step would be to send a proposal. Sample chapters or the whole book manuscript is sent for fiction. If the book is published through self-publishing all steps from writing or creating the book to its layout to its marketing and publicity and sales would need to be done by the author, or to people the author hires to help. The best way to publish songs is through networking to get your work in front of the publishers and artista or through self-publishing and registering your publishing company with BMI.

Exercises

1. This exercise involves looking at books the way a writer would, not like a reader would. Study five books similar to a type of book you might want to write. Note who publishes those books. How long is each of the books? Look at the chapters. Do they vary in number of pages per chapter or are they fairly consistent? Do they contain graphics or charts or other kinds of illustrations? Do they use simple or sophisticated language? What makes one book more appealing than another?

2. Go online to three specific book publishers' websites. Search for their writers' guidelines or author information. Compare/contrast the guidelines for these three publishers.

3. Choose three companies that help people self-publish. List the requirements of each, including costs, royalty amounts/percentages, and technical expectations (layout, formatting, etc.). How many books would you need to sell in order to make any money? Does the company offer a marketing plan? If so, how much does it cost? Search online for success and failure stories from people who have used these three companies.

4. Go to your local bookstore or campus library or other place where lots of books are stored. Find three books in a subject matter in which

you're interested. Look at the acknowledgments page. Did the writers mention an agent? What people and their roles did they thank? Cross-reference these books with their publishers' websites. Does it say on the website that they only take agented work?

5. Choose three photographers from this list: James Leo Bantle, Vivian Maier, Julius Schulman, Richard Mosse, Susan Meiselas, and William Eggleston. Research who published their books, what types of books they are (only photographs, memoir, photos accompanying text by someone else?), and where are the books for sale?

References

Blume, Jason. "I Know I've Got a Great Song—Now What?" Last modified March 25, 2014. www.bmi.com/news/entrey/i_know_ive_got_a_great_song_now_what.

Browne, Laura. *Why Can't You Communicate Like Me? How Smart Women Get Results at Work*. Glendale, AZ: In Your Face Ink LLC, 2005.

Bergmas, Jillian. "The Role of the Literary Agent: What They Do and Why You Might Need One." *Independent Publisher*. Accessed March 20, 2018. http://independentpublisher.com/article.php?page=1586.

"Definitions." Science Fiction and Fantasy Writers of America. Accessed March 12, 2018. www.sfwa.org/other-resources/for-authors/writer-beware/vanity.

Goes, Ken. "How to Guide to Music Publishing." *TuneCore*. Accessed March 20, 2018. www.tunecore.com/guides/basics-to-know.

Goldberg, Justine Tal. "200 Million Americans Want to Publish Books, But Can They?" *Publishing Perspectives*. Last modified May 26, 2011. https://publishingperspectives.com/2011/05/200-million-americans-want-to-publish-books.

Ha, Thu-Huong. "China and U.S. Make Nearly Half the World's Books." *Quartz*. Last modified August 18, 2017. https://qz.com/1057240/which-country-publishes-the-most-books.

"How to Write a Darn Good Query Letter." New York Book Editors. Last modified December 2015. https://nybookeditors.com/2015/12/how-to-write-a-darn-good-query-letter.

Larsen, Michael. "Writing an Irresistible Book Proposal." *Writers Digest*. Accessed March 7, 2018. www.writersdigest.com/wp-content/uploads/Writing-an-Irresistible-Book-Proposal-BK.pdf.

McLeod, Lisa Earle. "Why Do People Still Bother to Write Books?" *Huffington Post*. Last modified January 31, 2012. www.huffingtonpost.com/lisa-earle-mcleod/why-do-people-still-bothe_b_1244707.html.

Murabayashi, Allen. "Three Approaches to Publishing Your Photo Book." *PetaPixel*. Last modified February 26, 2015. https://petapixel.com/2015/02/26/three-approaches-to-publishing-your-photo-book.

Neary, Lynn. "When It Comes to Book Sales What Counts as Success Might Surprise You." *National Public Radio Weekend Edition*. Last modified September 19, 2015. www.npr.org/2015/09/19/441459103/when-it-comes-to-book-sales-what-counts-as-success-might-surprise-you.

Simmons, Jerry D. "Publishing 101: What You Need to Know." *Writers Digest*. Last modified September 22, 2009. www.writersdigest.com/writing-articles/by-writing-goal/business-legal-matters/publishing-101-what-you-need-to-know.

Swainson, Bill. "The Publishing Process." *Writers and Artists*. Accessed March 20, 2018.www.writersandartists.co.uk/writers/advice/145/preparing-for-submission/what-does-a-publisher-do/the-publishing-process.

Zillman, Claire. "Why J.K. Rowling May Be a Billionaire." *Forbes*. Last modified November 24, 2016. http://fortune.com/2016/11/24/jk-rowling-net-worth-harry-potter.

Resources to Rock Your Freelance Career

Having a successful freelance career, whether pursued part- or full-time, involves utilizing inner resources such as persistence, courage, resilience, hard work, and a bit of chutzpah. Success also depends upon your research skills, marketing skills, and business skills, and knowing where to find help when you need it. Chapter 7 explores what it takes to be successful, where to find the resources within yourself and outside yourself, such as online resources, books of interest, professional organizations, and certificate and graduate programs for each specific kind of freelance career.

In the first chapter of this book, we stated that in 2016, 53 million Americans categorized themselves as freelancers (McCready, 2016), and we discussed that people freelance or launch themselves into entrepreneurial careers for a range of reasons. Researchers, like Michael Fritsch and Alina Rusakova (2010), at the Max Planck Institute of Economics in Jena, Germany, have been studying how certain personality traits can influence whether a person goes into self-employment and can be successful at it.

In the past, researchers have categorized the psychological traits of the self-employed or entrepreneurs as over optimism, self-efficacy, relatively low risk-aversion, plus a desire to have control (or what researchers called an "internal locus of control") and a need for achievement (Busenitz and Barney, 1997; Caliendo et al., 2009; Camerer and Lovallo, 1999; Chen et al, 1998; Cooper et al., 1988; Ekelund et al., 2005; Fraser and Greene, 2006; Lee-Ross, 2014; Lowe and Ziedonis, 2006; Koellinger et al., 2007; Stewart and Roth, 2001; Utsch et al., 1999; Zhao et al., 2005).

Utilize Your Inner Resources

Being overly optimistic can be both a strength and a weakness, depending on what other personality traits you have that balance the over-optimism. *Business Insider* reports that being too optimistic can lead to impracticality and overconfidence, especially if you don't consider the things that could go wrong, and determine ways to mitigate or guard against those (Morin, 2017). We can still be highly optimistic in our endeavors and expect we will succeed, while acknowledging where we need more training and collaboration with others in order for that success to become a reality. Sir Richard Branson, founder of Virgin brands, said, "Entrepreneurial business favors the open mind. It favors people whose optimism drives them to prepare for many possible futures, pretty much for the joy of doing so" (Economy, 2015).

Self-efficacy is related to optimism, as it is defined as a person's belief that she has the capacity to behave in a way that will help her attain certain goals or produce certain effects (Bandura, 1994). Self-efficacy includes a person's emotional state, their thought patterns, their motivation, and their self-regulation (or their influence over the other three plus their actions). Being self-employed takes discipline and determination, plus a drive to make things happen.

And like Richard Branson, who has a reputation as much for his business acumen as he does for his flamboyance and limit-pushing, as *Inc.* calls it, a person who goes into self-employment needs to be comfortable with risk, with putting himself out there and trying new things (Economy, 2015). Branson credits his drive to challenge himself daily as the motivating factor in his career, and calls life "one long university education" (Economy, 2015).

Over optimism, self-efficacy, low risk aversion, a desire for control and achievement are all characteristics that comprise a self-employed personality, and Fritsch and Ruskova (2010) also add the characteristics of the Big Five model of personality to the mix: extraversion, openness to experience, agreeableness, conscientiousness, and emotional stability. Fristch and Ruskova (2010, p. 2) report that "early entrepreneurial interest is related to higher levels of openness to experience, extraversion, and conscientiousness." But of course, that doesn't mean you cannot be

an introvert and have a successful, self-employed career; some freelance careers lend themselves much better to introverted personalities. Kristie Burns, who has case studies in Chapters 5 and 6 is an example of a very successful introvert businessperson.

Your inner resources are not limited to your personality traits; your inner resources include your ambition (what drives you to do the work you do), your vision (where you'd like to go), and your intelligence (not only your smarts but knowing when to bring in help and collaborate and not do it alone). All of these things—you and all of the stuff that is in you—are what will rock your freelance or entrepreneurial career.

Case Study 7.1 shows how Tarlan Seyedfarshi, of Klo Portfolios, Vancouver, British Columbia, let her unexpected talents lead her from one planned entrepreneurial career into a different one.

Case Study 7.1 Tarlan Seyedfarshi

From a young age, I'd dreamed of being a fashion designer, but I took the more practical route and enrolled in a two-year marketing program. After graduating, I worked for a few years in the online marketing field, and although I enjoyed it, the idea of becoming a fashion designer was so much more exciting to me. So back to school I went, enrolling in a local college in a two-year fashion design program. I quickly realized my new area of focus was very technical with lots of pattern making and sewing, which I couldn't keep up with. I struggled to finish projects and when I did, they left a lot to be desired.

For our final project of the year, our instructor asked us to create a physical presentation piece to showcase a collection we had been working on. After searching online and in stores for a solution, I didn't find anything that had the wow factor. There were only off-the-shelf pieces that were boring and uninspiring.

With my marketing background and knowledge of laser cutters and Computer Numerical Control (CNC) machines, I designed a portfolio to hold my work and had a friend who had access to these

machines create it for me. The final piece was a total hit with my instructor and classmates. And my instructor pulled me aside to let me know that although my collection could use some work, the presentation piece was beautiful. I was elated! I decided to submit it to the design blog NotCot that featured the portfolio (here's the link: www.notcot.org/?action=search&postsub.x=0&postsub. y=0&show=&query=klo+portfolios and mine is first image on the left). And overnight, I received thousands of views and had dozens of design students from around the world ask if I could make them one, too. It was at this moment that I realized I had something.

After finishing my first year of the fashion design program, I decided not to go back. I found a job at a local tourist attraction as their online marketing coordinator and worked 9–5 at my new job and 5–9 on building my new business. I spent nearly two years honing down my product offering, finding fabricators, sourcing materials, building a website, and learning to take high-quality photos with a DSLR camera. During this time, I was taking orders from designers who had found the blog feature and were e-mailing my hotmail account with their orders.

Once my website launched, I went out on a limb and quit my full-time job. I figured if I failed, I could always go and get another job. Jump and the net will appear, right? At first I was a one-woman show who outsourced a lot of the work. This wasn't ideal since it was expensive and I had less control over the final product.

After a couple of years, I asked my boyfriend (now fiancé) to quit his job and come help me. He was hesitant at first, but then a bicycle accident that left me with a broken elbow for months ended up being a real catalyst! I was physically out of commission and needed his help. So he quit and became my business partner. Together we've grown the company and purchased all the necessary machinery to bring the work in-house and are now working on an exciting website re-launch that will include four new products. We've created tens of thousands of beautiful custom portfolios and proudly offer the highest quality and largest selection of materials.

As we began to grow and absorb all of the manufacturing, along with marketing efforts, in-house, we needed help with graphic design, production, and customer service so that we're able to offer customers the best personalized experience. It can be a hard transition since you're used to doing everything a particular way but in order to grow, you have to put faith in others so that you can concentrate on the bigger picture. Once you find quality team members and can communicate your vision and get buy in, beautiful things happen.

The biggest learning experience of my career so far has grown from when I went back to school to study fashion design and was horrible at it, it felt like I had failed at the one thing I thought I wanted to pursue. I spent a lot of time beating myself up even though ultimately this experience is what led me to solving a problem for other designers. I learned that trying and failing at something is okay because you never know what other golden nuggets you'll discover along the way. Things don't always go as planned, and if we're willing to be more flexible in situations, then other opportunities may present themselves if we're open to it.

My greatest success is tied to that same scenario: it has been turning a failure into an opportunity. Fashion design ended up not being my calling. It did, however, expose me to a problem that needed solving for other designers, and I was astute enough to pick up on it and see it through. One of my favorite quotes is "We learn from failure, not from success."

When others come to me for business advice, I tell them: If there's a business you'd like to start, start small. You don't need loads of cash to test an idea out. You can create an e-commerce website using platforms like Shopify or test out your product by creating an Etsy shop, which gives you access to a huge customer base that could be searching for your product.

Also, launch fast and iterate often. I used to think that a product had to be perfect before it could be launched, but how can that be when you haven't had any feedback? I quickly learned that it's better to launch a product even before it's perfect so you can get adequate feedback from customers and constantly fine tune it.

If you're not embarrassed about the first version of your product, you've probably launched it too late.

And, chances are there's an awesome small development center in your town with mentors and staff that can help you with a checklist of things you need to get started. This can include registering your business, getting help with a business plan, or getting answers to questions about taxes and financing. There are a lot of helpful resources online, although sometimes it helps to seek the wisdom of someone in the real world.

The one thing I wish I had known before going into business for myself was that no one tells you the emotional roller coaster the entrepreneurial life entails. Some days you feel like you're on top of the world, and other days you wonder if you know what you're doing. It's important to take breaks and do other things you enjoy to help energize and refocus. Having a life outside of your business and taking the time for self-care will allow you to have perspective and balance in your life.

As rewarding as it is to work for yourself and build something from the ground up, it's not always going to be glamorous and that's okay. There'll be a lot of sleepless nights and missed events with friends and family, and you have to mentally prepare yourself for long hours and a lot of multi-tasking. Tough skin is definitely a prerequisite!

Tarlan Seyedfarshi
Founder and customer service manager, KloPortfolios
www.kloportfolios.com
Twitter: @tarlanklo
Facebook: www.facebook.com/kloportfolios
Instagram: @kloportfolios
Flicker: www.flickr.com/kloportfolios

Tarlan Seyedfarshi learned to focus on her strengths, to trust her instincts, and to seek help from others, who had skills that complemented hers. Throughout this book, we have discussed business skills that freelancers must have to succeed. Now, let's look at those a bit

more in-depth and explore resources in case you need to brush up any of these skills.

Develop These Skills

Artist and professor Paul Klein (2013) believes that for artists to succeed, they need to step outside of the art and to devote 30 to 70 percent of their time to the business side of their careers. Part of that time needs to be spent in these three crucial areas: research, business, and marketing.

Research

Research is critical in the planning, launch, and ongoing running of a freelance or entrepreneurial business. You'll need to be able to research the market, quite possibly your competitors, and your potential customers/ clients and current ones to understand their needs. *Entrepreneur* calls researching "both an art and a science, as there are practical rules to follow but also an instinctual element to success. Proper research can solve—or prevent—almost any common problem in the earliest courses of your business development" (Johansson, 2015).

Business

The Small Business Development Corporation (2018) says that financial management; marketing, sales, and customer service; communication and negotiation; leadership; project management and planning; delegation and time management; problem solving; and networking are the skills it takes to run a successful business. *Inc. Magazine* adds curiosity to that mix, stating:

> The best business skill has always been a healthy curiosity. This will lead you to look into what your competitors are doing, and it will also allow you to utilize new technologies to the best of your ability to streamline your business and even reach out to new customers. When the only limit you have is what you can imagine and apply, just about anything is possible.
>
> (Newlands, 2014)

Business skills, like research skills, can be brushed up or learned, if you feel you're lacking in any area. In a few sections, we'll discuss some online courses you can take (many of which have $0 tuition).

And if you'd like to hear how some other entrepreneurs have developed their business skills, and what they've learned over the years, Khan Academy has numerous video interviews with entrepreneurs that are inspiring, thought provoking and educational. See www.khanacademy.org/college-careers-more/entrepreneurship2/interviews-entrepreneurs to access all of them.

Or if you want more formal education (and to say you've been to Harvard) Harvard Business School offers a four-week Entrepreneurship Essentials program that runs during the summer, and its tuition is under $1,000. See https://hbx.hbs.edu/courses/entrepreneurship-essentials/ for more details.

Regardless of how many skills we possess, which guide us in our freelance careers, like Richard Branson said, we never stop learning if that's how we choose to view life and business.

Marketing

Marketing may be one of our most time-consuming areas of focus as we start our freelance careers. Directly pitching to clients, networking, and Internet marketing can seem like endless tasks. Some freelancers set aside an hour per day to pitch clients, as they find having a designated time and a cut-off time more mentally manageable. The key ingredient we need to remember as we market our freelance businesses is to be consistent. Our messaging will hit its marks when we aim it at a particular demographic and have all parts of our marketing (e-mail, social media, advertising, branded content, etc.) showing a consistent brand and message.

If you feel you need a refresher on online marketing, the following courses are available (some of which are free):

Internet Marketing for Smart People www.copyblogger.com/online-marketing-course.

Content Marketing for Business to Business (B2B) Enterprises www.udemy.com/b2b-content-marketing-training.

Social Media Marketing with EdX www.edx.org/course/social-media-marketing-bux-qd504x.

Digital Marketing Course with Google www.google.com/online challenge/dmc.

Viral Marketing and How to Craft Contagious Content with Wharton School of Business www.coursera.org/learn/wharton-contagious-viral-marketing#pricing.

Or Cornell University's online school (called eCornell) has a whole certificate program in Marketing www.ecornell.com/certificates/marketing, in case you want to formalize your approach and add this program to your resume or CV.

Networking (or Where to Find Help When You Need It)

Just as important as the skills of research, understanding general business principles and methods, and marketing, is the skill of networking. And remember, networking can happen anywhere at any time. In a YouTube video posted by the Silicon Valley Historical Association, Apple founder Steve Jobs (2011) talks about the power of asking for help or for what you want. He relates a story of his life at the age of 12, calling Bill Hewlett, co-founder of Hewlett-Packard, on the phone after getting his number from the phone book and asking him for spare parts so he could build a frequency counter. Hewlett agreed to give him the parts, and he offered the prepubescent Jobs a summer job assembling frequency counters. This is just one example of how you never know to what opportunities asking for help may lead.

Jobs (2011) said,

I've never found anyone who's said no or hung up the phone when I called. I just asked. And when people ask me, I try to be as responsive, to pay that debt of gratitude back. Most people never pick up the phone and call, most people never ask. And that's what separates, sometimes, the people that do things from the people that just dream about them. You gotta act. And you've gotta be

willing to fail, you gotta be ready to crash and burn, with people on the phone, with starting a company, with whatever. If you're afraid of failing, you won't get very far.

We succeed in our careers when we view every meeting with anyone, even people we run into while we are out socially or while we're traveling, as possible networking opportunities. You never know who will cross your path and how that person will contribute to your career or you to theirs.

Many successful freelancers or entrepreneurs will tell you (and the case studies in this book testify to this fact) that they learned a lot by doing and failing and redoing, and that their education is ongoing through workshops, online courses, conferences, and through networking with other professionals. They are business people who are simultaneously lifelong learners. Danielle Brooks, in Case Study 7.2, is an example of someone who has had success with a number of businesses and who never stops learning and helping others achieve their dreams, too.

Case Study 7.2 Danielle Brooks

Have you've ever had someone tell you you'll probably fail? This is what my mom said to me when I was 17. This was just before she announced she had met an anesthesiologist whom she planned to live with. This meant she was leaving Seattle, and me, for New York. I was working as a grocery store bagger at the time. My mom helped me open a checking account and then said, "You're on your own now." I interpreted her leaving to mean she didn't love me and that I wasn't good enough. I remember being so angry, and so determined to prove her wrong.

Because I had no real skills I worked two jobs as a waitress and grocery clerk and was barely making ends meet. My future looked bleak. I decided to go to school so I—who had a 1.7 GPA in high school—enrolled at a community college and I worked hard. By the time I was done I had brought my GPA up to 3.4. I studied physical

therapy and got a job in my major, and the people who worked with me became my mentors. They noticed that I was good with my hands and encouraged me to study massage. I did, and when I graduated, my mentors encouraged me to open up my own business. I had no idea how to do this. With their support, the next thing I knew I was giving nine massages per day, and had hired six other massage therapists as employees and we had a two-week wait list.

And then I was in a car accident and herniated a disc in my neck and I needed surgery. I thought I would lose it all, but my employees rallied around me and kept the business going while I was healing. When I returned, I knew my body would not be able to tolerate giving massages so I ran the practice for a while. My bliss was helping people, not doing paperwork and trying to get money from insurance companies. So I went back to school and became a nutritional therapist practitioner and practiced part time while I ran the business. I then became a clinical herbalist and eventually hired a business manager to manage the business so I could work with people. This was the best thing I had ever done. She loved paperwork, and I loved working with people; it was the perfect match.

This gave me the freedom to write a book called *Good Decisions . . . Most of the Time (Because Life Is Too Short Not to Eat Chocolate)*. I started a second company called Good Decisions and began to do some public speaking, at professional conferences and leading workshops.

Throughout my career I have realized how important it is to hire out your weaknesses. Soon, my massage practitioners out skilled me, my business manager made the business more efficient, and I had the freedom to continue to learn and grow. I surrounded myself with similarly minded, entrepreneurial people, and learned from them. Every year I attend at least two or three workshops. Some on developing my skills as a practitioner, some on developing my marketing, branding, and online acumen, and some on personal growth. I joined an entrepreneurial group and learned the importance of asking for help and utilizing the resources of professional organizations.

I now live in a community of self-employed, entrepreneurial like-minded people. From them, I have learned that to increase my ability to impact others increasing my online presence is a must. So I learned the online language that includes sales funnels, e-mail sequences, lead pages, SEO, backlinks, and other terms that made my eyes roll to the back of my head. But I did it. I have done many things that have made me uncomfortable in order to grow.

I've also learned to not be afraid to fail. If you aren't failing, you aren't growing. If it hadn't been for my mom's comment and those early years of scrambling to get by and having bill collectors call, I may not have had the chutzpah I have today. I wouldn't be as successful or enjoy this life of helping others.

Five things I wished I knew before I started this entrepreneurial journey are:

- Don't be afraid to hire people or work with people more talented than you. Play to your strengths, it will be more fun.
- Don't be afraid of what you don't know, and don't let what you don't know stop you.
- Get your ego out of the way and ask for help from others who have gone before you.
- Get off of the thought or belief that what you do has to be perfect. Slap it together, throw it out there, and if sticks, make it better. If it doesn't, let it go.
- There is no such thing as being worthy. The idea of being unworthy is the biggest lie society has collectively bought into.

All throughout my life I would check in with my mom to see, "Hey mom, do you love me now?" "Am I good enough now?" and for the longest time I never felt that I was.

Then about three years ago she died of cancer. As I cared for her I realized everything I had told myself all those years was a lie. My mom did love me. She did the best she could with what she was given. And for the first time I saw her. I got to know who she was,

not as my mom, but as a woman. And she was beautiful. Of course I was loved and of course I was good enough.

Now, I still sometimes catch myself trying to be perfect. I still hear the voice in my head that says, "Who do you think you are?" and to that voice I say, "I am Dani. I am free to be, do, or have whatever I want." I then do a sexy shimmer and get on with my day.

Danielle Brooks, N.T.P., C.H.
Author, nutritional therapist practitioner, clinical herbalist
www.lakewashingtonwellness.com
www.gooddecisions.com

Danielle Brooks had the drive and determination to make successful businesses from her interests and endeavors. And she had the wisdom to surround herself with people who complemented her skillset and who encouraged her to learn and grow and stretch herself. In order to rock our freelance careers, we need to know when to look within and when and where to look outside ourselves. So let's explore some essential resources outside ourselves.

Resources Outside Yourself

Online

The Internet is awash with resources, from groups to join, blogs and newsletters to follow and read, courses to take to gain more knowledge and skills, Twitter feeds filled with microencapsulated bites of wisdom to follow, and podcasts that bring humor, education, and entrepreneurial anecdotes to our ears. Let's review a few pertinent groups on LinkedIn first. Their descriptions are taken from their group's homepages.

Entrepreneur's Network is a network for current and aspiring entrepreneurs. A place to find answers, ask questions and connect with people in this space.

Founded in 2007, **FlexJobs** is dedicated to helping job seekers find a better way to work. We are a company full of passionate people who believe in the importance of remote and flexible jobs and are committed to providing a better way to find them. We think the old ways of working are rigid and broken and that there is a better way to work.

The Freelancer Writers' Connection is a group for freelance writers. We're here to offer community support, networking opportunities and to share mutual experiences about the craft and business of freelance writing. Our goal is to advance our individual writing careers while connecting with others in meaningful relationships. No one is an island. When one succeeds, we all benefit.

Since 2010, **Independent Contractor Alliance** is the premiere group to share information, opportunities, resources, and services that will help advance independent contractors, freelancers, and solopreneurs (1099s) in the U.S. corporate workforce.

The Personal Branding Network is a collective group of individuals, spread across the globe, who come together to build powerful brands. Whether it's professional or personal development, the PB Network will connect you with experts who can answer your questions. The PB Network was established by leading expert and author, Dan Schawbel, and is open to anyone and everyone who wants to make a difference in the world. They have just short of 20,000 members.

Self-Employed Leadership Group states that if you are self-employed, or are on the road to being your own boss, yet you sometimes feel isolated or just like to keep up with business trends and info, then this group is for you. Gain support, understanding, and business growth insights with other like-minded business owners. Posting your business articles, thoughts, and ideas is encouraged, as is commenting on other posts.

Unintentional Entrepreneur is comprised of unintentional entrepreneurs, self-employed professionals, side business owners, startup founders, and freelancers who are starting and growing businesses in spite of economic conditions. We're without the support of credit

markets, the government, or big business; many have been laid off before meeting the challenge of entrepreneurship. We work for ourselves with far greater demand on our own business than any one else would put.

LinkedIn continues to be a hub of professional activity. Joining groups is a great way to connect with others. Not only do these LinkedIn groups for freelancers and entrepreneurs help with finding new clients and opportunities, they also serve as a place to connect and network with other freelancers and read up on industry information.

Blogs, Newsletters, and Magazines

Artrepreneur https://mag.orangenius.com covers the business of art and they also publish the *Art Law Journal* https://alj.orangenius.com.

Freelancers Union blog https://blog.freelancersunion.org covers everything related to freelance business and freelancers as people (finances, productivity, managing transitions, social media, home-buying tips for the self-employed, etc.).

LancerLife www.lancerlife.com was created to help freelancers and those who outsource to freelancers. Articles include "How to Grow Your Freelance Business," "On Landing Great Freelance Clients," "5 Errors that Could Destroy Your Freelance Business," and more.

Leaving Work Behind https://leavingworkbehind.com/blog covers ways to handle clients who won't pay on time, how to sell your affiliate website, how to set goals and actually motivate yourself to achieve them, and how to get more money from a better designed Hire Me page.

Marie Forleo has an inspiring blog www.marieforleo.com/blog that covers things like "How to Make Your Business Remarkable, Even with Tons of Competition" and "How to Build a Business When You Hate Marketing & 5 More Dilemmas Solved!"

MediaBistro www.mediabistro.com is your paid access to e-mail addresses for editors and publishers of newspapers, magazines, and websites, and for publishing industry news.

Michael Hyatt https://michaelhyatt.com/magazine publishes a magazine and does podcasts all related to various aspects of business and success. Articles include titles like, "Why You—Yes, You—Should be an Entrepreneur" and "Productivity Investments that Pay for Themselves."

One Woman Shop was created because "going it alone shouldn't feel lonely." The blog http://onewomanshop.com/blog covers topics such as clarity in decision-making, ways to make Facebook work for your business, and how to generate publicity in 30 minutes per day.

ProBlogger https://problogger.com/blog offers tips on how to use your blog to crowdfund a project, how to build an engaged audience, how to get more traffic, and what is the best blog hosting solution, and much more.

Screenwriting U Magazine https://screenwritingumagazine.com is all about the craft of screenwriting and screenwriting competitions.

Smart Passive Income Blog by Pat Flynn www.smartpassiveincome.com. Flynn takes readers through the fundamentals of affiliate marketing, better blogging, e-mail marketing, and podcasting as ways to make passive income.

Courses and Schooling

We've already discussed some marketing-specific courses you could take in the marketing section of this chapter. But let's explore some places where you could take general freelance or entrepreneurship courses to increase your knowledge and skillset. Udemy, Coursera, Grammarly, SkillShare all offer support in this way.

Seth Godin offers a course through Udemy called **Freelancer's Course**, where students learn to "become remarkable, find better clients, and do work that matters." www.udemy.com/seth-godin-freelancer-course/?siteID=NS6CLIT2G_I-4mFcuojGKWjmuzlhdT9I3g&LSNPUBID=NS6CLIT2G%2FI.

Guy Kawasaki teaches **The Essential Guide to Entrepreneurship**, which includes the critique of a live pitch and the dos and don'ts

of entrepreneurship. www.udemy.com/entrepreneurship-course-by-guy-kawasaki/?siteID=NS6CLIT2G_ICy.oSLnUVfmZaskqzy.Zvg&LSN PUBID=NS6CLIT2G%2FI.

Freelancing for Creatives: Strategies and Resources from First Leap to Finances, by Margot Harrington, is a one-hour course that includes how to create a mission statement and tips on working with clients, in addition to advice on finances. www.skillshare.com/classes/Freelancing-for-Creatives-Strategies-Resources-from-First-Leap-to-Finances/591897973?via=search-layout-grid.

Freelance Kickstart: Launch a Successful Freelance Business Today, by Phil Ebiner, provides a blueprint for establishing a freelance career. www.skillshare.com/classes/Freelance-Kickstart-Launch-a-Successful-Freelance-Business-Today/622166049?via=search-layout-grid

And if you prefer to study freelancing or entrepreneurship a bit more formally, *U.S. News* reports that the top 10 schools in 2018 to get a Master's Degree in Entrepreneurship are (in order): Babson College, Stanford University, Massachusetts Institute of Technology, Harvard, University of California—Berkeley, University of Pennsylvania, University of Michigan, University of Southern California, Indiana University, and University of Texas at Austin ("Best Graduate Schools in Entrepreneurship," 2018).

Twitter Handles

But sometimes our best learning comes more informally, by learning from others who have gone before us. The following twitter handles are only a handful of those that offer insightful tips for freelancers in a variety of industries.

@ATGraphicDesign For graphic design professionals

@bandzoogle Created for musicians who want to improve their websites

@BCFilmmaker Peter Marshall uses his experience to encourage up and coming filmmakers

@designtaxi A global creative network

@freelanceadvice An accounting firm that focuses on financial topics as they relate to freelancing

@Freelancersu The Freelancer's Union

@GDUSAmagazine Magazine for graphic design and creatives

@khoi Great for people in design fields

@musicclout Offers opportunities for musicians

@NiemanLab A Harvard-based organization that tries to figure out the future of news. Great for writers and journalists

@ProBlogger Advice on boosting your online business, blogging and more

@Sara_Horowitz Founder of the Freelancer's Union

@scrivenercoach For screenwriters

@Sheri_Candler Author of *Selling Your Movie Outside the U.S.* tweets great advice

@suitcasepreneur Natalie Sisson runs a six-figure business from her laptop and smartphone while she travels around the world

@TheWriterLife For writers

@Typographica All about fonts and design

Podcasts

The one commonality in this list of podcasts is that all of the hosts and the guests are people who have built their own businesses and worked as freelancers or contract employees in one capacity or another. We can use them as brief mentors and role models, and for a bit of camaraderie so that we don't feel like we're alone in our solopreneurship.

The 99U podcast is produced by Behance, the worldwide network of creatives. The 99U podcast sits down with leading makers, thinkers, and

entrepreneurs for a deep dive into what makes their creative process tick. A good episode to start with is "Graphic Design Advice with Craig Ward," which leads with Ward's admission: "The idea of going freelance terrified me. I had no confidence I could turn this into a career."

The $100 MBA is a daily podcast offering quick, 10-minute, no-fluff lessons on topics in business, marketing, technology, and more. It calls itself Free Business Lessons for the Real World. https://100mba.net/show.

The Accidental Creative is a podcast, website, and book from Todd Henry focusing on techniques for creative thinking, leadership skills and positioning yourself. Be "prolific, brilliant, and healthy" is his mantra, and while this is not a podcast about freelancing per se, pretty much all the advice on offer will resonate with the average creative freelancer. www.accidentalcreative.com/category/podcasts/ac.

Cool Things Entrepreneurs Do Author of 12 books on the power of business relationships, sales, networking, presentation skills, and entrepreneurship, Thom Singer started the Cool Things Entrepreneurs Do podcast to share his knowledge and experiences in hopes of inspiring a new generation of thoughtful leaders. He has explored topics including running several companies at once, fitness for entrepreneurs, and understanding trends before they happen. http://thom singer.com/podcast.

EntreLeadership is podcast focused on sharing lessons, tips, and tricks from some of today's top entrepreneurs. It's named after host Dave Ramsey's concept of "EntreLeadership," which explores how businesses can use effective management to create ventures that grow and prosper. www.entreleadership.com/blog/podcast.

Entrepreneurs on Fire is on seven days a week. Host John Lee Dumas releases an episode on the individual journey of each guest. Subscribers to Dumas' show have heard stories from Tony Robbins, Seth Godin, Gary Vee, Barbara Corcoran, Tim Ferriss, and many other influencers and business leaders, gaining insight into how their success stories transformed them into entrepreneurs on fire. www.eofire.com/about.

Freelance Lift is a series of short, to the point podcasts featuring advice and guidance from former freelancers who've made the transition to the top level of earning. Past interviewees have included Amy Hoy, Brant Cooper, and Paul Jarvis. www.freelancelift.com/podcast.

The Freelance Podcast is targeted at people in steady jobs who are doing a bit of freelancing on the side, and are nervous about transitioning to full-time freelance. Host R.J. McCollam sets out to help, by "giving real world advice and information that can be acted on immediately." https://thefreelancepodcast.simplecast.fm.

Harvard Business Review's Ideacast features weekly episodes under 20 minutes apiece covering a range of executive-level topics. https://hbr.org/2018/01/podcast-ideacast.

How to Start a Startup is a recording of Stanford Professor Sam Altman's class about starting a business, which teaches lessons like how to manage, how to build products users love, and how to raise money. https://itunes.apple.com/us/podcast/how-to-start-a-startup/id922398209?mt=2.

The Introvert Entrepreneur is a fabulous resource is networking scares you. Launched in 2010 and hosted by author, speaker and professional coach Beth Buelow, this podcast talks about business and life from an introvert perspective, through interviews and discussions. http://theintrovertentrepreneur.com/category/podcast.

Invisible Office Hours is a weekly podcast that playfully explores the intersection of creativity and commerce, hosted by Jason Zook and Paul Jarvis. As the name implies, it's targeted at people who've struck out on their own and are no longer confined to a 9–5 physical office, or bound by conventional thinking. https://invisibleofficehours.com.

Life Skills That Matter helps you "create work with purpose": Stephen Warley and a range of guests explore how to create a life and career that is on your own terms. Topics include how much money you will need, how to get unstuck, how to find your path, and much more. https://lifeskillsthatmatter.com/podcast.

The Solopreneur Hour, hosted by Michael O'Neal, features the best and brightest solo entrepreneurs from all walks of life, including network

marketing, music, fitness, actors, and comedians. There's no specific design focus, but that does mean you get a wide range of different perspectives on freelancing and entrepreneurship than you might not get from a designer-only podcast. https://solopreneurhour.com.

The **Youpreneur** podcast is for entrepreneurs striving to build their personal brands and virtual business success. The host, Chris Ducker, shares his own knowledge and expertise on shifting away from traditional business practices and attitudes. Ducker knows that even after finding success, entrepreneurs should constantly strive to learn and evolve with the times. www.chrisducker.com/podcast.

Other resources outside yourself include YouTube videos (which number in the millions and seem to have tutorials to teach us to do just about anything). Dan Vassiliou, in Case Study 7.3 attributes much of his knowledge and the foundation of his business success to online courses and YouTube videos, from which he learned about digital marketing.

Case Study 7.3 Dan Vassiliou

I spent my time after college selling things, everything from phone systems to mobility scooters, until about 12 years ago when I decided to leave others' employ and go to work for myself in a business selling trophies from my home. My wife and I had our first child and she wanted to pursue her dream job outside of the home, that of being a piano teacher, so I moved home with my work so I could also be a stay-at-home dad.

During my trophy business, I learned how to market, mostly from reading articles online and watching YouTube tutorials on how to digitally market yourself and products through content marketing, guest posting, etc. From my sales experience, I understood how to pitch a product, whether you were verbalizing it or writing it out. I knew how to promote the strengths of a product or service, what factors that people are going to want or needed to be convinced of needing. In sales, you get kind of a sixth sense for avenues that are

likely to produce quality traffic flows to sell your product, whether that be through print advertising or radio, television, a market stall or foot traffic in a town center, to various traffic avenues online like search traffic, social media traffic, paid advertising through sites, etc. You also still need to be able to carry your product or service to potential clients who have found your service and want to run through it or see if your service or product can solve a problem for them. Sales ability is certainly pertinent then. You also learn to accept dips in revenues, peaks, and troughs, as I call them. This hardens you and makes you very persistent, resilient, even. The knock backs simply become one more hurdle to climb over. This happens a lot online as algorithms for organic traffic change and certain campaigns draw blanks or poor results. You certainly learn how to roll with the punches as a salesman.

While I was learning these new skills, I saw that a lot of people out there knew even less about online marketing than I did . . . and that I could monetize my new skills by helping them, with the niche of content marketing, so I left the trophy business to pursue a digital marketing endeavor. As more and more businesses moved online, I saw that offering specific products that could help clients in a specialized marketplace was going to be an opportunity to start a business that was going to be able to take advantage of constant growth at least in the short to medium term. That hasn't been proved wrong yet. I knew I had to learn a lot of new skills. Lots of YouTube and online courses, lots of working with other agencies in a freelance capacity and learning how they managed things. I knew that this was where I was going to make my living for the next 20 years at least. I had the good fortune to really focus on the content marketing side of things, and through that getting exposure for clients in blogs and news sites that helped enhance their search engine rankings as well as gave them access to decent traffic opportunities, which in turn helped my business grow.

My clients are often found through word of mouth and recommendation when it comes to managing actual clients/end user sites. My business is split into two key areas: actual companies who I advise and manage sites for focusing mainly in the content marketing

aspect of promotion, and agencies who buy content marketing related products from me to service their clients. Many agencies do not have the manpower or time to create their own outreach or networking teams to create opportunities for them to get the products I can easily supply. It is quicker and less complicated for them to use me, and in some cases, to hire me as a freelancer to work solely with them on various products.

Outside of word of mouth I get traffic from Internet searches that hit my site advertising that I target at communities (largely agencies), who may find my products and services fulfill the needs of their own clients. And then they tend to reach out and I pitch them on why it's a good idea to outsource this area of their business to me and how I can fulfill their needs.

You need to have a lot of self-drive and determination as a freelancer. You also need to be able to handle the ups and downs, feasts and famines. Being able to create worthwhile relationships always helps as people tend to offer business to people they get on with. Being reliable and having a desire to make your work better than others will also endear you to the people you build relationships with as they will have a person they get on with who also produces a level of work the are happy with. Rome wasn't built in a day, so gathering a large enough client base can take some time. It took me over two years to be able to earn a living from my client base. Some clients will go elsewhere, some will change the kind of work they are looking to buy services from or employ, you need to be able to get over setbacks like that quickly and get back on track finding new clients. My main advice would be to keep learning about what you are doing and improving whatever it is that you offer. Try to make it the best service or product out there. A good service or product will always find clients . . . the best ones find clients easier.

Having children shaped my career as I felt that I wanted to be able to work, yet still raise them while my wife followed her dream of teaching the piano outside of our home. Without that opening up as a track for me to follow, I don't know whether I would have gone into the digital world as I did. Being a resilient guy and being

experienced in selling definitely helped me along that track. YouTube is my favorite resource as you can learn almost anything from the free videos that you find there. Other SEO softwares, like MOZ.com, have also been invaluable. Using platforms like Upwork and PeopleperHour have also been invaluable in helping find people that I can work with myself, who themselves are freelancers, to create the products that I sell on to my clients.

Success, to me, means building a world for my family where we can live in comfort, enjoy the things we want to enjoy and not have to worry about money, and to be able to know that my wife and I can retire happy one day, that we have enough money to be able to enjoy our golden years. Success also gets tied into my work. I want to know my clients have gotten above and beyond what they expected working with me or buying my products. I need to know the stuff I put together to sell is top quality so I gain a sense of success when it is proved or proven to work much better than other people attempting the same thing.

Dan Vassiliou
CEO of Edivan Digital
http://edivandigital.com
Twitter: @EnduranceSEO
Facebook: www.facebook.com/AuthorityGuestPostingService

Books

Sometimes we just need to read a good book (in addition to this one). Books for business abound; books for freelancers aren't quite as prevalent. Here's a short list that you may find useful.

The Freelancer's Bible (2012) by Sara Horowitz broadly covers how to manage yourself (time, health insurance, productivity, etc.) and your freelance business (making contacts, marketing yourself online, managing your office, taking care of taxes). This book is broadly written and a bit timeless.

Freelance to Freedom: The Roadmap for Creating a Side Business to Achieve Financial, Time and Life Freedom (2018) by Vincent Pugliese. Pugliese chronicles how he used his side business as a photographer to gain the freedom to leave his day job and to pay off all of his debt.

The Freelance Manifesto: A Field Guide for the Modern Motion Designer (2017) by Joey Korenman. This is the playbook for becoming a six-figure-earning animator or motion designer.

Starting Your Career as a Freelance Writer (2011) by Moira Anderson Allen includes basics like how to set aside time to write, how to set goals, where to find ideas, how to cope with rejection, how to do web research, how to write a first draft before it gets to the nuts and bolts of researching markets, writing queries, understanding contracts, and how to become a commercial copywriter or writer. The book is very thorough, writer-specific, and geared to a general readership that has thought about trying to become writers.

Survive the Corporate World and Go Freelance as a Creative Designer (2017) by Alex Aráez is for designers who are thinking of going off on their own and becoming full-time freelancers. The book covers how to set pricing for clients and to showcase your best work and how to deliver presentations that sell.

Professional Organizations

We've talked about networking and professional organizations and how important they are. Though we are solopreneurs, we cannot find success by going it alone. We need collaborators. We need clients and customers. That means we need to interact with others. The Appendix towards the back of this book has a list of useful professional organizations, categorized by industry.

The Meaning of Success

Success means many different things to people. Some people want to communicate with the world. For others, success means attention or being recognized by the experts or the public, or it means winning a certain

award. For others, success means making enough money to support themselves and their families and have enough for retirement and everything they want, like Dan Vassiliou in Case Study 7.3. Other people seek to do work that others can enjoy or with which others emotionally engage.

For Kerry James Marshall, success means finding himself and his work in art history books, or as *The New York Times* reports, "the Chicago-based artist has made it his mission to paint black figures into the canon" (Mason, 2016). Like great chess players, successful freelancers look ahead many moves or jobs or contracts and know what they want. They have five- or ten-year plans in their heads at a minimum and on paper, ideally, even if these plans change and evolve over time.

Author Nicolas Cole (2018) for *ThriveGlobal* writes that people tend to define success as a certain number in their bank accounts, as building something a certain number of people praise, as being a pioneer of change or being remembered after death, as making a meaningful impact or changing lives, or doing a certain thing and then associating that thing with success. Having external motivators for success is why he believes many people never become what they consider successful.

> The true feeling of success is at the heart of what you love. And if that is your intention, then you could achieve one thing or one hundred things and either way the feeling would remain the same. Because the "feeling" of success then is internal. It is a love for the journey, not the end result in itself.
>
> (Cole, 2018)

Screenwriter and novelist Marjory Kaptanoglu would agree with Cole. She defines what success means to her in Case Study 7.4.

Case Study 7.4 Marjory Kaptanoglu

I majored in English in college and always thought I would write, but I didn't know what I wanted to write yet. To support myself, I got a job as a software engineer (after having taken some programming

classes in college), and stayed with that for a number of years. I was with Apple for six years and wrote the text-editing software for the first color Macintosh. I left when my husband and I started a family, in order to spend more time with my children. At the same time, I began to write software independently. I wrote a program that could create a jigsaw puzzle out of any picture, and eventually sold it back to Apple. However, I realized I loved the creative part of having my own business, but not the marketing/sales part. This was when I chose to quit the software business and try my hand at writing.

My husband had an idea for a sci-fi novel and we decided to write it together. We completed it and submitted to agents. In the meantime, I wrote some freelance articles for magazines, but I was never particularly interested in freelance article writing. I hoped it would lead to getting more recognition as a writer so that we could get our novel published, but it didn't work out that way.

Eventually we found an agent, but he was unable to get us a publisher. He suggested our novel might have more success as a screenplay. I took classes in screenwriting and discovered I loved writing in that form. I liked that screenplays could be finished in less time than a novel. With a screenplay you can get right to plot and character development without spending a lot of time on setting the scene, for example. This helped me improve my storytelling skills, and I wrote many screenplays once I learned the craft.

Breaking in as any kind of writer is extremely difficult, but the challenges in screenwriting are even greater. This is because making a film is expensive, and therefore a lot of people are involved in the decision-making process. It isn't easy convincing such a large group of people that they should spend lots of money on your script.

I optioned several feature-length screenplays, but the producers were unable to get them made. I realized then if I hoped to see my work on film, I had to start small. I began to write short films and found I had an affinity for them. I enjoyed the succinct style (like a short story compared to a novel; it's really a different form).

To succeed, I needed to attract filmmakers to my work. I did this in several ways. One was entering contests. My short film scripts won

the grand prize in a number of screenwriting contests, including the Slamdance Film Festival, Table Read My Screenplay, International Horror and Sci-fi Film Festival, and Harlem Film Festival. The prize in the Slamdance contest was that they made the film, and they did a fantastic job on *Dead in the Room*. Winning other contests gave my screenplays credibility and helped garner filmmaker interest.

Kansas City Women in Film and TV (KCWIFT) was responsible for another one of my shorts getting picked up. When my script *Run, My Dear* won their Best Female Protagonist award, they did a staged reading. A producer who attended contacted me and then optioned the script. The film will be completed in spring, 2018.

Another film of mine (*Dearly Departed*) was produced by a friend and fellow screenwriter. We were in a screenwriting group together. Joining a group of writers is always a valuable experience and can lead to opportunities. My friend hired a director who did a terrific job on the film, and I've worked with him on developing a feature since then.

Four other short screenplays of mine have all been discovered by different filmmakers on the Inktip short script listing service (www. inktip.com). It's a free service that allows you to list your logline (one-sentence description) and contest credits. Filmmakers saw my listings and got in touch.

It was exciting to be able to observe filming on the sets of *Dearly Departed* and *Dead in the Room*. In the latter film, I also appeared as an extra. Afterwards, I was thrilled to attend the premieres for my films, which drew packed audiences. *Dead in the Room* played at the Slamdance Film Festival (which runs in Park City, Utah, concurrently with the Sundance Festival), while *Dearly Departed* had its debut at the Santa Barbara International Film Festival.

My proudest moments have come when I've attended the many festivals where my films have screened. I love listening to/watching audiences react to my stories. This is why I write: to entertain and affect people. When my writing evokes the emotional response I was going for, there's nothing better.

Because of my overwhelming desire to entertain and move people emotionally, I made the decision to switch back to novel writing

again. I realized it was likely most of my screenplays would never be filmed, but I could still try to find audiences for them by turning them into novels. My scripts serve as outlines, which I expand and deepen into narrative prose.

The other reason I'm pursuing novels now is that I realized self-publishing has become a much more widely accepted form of publishing, and far easier to do than it was before. It took only a few months for me to self-publish my second novel, *Dreadmarrow Thief*. The next time will be faster. And now, at last, there are people reading my work, commenting on it, reviewing it, enjoying it, and being moved by it. It makes me very happy.

Many writers and entrepreneurs get concerned about creating a brand, as that's what the industry tells them to do. I suppose my brand is sci-fi/fantasy, as much of my work falls under that banner. However, I won't allow branding to limit my options. If I want to write a mystery or thriller, I'll do so. Currently, I'm a screenwriter and novelist of young adult and adult sci-fi/fantasy. For now that can be considered my brand, but I will continue to write whatever I love.

When I'm asked to offer advice to other writers, the first thing I tell them is: Don't jump into self-publishing too fast. Make sure to put out a quality product. It's wise to hire experts to design the cover, edit the book, and format the book. You'll need help with marketing, too. Fortunately, these costs are reasonable compared to the general costs of starting a business.

More generally, in any type of writing, do your homework. Take classes and join a writing group to perfect your craft. Get feedback from other writers and professionals in whichever field of writing you pursue. Always be learning and trying to improve. Succeeding at writing, or in any business, is a marathon.

A newly published author, whether indie or traditional, is going to have a hard time finding an audience. Most people will not buy a book from someone they've never heard of. Because of this, I would say, don't be afraid to give away your work. I've joined the

site, wattpad.com, and I am posting my novel *Dreadmarrow Thief* chapter by chapter, until the whole book will be there. For free. I also have short stories posted on the site.

I love that people are reading and commenting and giving the chapters thumbs up. I'm reaching audiences. So far they are not a paying book-reading audience, but they may be someday. They may at least be people who can recommend my work to others, or who may buy the sequel, or other books of mine. But mostly I love that I'm reaching an international audience that's enjoying my work. I feel as if I'm contributing to literacy around the world. These are the reasons I write. Overall, I'm happy with the choices I've made at each step of my career.

Marjory Kaptanoglu
Screenwriter and novelist
www.marjorykaptanoglu.com
Twitter: @margiebk
Facebook: www.facebook.com/marjorykaptanoglu
LinkedIn: www.linkedin.com/in/majorykaptanoglu

Success, like many things in life, begins with our attitudes and our passions. Walt Disney said, "All our dreams can come true if we have the courage to pursue them (Haden, 2018). And Disney's career is an example of that belief. He started his freelance and entrepreneurial career as a child, when he drew and painted pictures and sold them to neighbors and family friends, and then worked as a cartoonist for his high school newspaper, until he dropped out of school. He then worked at a newspaper, an art studio, and a film advertising company, before setting off on his own to create an animation studio (Thomas, 1994). And the rest of his entrepreneurial life and his creations have become a part of American history.

Where will your attitudes, passion, and success take you on your freelance journey? Only hard work, drive, and time will tell.

Chapter Summary

Persistence, courage, resilience, and hard work are all necessary to succeed in a freelance career. Plus it helps to be optimistic, open to experiences, conscientious, have a drive for achievement, and to be willing to take risks. Resources—experts, collaborators, online groups and professional organizations, podcasts, courses, blogs, magazines, and books—abound to help us on our journeys, if only we reach out to them when we need them. It is up to us, and only us, to determine what success looks like in our lives and when we will have achieved it.

Exercises

1. Create a list of your personality traits and write how each would help or hurt you in self-employment. (If needed, take a personality test such as Myers-Briggs www.myersbriggs.org/home.htm?bhcp=1 or the Big Five https://openpsychometrics.org/tests/IPIP-BFFM to learn more about yourself.)
2. Create a list of professional publications for your intended profession. Why is each important?
3. Compare a graduate program with a skill-level certificate program. What would be the pros and cons of doing one versus the other? How will each help your career?
4. Interview a person in the career you want. How did they get there? What were the struggles they had along the way? What is the most important thing they have learned? What advice can they give you as you start your journey?
5. Take a few moments and analyze what success means to you. List all of the milestones that you think a successful person has attained.

References

Bandura, Albert. "Self-Efficacy." *Encyclopedia of Human Behavior*, edited by V.S. Ramachaudran. New York: Academic Press, 1994.

"Best Graduate Entrepreneurship Programs." *U.S. News and World Report*. Accessed March 12, 2018. www.usnews.com/best-graduate-schools/top-business-schools/entrepreneurship-rankings.

Busenitz, Lowell and Jay B. Barney. "Differences Between Entrepreneurs and Managers in Large Organizations: Biases and Heuristics in Strategic Decision Making." *Journal of Business Venturing* 12 (1997): 9–30.

Caliendo, Marco, Frank M. Fossen, and Alexander Kritikos. "Risk Attitudes of Nascent Entrepreneurs: New Evidence from an Experimentally Validated Survey." *Small Business Economics* 32 (2009): 153–167.

Camerer, Colin and Dan Lovallo. "Overconfidence and Excess Entry: An Experimental Approach." *American Economic Review* 89 (1999): 306–318.

Chen, Chao C., Patricia G. Greene, and Ann Crick. "Does Entrepreneurial Self-Efficacy Distinguish Entrepreneurs from Managers?" 13, no. 4 (1998): 295–316.

Cole, Nicolas. "The Reason You Are Not Successful Is Because You Don't Want to Admit this 1 Thing." *ThriveGlobal*. Last modified March 20, 2018. www.thriveglobal.com/stories/26292-the-reason-you-re-not-successful-is-because-you-don-t-want-to-admit-this-1-thing?utm_source=Arianna&utm_medium=LinkedIn.

Cooper, Arnold C., Carolyn Y. Woo, and William C. Dunkelberg. "Entrepreneurs' Perceived Chances for Success." *Journal of Business Venturing* 3 (1988): 97–108.

Economy, Peter. "Richard Branson: 19 Inspiring Power Quotes for Success." *Inc.* Last modified March 20, 2015. www.inc.com/peter-economy/richard-branson-19-inspiring-power-quotes-for-success.html.

Ekelund, Jesper, Edvard Johansson, Marjo-Riitta Järvelin, and Dirk Lichtermann. "Self-Employment and Risk-Aversion: Evidence from Psychological Test Data." *Labour Economics* 12 (2005): 649–659.

Fraser, Stuart and Francis J. Greene. "The Effects of Experience on Entrepreneurial Optimism and Uncertainty." *Economica* 73 (2006): 169–192.

Fristch, Michael and Alina Rusakova. "Personality Traits, Self-Employment, and Professions." *Jena Economic Research Papers*. October 2010. No. 2010-075.

Haden, Jeff. "75 Inspiring Motivational Quotes About Success." *Inc.* Accessed March 12, 2018. www.inc.com/jeff-haden/75-inspiring-motivational-quotes-about-success.html.

Jobs, Steve. "Steve Jobs on Failure." Silicon Valley Historical Association. Last modified October 31, 2011. www.youtube.com/watch?v=zkTf0LmDqKI&feature=youtu.be.

Johansson, Anna. "5 Skills that Are the Foundation of Entrepreneurial Success." *Entrepreneur*. Last modified September 22, 2015. www.entrepreneur.com/article/249137

Klein, Paul. "How to Succeed as an Artist." Klein Artist Works. Last modified March 12, 2013. www.youtube.com/watch?v=UcTYhaA72iY.

Koellinger, Philipp, Maria Minniti, and Christian Schade. "I Think I Can, I Think I Can: Overconfidence and Entrepreneurial Behavior." *Journal of Economic Psychology* 28 (2007): 502–527.

Lee-Ross, Darren. "Personality Characteristics of the Self-Employed: A Comparison Using the World Values Survey Data Set." *Journal of Management Development* 34, no. 9 (2014): 1094–1112. https://doi.org/10.1108/JMD-06-2014-0062.

Lowe, Robert A. and Arvids A. Ziedonis. "Overoptimism and the Performance of Entrepreneurial Firms." *Management Science* 52 (2006): 173–186.

McCready, Ryan. "How Much Do Freelance Writers Actually Make?" Venngage. Last modified June 10, 2016. https://venngage.com/blog/how-much-do-writers-make.

Mason, Wyatt. "Kerry James Marshall Is Shifting the Color of Art History." *The New York Times*. Last modified October 17, 2016. www.nytimes.com/2016/10/17/t-magazine/kerry-james-marshall-artist.html.

Morin, Amy. "3 Times Optimism Does You More Harm Than Good." *Business Insider*. Last modified November 17, 2017. www.businessinsider.com/overly-optimistic-isnt-the-same-as-mentally-strong-2017-11.

Munroe, Myles. *Principles and Power of Vision: Keys to Achieving Personal and Corporate Destiny*. New Kensington, PA: Whitaker House, 2015.

Newlands, Murray. "5 Most Important Business Skills Every Entrepreneur Must Have." *Inc*. Last modified August 11, 2014. www.inc.com/murray-newlands/5-most-important-business-skills-every-entrepreneur-must-have.html.

Small Business Development Corporation. "Essential Business Skills." Accessed March 12, 2018. www.smallbusiness.wa.gov.au/business-advice/starting-your-business/business-skills.

Stewart, Wayne H. and Philip L. Roth. "Risk Propensity Differences Between Entrepreneurs and Managers: A Meta-Analytic Review." *Journal of Applied Psychology* 86 (2001): 145–153.

Thomas, Bob. *Walt Disney: An American Original*. Burbank, CA: Disney Publishing, 1994.

Utsch, Andreas, Andreas Rauch, Rainer Rothfuß, and Michael Frese. "Who Becomes a Small-Scale Entrepreneur in a Post-Socialistic Environment: On the Differences Between Entrepreneurs and Managers in East Germany." *Journal of Small Business Management* 37 (1999): 31–42.

Zhao, Hao, Scott E. Seibert, and Gerald E. Hills. "The Mediating Role of Self-Efficacy in the Development of Entrepreneurial Intentions." *Journal of Applied Psychology* 90 (2005): 1265–1272.

Appendix

Professional Organizations, Associations, and References for Freelancers or Entrepreneurs

Note: This Appendix is organized by industry, though many of the organizations serve members whose work crosses industries. While this list is inclusive, it is not exhaustive.

Freelancers (General, Writers, Editors, Indexers, Proofreaders, Translators, Publishers, etc.)

Editorial Freelancers Association www.the-efa.org

Freelancers Union www.freelancersunion.org

National Association for the Self-Employed www.nase.org

National Association of Entrepreneurs www.thenae.org

National Association of Independent Writers and Editors https://naiwe.com

National Writers Union https://nwu.org

Writers Guild of America East www.wgaeast.org

Writers Guild of America West www.wga.org

Graphic Design

American Institute of Graphic Arts www.aiga.org

Art Directors Club http://adcglobal.org/about/what-is-adc

Association of Registered Graphic Designers www.rgd.ca

Graphic Artists Guild www.graphicartistsguild.org

International Council of Graphic Design Associations www.ico-d.org

Society for Experiential Graphic Design www.segd.org

Society for News Design www.snd.org

Society of Illustrators www.societyillustrators.org

Society of Publication Designers www.spd.org

Type Directors Club www.tdc.org

World Design Organization http://wdo.org

Interior Design

American Society of Interior Design www.asid.org

Designer Society of America www.dsasociety.org

Interior Design Educators Council www.idec.org

Interior Design Society http://interiordesignsociety.org/index.php

International Federation of Interior Architects/Designers https://ifiworld.org

International Interior Design Association www.iida.org

Journalism

American Press Institute www.americanpressinstitute.org

American Society of Business Publication Editors www.asbpe.org

American Society of Newspaper Editors http://asne.org

Asian American Journalists Association www.aaja.org

Associated Press Media Editors www.apme.com

Association for Women in Communications www.womcom.org

Association for Women in Sports Media http://awsmonline.org

Association of LGBTQ Journalists www.nlgja.org

Association of Magazine Media www.magazine.org

BEA Broadcast Education Association www.beaweb.org

National Association of Black Journalists www.nabj.org

National Association of Broadcasters www.nab.org

National Association of Hispanic Journalists www.nahj.org

National Federation of Press Women www.nfpw.org

National Newspaper Association www.nnaweb.org

National Press Club www.press.org

Native American Journalists Association www.naja.com

Newspaper Guild www.newsguild.org/mediaguild3

Online News Association https://journalists.org

Overseas Press Club https://opcofamerica.org

Radio-Television News Directors Association https://rtdna.org

Religion Newswriters Association www.rna.org

Reporter's Committee for Freedom of the Press www.rcfp.org

Society for News Design www.snd.org

Society of American Business Editors and Writers (Sigma Delta Chi Foundation) https://sabew.org

Society of Environmental Journalists www.sej.org

South Asian Journalists Association www.saja.org

UNITY: Journalists for Diversity www.unityjournalists.org

Musicians and Composers

Alliance of Artists and Recording Companies http://wp.aarcroyalties. com

American Association of Independent Music http://a2im.org

American Composers Alliance www.composers.com

American Composers Forum www.composersforum.org

American Federation of Musicians www.afm.org

American Society of Composers, Authors and Publishers www.ascap. com

American Society of Music Arrangers and Composers www.asmac.org

Association of Independent Music Publishers www.aimp.org

Association of Music Producers www.ampnow.com

Audio Engineering Society www.aes.org

Broadcast Music, Inc. www.bmi.com

Christian Music Trade Association www.cmta.com

Church Music Publishers Association http://cmpamusic.org

Country Music Association www.cmaworld.com

Film Music Network www.filmmusic.net

Future of Music Coalition https://futureofmusic.org

Gospel Music Association www.gospelmusic.org

Harry Fox Agency www.harryfox.com (Author's note: This organization was included because in 1927, the National Music Publishers' Association established HFA to act as an information source, clearinghouse, and monitoring service for licensing musical copyrights. HFA is now the nation's leading provider of rights management, licensing, and royalty services for the music industry and issues the largest number of mechanical licenses on behalf of its affiliated publishers for the use of music in both physical and digital distribution formats.)

International Alliance for Women in Music http://iawm.org

International Computer Music Association www.computermusic.org

International Federation of the Phonographic Industry www.ifpi.org

Jazz Alliance International www.jazzai.org

Latin Recording Academy Inc. www.latingrammy.com

MIDEM www.midem.com

Music Business Association www.musicbiz.org

Music Managers Forum-USA www.mmfus.com

Music Performance Trust Fund www.musicpf.org

Music Publishers Association www.mpa.org

Nashville Songwriters Association International www.nashvillesong writers.com

National Association of Music Merchants www.namm.org

National Association of Record Industry Professionals www.narip. com

National Association of Recording Arts and Sciences www.grammy. com

National Music Publishers Association http://nmpa.org

New Music USA www.newmusicusa.org

North American Performing Arts Managers and Agents www.napama. org

Recording Academy www.grammy.org/recording-academy

Recording Artists' Coalition www.grammy.org/recording-academy/ advocacy/rac

Recording Industry Association of America www.riaa.com

Rhythm and Blues Foundation www.rhythmblues.org

Screen Actors Guild and AFTRA www.sagaftra.org

Society of Composers www.societyofcomposers.org

Society of Composers, Authors, and Music Publishers of Canada www.socan.org

Society of European Stage Authors and Composers http://sesac.com

Society of Professional Audio Recording Studios) www.spars.com

Songwriters Guild of America (SGA) www.songwritersguild.org

SoundExchange www.soundexchange.com

Tennessee Songwriters Association International www.tennessee songwriters.com

Fine and Visual Arts

National Art Education Association www.arteducators.org

National Association of Women Artists, Inc. www.thenawa.org

National Society of Artists www.nsartists.org

Professional Association of Visual Artists, Inc. www.pava-artists.org

Computers/Video Games (Plus Fonts and Graphics)

Association for Computing Machinery www.siggraph.org

Association Typographique Internationale www.atypi.org

Entertainment Software Association www.theesa.com

International Colour Association www.aic-color.org

International Game Developers Association www.igda.org

International Society of Typographic Designers www.istd.org.uk

Inter-Society Color Council www.iscc.org

Society of Illustrators, Artists, and Designers www.siad.org

Society of Typographic Aficionados www.typesociety.org

Type Directors Club www.tdc.org

Performing Arts (Theatre, Film, Dance)

Actors Equity Association www.actorsequity.org/home.html

The ActorSource www.theactorsource.com

Alliance for Women in Media www.allwomeninmedia.org

American Alliance for Theatre and Education www.aate.com

American Association of Community Theater www.aact.org

American Society for Theatre Research www.astr.org

American Society of Theatre Consultants www.theatreconsultants.org

American Theatre Wing www.americantheatrewing.org

American Theatre Works www.theatredirectories.com

Americans for the Arts www.americansforthearts.org

Association for Theatre in Higher Education www.athe.org

Association of Arts Administration Educators www.artsadministration.org

Broadway League http://ww.broadwayleague.com

Casting Society of America www.castingsociety.com

Congress on Research in Dance www.cordance.org

Drama League www.dramaleague.org

Dramatists Guild of America www.dramaguild.com

Educational Theatre Association/ITS www.schooltheatre.org

Entertainment Services and Technology Association www.esta.org

Independent Film and Television Alliance www.ifta-online.org

International Alliance of Theatrical Stage Employees www.iatse.lm.com

International Association of Lighting Designers www.iald.org

International Documentary Association www.documentary.org

League of Resident Theaters www.lort.org

Literary Managers and Dramaturgs of the Americas www.lmda.org

Minnesota State Film Board www.mnfilm.org

National Endowment for the Arts www.arts.gov

National Theatre Conference www.nationaltheatreconference.org

New York Foundation for the Arts www.nyfa.org

Organization of Black Screenwriters www.obswriter.com

Society of American Fight Directors www.safd.org

Society of Dance History Scholars www.sdhs.org

Society of Stage Directors and Choreographers www.ssdc.org

Southeastern Theatre Conference www.setc.org

Stage Directors and Choreographers Society www.sdcweb.org

Theatre Communications Group www.tcg.org

Theatre Library Association http://tla.library.unt.edu

United Scenic Artists www.usa829.org

United States Institute for Theatre Technology www.usitt.org

University/Resident Theatre Association www.urta.com

Women in Film www.wif.org

Photography

American Photography Association www.americanphotographyasso-ciation.org

American Society of Media Photographers www.asmp.org

National Association of Professional Child Photographers www.napcp.com

National Photographic Society www.thenps.com

National Press Photographers Association www.nppa.org

Professional Photographers of America www.ppa.com

Wedding and Portrait Photographers International www.wppionline.
com

Author Biography

Jill L. Ferguson has been a freelancer writer since she was first published at age 12. She is an award-winning writer, an artist, a business and higher education consultant, and a serial entrepreneur. She is the author of eight books, including the novel *Sometimes Art Can't Save You*, two business books for women, two academic books on assessment in creative disciplines, and two children's picture books. She has written for the *Washington Post*, *Huffington Post*, *Sierra Club Magazine*, and more than 200 other magazines, newspapers, and websites. Plus she has contributed chapters to half a dozen books. Her paintings have been commissioned in the United States and in Japan.

Jill L. Ferguson is the former chief of staff of the Western Association of Schools and Colleges, Senior Commission; the former department chair of General Education, assessment coordinator, and a professor at the San Francisco Conservatory of Music; and senior lecturer in the School of Business and Management at Notre Dame de Namur University. She is the founder of Women's Wellness Weekends (www.womenswellnessweek ends.com), and she can be reached either through www.jillferguson.com or www.creatingthefreelancecareer.com.

Contributor Biographies

Sahba Aminikia was born in 1981 in Tehran, Iran. Sahba studied music composition in Russia at the St. Petersburg State Conservatory under Boris Ivanovich Tishchenko, a post-graduate student of Dimitri Shostakovich. In his homeland, Aminikia studied under renowned Iranian pianists Nikan Milani, Safa Shahidi, and Gagik Babayan. He was perhaps most influenced by work with his first teacher and renown composer Dr. Mehran Rouhani, a post-graduate of the Royal Academy of Music and former student of Sir Michael Tippett.

Sahba received his Bachelor of Music and his Master of Music with honors from San Francisco Conservatory of Music under Dan Becker, David Garner, and David Conte, where he was the proud recipient of the Phyllis Wattis Foundation scholarship. He has also received lessons from Conrad Susa, Richard Danielpour, John Corigliano, Oswaldo Golijov, and John Adams. He is the recipient of various commissions from theatre troops to contemporary classical ensembles, film scores, Persian traditional music groups to jazz bands including Kronos Quartet, Symphony Parnassus, San Francisco Conservatory of Music New Music Ensemble, Mobius Trio, Delphi Trio, and Living Earth Show.

One of his most recent projects was a piece for Brooklyn Youth Chorus and Kronos Quartet involving pre-recorded media called "Sound, Only Sound Remains," which is a piece focused on Iranian female singers whose voices have never been heard in public before. His music has been widely performed in the United States, Canada, Iran, United Arab Emirates, Brazil, Ecuador, France, Italy, Poland, China, Greece, Turkey, and Israel.

Scilla Andreen (pronounced Sheila) is the CEO and co-founder of IndieFlix and the founder of the IndieFlix Foundation. She is an Emmy nominated costume designer and an award-winning producer of such films as *Bit Players*, *The Empowerment Project*, *Screenagers*, and the recently released *Angst*, a documentary created to raise awareness around anxiety. She is a popular speaker at Sundance, Cannes, CES, SXSW, Women in Film, and other major industry events. Frustrated by complicated and one-sided distribution deals, Scilla co-founded IndieFlix, which has become one of the most meaningful global online streaming platforms in the industry. IndieFlix specializes in edutainment, streaming over 6,000 films from 85 countries and creating and screening social change documentaries offline in over 10,000 communities in 20 countries. Scilla is on a mission to change the world with film.

Becca Bair created her first video game at the age of 11 and has been deeply entrenched in the growing world of indie game development since it first began. Over the years she has studied game art trends and techniques, mastering each new skill set and learning what it is the player wants to see most in a game.

Becca is classically trained in the art of figure drawing, university educated in architecture and interior design, and has over three years of garment design and construction experience. All her training comes together to yield convincing townscape designs, practical and plausible costumes in her concept art, and beautifully rendered backgrounds and tilesets made to integrate seamlessly into games.

Most recently, Becca is credited as art director for the RPG Puzzler Vidar (www.vidarthegame.com), available now on Steam. Becca currently serves as the creative director at Twin Otter Studios where she directs design and creates all art assets for Arcadian Atlas.

Emily Brantley was born and raised in sunny Los Angeles, lives near the beach, and finds inspiration from the beauty in nature and in people. Every plant, animal, and person is unique, and her art captures the vibrant colors and diversity of the world. A cause close to her heart is conservation, and much of her work celebrates the many creatures that are endangered by human carelessness and interference with nature.

Ever involved in the South Bay art scene of southern California, Emily was recently appointed by the mayor of Redondo Beach to the position of public art commissioner. She is also associated with the Redondo Beach Art Group, Hermosa Beach Artist Collective, and several others. Her work has been shown in prestigious shows throughout California and is collected nationwide.

Emily spends her free time serving at her church, traveling, and investing in her friendships. She can often be found riding her beach cruiser along the strand or exploring a local hiking trail.

Danielle Brooks is the author of *Good Decisions . . . Most of the Time*, a best-selling author, nutritional therapist, clinical herbalist, professional speaker, and founder of Lake Washington Wellness Center, and Good Decisions Inc. She is also a freelance writer with an entrepreneurial spirit who has worked in the health care field for over two decades. She currently practices nutrition in Washington State. Weight loss and the psychology of food are her passions and by far what she works with the most.

Danielle's approach to diet combines nutritional science with the psychology of food and reminds us that looking at our relationship with food is as important as the food itself. She is always looking for new and effective strategies to help her clients self-govern effectively around food and emphasizes that food is something to be enjoyed, not something we feel guilty about.

In her free time Danielle enjoys spending time online with the *Good Decisions* community to share what she is continuously learning, and also developing delicious, healthy new recipes. She enjoys swimming in the ocean, sailing, downhill and cross-country skiing, and checking things off her bucket list!

Kristie Burns, PhD, studied anthropology and linguistics at Northwestern University in Evanston, Illinois and then moved to Cairo, Egypt where she worked as a documentary photographer and journalist, using the ethnographic skills learned from her mentor, Ozwald Werner. One of her studies in the region covered the cultural phenomenon of folk medicine, which prompted her to earn certificates in homeopathy and iridology and degrees as a master herbalist and naturopath. Along with consultations,

she also uses the chemistry, biology, and research she studied during her master's degree to assist with environmental fieldwork. When she became a parent, Kristie became certified as an early childhood Waldorf educator as well as a Montessori early childhood educator and studied other methods of education. These certifications along with previous experience grew into a business called Earthschooling, which currently offers earth-based curriculum for ages preschool through eighth grade to parents, teachers, charter schools, and public and private schools. Kristie has traveled internationally speaking and teaching on the topics of education, plant biology and history, wildlife research, and education. She has been a speaker/presenter at more than 200 events worldwide. Kristie currently offers educational programs for adults and children through her nature-based educational materials at www.TheBEarthInstitute.com, does field research and presentations as a wildlife anthropologist for www. PellaWildlifeCompany.org, and has been the director of the Academy of Wildlife Education since 2010. She has published numerous articles on the topic of anthropology, wildlife, education, and natural healing. Kristie is the author of the popular teacher reference guide, *The Temperaments and the Adult–Child Relationship*, and is currently working on a research guide called *Zothnography, Ethnography, and the Culture of Animal–Human Relationships*.

Emily A. Danchuk Esq. has years of experience in trademark and copyright law, handling copyright and trademark transactional work, practice before the Trademark Trial and Appeal Board, litigating copyright and trademark infringement matters, and drafting and negotiating business and licensing agreements. She has also gained significant experience working with both large and small clients, assisting in various intellectual property-related matters while working as an associate at the Webb Law Firm in Pittsburgh, Pennsylvania. She served as in-house counsel on an independent contractor basis for Film Movement, LLC, a film distribution company specializing in independent and foreign films, and as an associate and counsel and legal intern with other New York and Pittsburgh firms. Presently, Emily runs her own successful trademark and copyright practice in Falmouth Maine and is leading the operations of a website-based association, Copyright Collaborative, LLC, which assists artists and creative types in understanding, protecting, and managing their intellectual property rights.

Kristen Gill is a creative writer, photographer, and media consultant. She delivers fresh content that resonates with the intended audience. She has worked with Fortune 500 Companies, Tourism Boards, Destination Marketing Organizations, Conservation agencies, lodges, hotels, tour operators, trade associations, and marketing and representation companies. She also writes trip reviews, tech reviews, and product/gear reviews. She will help you tell your story!

Abby Glassenberg is a sewing pattern designer, craft book author, teacher, and writer. On her blog, WhileSheNaps.com, she writes about the sewing industry, running a creative business, and the online culture of craft. She is the co-founder of Craft Industry Alliance. Abby has an undergraduate degree in history from Johns Hopkins and a master's degree in education from Harvard. She taught middle school social studies in Mississippi through Teach For America, and sixth grade in the Newton Public Schools before becoming a textile artist. She is the author of three sewing books. Abby lives in Wellesley, Massachusetts with her husband and three daughters.

Matthew Holmes-Linder has concertized all over the United States and Europe, including performances at Washington DC's Kennedy Center and San Francisco's Herbst Theatre. As a founding member of Mobius Trio, Matt has helped commission over three dozen new works for guitar trio and performed them all over the country.

As an educator, Matt has given master classes at the San Francisco Conservatory of Music's Preparatory Division, Cornish College, and Western Washington University and taught workshops all over the Unite States. Matthew was named winner of the 2008 Wesleyan Univers' Concerto Competition and 2011 San Francisco Conservatory of Mu Guitar Concerto Competition.

Matt holds an MM from the San Francisco Conservatory of M (where he studied privately with Sergio Assad), a BA from Wes' University, and studied privately with Antigoni Goni while a st at the Juilliard School Pre-College Division. He lives in San Frar where he performs frequently with his group, Mobius Trio.

Jane Hughes is an Assistant Professor of Interior Design at Carolina University, and she has spent the past 28 years in pro

practice as an interior designer including work in the resort, multi-family, and condominium sectors. Her research interests are in quality of life in the elder care industry as it relates to acoustics and lighting. She is a frequent speaker at interior design conferences. Jane holds a BS from Miami University in Ohio, and an MA from the University of Kentucky at Lexington.

Marjory Kaptanoglu is a produced screenwriter and published novelist. Among her screenplays, *Dead in the Room* won the Grand Prize in the Slamdance Short Screenplay Competition and the film premiered at the Slamdance Film Festival. *Dearly Departed* won the Silver Page Award and premiered at the Santa Barbara International Film Festival. Other script awards include First Place in the Cynosure, Table Read My Screenplay, Harlem Film Festival, Worldfest Houston, Script Savvy, and International Horror & Sci-fi Festival screenwriting contests. *The Courtesan* is a two-time Academy Nicholl Fellowships quarterfinalist, *Direct Descent* was a finalist for the Hearst Screenwriting Grant, and *Deviled Girl* won a Writers' Boot Camp Fellowship. Marjory was hired to write *Slander*, a feature screenplay adapted from the novel *Gossip* by Christopher Bram (*Gods & Monsters*).

On the horizon, three more short films from Marjory's scripts are currently in post-production. She is nearing completion on her third novel, a sci-fi thriller called *Invader*, and *Dreadmarrow Thief*, her recently published second novel, won the Wishing Self Book Awards bronze medal. Marjory is in negotiations to option *Deviled Girl* to a UK producer.

Marjory graduated from Stanford University with a BA in English and was a selected participant of the Squaw Valley Community of Writers Screenwriting Workshop. She is a screenplay contest judge and has appeared on screenwriting panels.

Kate Peters is the co-founder and president of Vocal Impact, Inc. a network of voice professionals dedicated to guiding and inspiring leaders to be real and relevant heroes in their own stories and the stories of their organizations. After 25 years as a professional singer and voice teacher, Kate changed career directions, establishing Vocal Impact to work with executives at Cisco, First American, Invensys, Intel, Verify, British

Petroleum, Disney, Nissan, and HPE, as well as speakers at TED events. Kate's approach to vocal impact and executive presence has led to interviews wherein the KNX newsroom tried out mask resonance, and radio audiences in Canada heard Valentine's Day advice on how to create a sexy voice.

An active blogger since the early 2000s, her Kate's Voice blog is among Prezi's 50 Best Public Speaking Resources, and she has been voted a top 30 Global Guru in Communications since 2013 at crowd-sourced globalgurus.net.

Alison Rose is a graduate of NYU Steinhardt's Department of Music and Performing Arts Professions and holds an MA in Dance Education and a BFA in Dance from California State University, Long Beach. In New York City, Alison danced with Randy James Dance Works, where she toured both nationally and internationally and fulfilled her dream to become a professional modern dancer. She has been teaching elementary school dance since 2009 in the Los Angeles Unified School District.

Alison Rose is a published children's book author and a member of the Society of Children's Book Authors and Illustrators. Her book, *Shoes off, Mommy?* was recently recommended as a new and popular release in *Dance Teacher Magazine*.

Madeline Sayet is a director, performer, writer, and educator based in New York and London. A member of the Mohegan Nation, she explores cultural intersections through original theatre productions in an effort to highlight indigenous perspectives. Her work ranges from reinterpretations of Shakespeare to absurdist comedy, and explores the complexities of race, culture, and media. In 2015, she premiered a critically acclaimed production of Mozart's *The Magic Flute* that embedded indigenous ideologies in the classic opera.

Madeline Sayet's mission is to present Native peoples with positive images and complex realities onstage. She is currently pursuing a PhD at the Shakespeare Institute (examining the long history between indigenous peoples and Shakespeare), developing Cathy Rexford's new play *Whale Song* at the Perseverance Theatre in Alaska, and directing a new production of *As You Like It* for Delaware Shakespeare, which

will tour to community-based organizations throughout Delaware. Sayet is a 2016 TED Fellow, a recipient of the White House Champion of Change Award, a National Directing Fellow, a Van Lier Directing Fellow at Second Stage, and a National Arts Strategies Creative Community Fellow. A director of new plays, classics, and opera, she was the resident director at Amerinda (American Indian Artists) Inc. from 2012–2016, where she developed new plays by Native playwrights and launched the Native Shakespeare Ensemble.

Rick Schank finally has his dream job and it's not work, it is passionate play as Senior Couch Po'tader Tot at Purple Couch Creative. He manages a small design studio called Purple Couch Creative, which specializes in brand building and identity creation. He has worked in the marketing communications industry for over 30 years. As the director of marketing and communications, he led a comprehensive team assigned to market the various programs offered at California State University, Long Beach. Rick has also had a career in publishing. He managed a large production department, providing every type of creative service to internal and external clients.

Rick's passion for design is shared with his love of teaching. He is an instructor at various universities and colleges in Southern California. He's been teaching marketing and graphic design courses, as an adjunct instructor, for over 25 years, and has been awarded the Part Time Instructor of the Year award on two occasions.

Rick holds a Bachelor of Arts degree in Communication Design from Kutztown State University of Pennsylvania and a Master of Fine Arts degree in Fine Art and Photography from California State University, Fullerton. He has also completed the Certificate in Marketing at the University of California, Los Angeles. Rick is a lifelong learner and has recently completed classes in French, calligraphy, and guitar.

Tarlan Seyedfarshi, as a fashion design student, searched aimlessly for a high-quality, custom portfolio book to house her work. She quickly realized that other designers were searching for the same. In 2011, Klo Portfolios was born, allowing designers and presenters creative freedom to perfect the details of their work while they take care of the piece that brings it all together.

Today, Klo Portfolios can be found on all five continents in the hands of tens of thousands of designers and professionals alike. Although every one of their customers' purpose is unique, their desire to stand out and let their work shine remains the same. Klo Portfolios can be found in the hands of everyone from recent graduates to executives at IBM and Amazon.

Tarlan and her husband, Addel, run the company together in Vancouver from their manufacturing facility where all of their products are made in-house. They continue to add presentation solutions for designers of all disciplines.

Dan Silberman started his musical journey at the age of 10 when he picked up his first instrument, the double bass. His formal training includes three classical performance degrees from several of the world's most prestigious conservatories, including an MA from the Royal Academy of Music (London), a BA from the San Francisco Conservatory of Music, and a diploma from the Interlochen Arts Academy.

Besides playing classical music, he has always loved to play music of other genres in his "spare time," which has afforded him the opportunity to work and perform with Grammy award-winning and nominated artists and groups in some of the most popular venues throughout the world. Dan is also a prolific composer and arranger. His music has been featured on Chicago's classical radio station WFMT, and musicians from the Chicago Symphony and other major orchestras throughout the world have performed his compositions and arrangements.

In 2012, Dan departed from his career in classical performance to start up his own studio and production company. His meticulous attention to detail, extensive musical training, and insistence on the highest-quality and finest-sounding new and vintage equipment all set him apart from most producers and engineers in today's digital age of music recording and producing.

The eclectic nature of his musical preferences and experiences renders him uniquely qualified in and for any and all types of musical genres including classical, rock, blues, jazz, pop, gospel, and just about any others you might think of. He is open-minded and flexible, curious, honest, and always on top of the latest trends, techniques, and styles of his industry. Most importantly, though, he loves to share with as many people as possible the joy that creativity and music can provide.

Lorna Stell is a wedding and portrait photographer based in Boston, Massachusetts. Originally from Blacksburg, Virginia, she began her creative career as a self-taught artist and went on to receive her BS from Radford University in Studio Art with a focus on graphic design. After graduating in 2011, she then moved to Boston and received a Post-Baccalaureate Certificate from the School of the Museum of Fine Arts in 2012, focusing on photography.

Since moving to Boston, Lorna has photographed over 60 weddings and events, and has photographed over 40 small business and portrait clients. When she's not behind the camera or her computer, Lorna can often be found on a yoga mat, exploring New England, or watching a sci-fi movie with her husband.

Mimi Tsang, founder and designer of hello shiso, curated her love for accessories from an early age, thanks to a mom who took great pride in dressing her hair with pretty clips, ribbons, and bows. Since 2010, Tsang has been creating high-quality, beautifully designed accessories full of fun and whimsy, with unusual details that appeal to kids and adults alike. The small design studio and workshop is a family owned and run business based in Berkeley, California.

Dan Vassiliou is a serial entrepreneur who has set up stores selling anything from trophies to digital marketing services. His agency www.edivandigital.com deals with selling cutting edge content marketing products and advising clients how best to garner traffic, brand authority, and business credibility from their content strategies. He has helped rank many sites on the first page of Google, using the techniques he advises others to use, and also given many companies exposure to large audiences that they would otherwise have missed out on through the same techniques. In his spare time he enjoys weight training and drumming, as well as spending as much quality time as possible with his family.

Armando Veve is an illustrator working in Philadelphia. His drawings have been commissioned by a range of clients including *The New Yorker, Bloomberg, Businessweek, MIT Technology Review, Smithsonian Magazine, Wired*, and *McSweeney's*. His work has been recognized by

American Illustration and Communication Arts, and awarded two gold medals from the Society of Illustrators. His illustration for *The New York Times Book Review* was nominated for a Spectrum Award. He was named an ADC Young Gun by the One Club for Creativity and selected to the Forbes 2018 30 under 30 list. Armando exhibits his original drawings in galleries across the United States and abroad.

Stephen Warley is a self-employment advocate and coach. He is the founder of LifeSkillsThatMatter.com. He believes self-employment is the future of work. He wants to inspire you to create your own work. He teaches self-management skills to the side hustlers, freelancers, and solopreneurs. He's been self-employed for the past 17 years. During that time he built a sales training business with annual revenue of $600,000, ran his business from Seville, Spain for four months and has saved enough money not to work the next eight years of his life. Learn how to make your work, work for you at lifeskillsthatmatter.com/getstarted.

Ali Wunderman is a freelance writer focusing on wildlife and travel journalism. Her work has appeared in more than 25 publications, and her guidebook, *Frommer's Belize*, was published in July 2018. She was born and raised in San Francisco, but currently lives in Montana with her husband and their dog.

Index